INGRES'S EROTICIZED BODIES

RETRACING

THE

SERPENTINE

LINE

CAROL OCKMAN

YALE UNIVERSITY PRESS

NEW HAVEN AND LONDON

YALE PUBLICATIONS IN THE HISTORY OF ART ARE WORKS OF CRITICAL AND HISTORICAL SCHOLARSHIP BY AUTHORS FORMERLY OR NOW ASSOCIATED WITH THE DEPARTMENT OF THE HISTORY OF ART OF YALE UNIVERSITY. BEGUN IN 1939, THE SERIES EMBRACES THE FIELD OF ART HISTORICAL STUDIES IN ITS WIDEST AND MOST INCLUSIVE DEFINITION.

SERIES LOGO DESIGNED BY JOSEF ALBERS AND REPRODUCED WITH PERMISSION OF THE JOSEF ALBERS FOUNDATION.

DESIGNED BY DEBORAH DUTTON.

SET IN ADOBE CASLON AND COPPERPLATE GOTHIC TYPE BY THE COMPOSING ROOM OF MICHIGAN, INC.

PRINTED IN THE UNITED STATES OF AMERICA BY THOMSON-SHORE, DEXTER, MICHIGAN.

LIBRARY OF CONGRESS CATALOGING-IN-PUBLICATION DATA

OCKMAN, CAROL.

INGRES'S EROTICIZED BODIES : RETRACING THE SERPENTINE LINE / CAROL OCKMAN.

P. CM. — (YALE PUBLICATIONS IN THE HISTORY OF ART)

INCLUDES BIBLIOGRAPHICAL REFERENCES AND INDEX.

ISBN 0-300-05961-2

1. INGRES, JEAN-AUGUSTE-DOMINIQUE, 1780–1867— CRITICISM AND INTERPRETATION. 2. NUDE IN ART. 3. FEMINIST ART CRITICISM.

I. TITLE. II. SERIES.

ND553.I5O35 1995

759.4—DC20 94-34311

CIP

A CATALOGUE RECORD FOR THIS BOOK IS AVAILABLE FROM THE BRITISH LIBRARY.

THE PAPER IN THIS BOOK MEETS THE GUIDELINES FOR PERMANENCE AND DURABILITY OF THE COMMITTEE ON PRODUCTION GUIDELINES FOR BOOK LONGEVITY OF THE COUNCIL ON LIBRARY RESOURCES.

10 9 8 7 6 5 4 3 2 1

TO RUTH K. OCKMAN

TO JULES OCKMAN, WHO DIED TOO SOON

AND TO LINDA NOCHLIN

CONTENTS

ACKNOWLEDGMENTS

The research for this book began in 1986, when I actively started to
explore my relationship as a feminist social historian to Ingres's
work. As the project progressed, the need to pose questions that
would enable me to look at Ingres's paintings of women as not just
predictable stereotypes of femininity became increasingly apparent.
If I have turned to history to explore the ways in which construc-
tions of gender, sexuality, and ethnicity are encoded in specific
works of art, it is with the hope of applying its lessons to theoreti-
cal and practical debates about women's power and pleasure today.

Much of the research for this book was done in France in the
spring of 1987 and the fall of 1990. I want first to acknowledge the
invaluable assistance of members of the Rothschild family and
staff. Above all, I would like to thank Baronne Elie de Rothschild
for her exceeding generosity and kindness. Anka Muhlstein, Baron
and Baronne Guy de Rothschild, Baron Eric de Rothschild, Baron
and Baroness Nathaniel de Rothschild, and Lord Rothschild also
provided aid critical to my research. I would like to acknowledge
the support of Prince Napoléon Murat, Jean-François Heim, and
Mr. and Mrs. David-Weill and their archivist, Mme Muraz. Pierre
Rosenberg and Marie-Catherine Sahut, and Régis Michel at the
Musée du Louvre, Philippe Grunchec at the Ecole des Beaux-
Arts, Jean-Pierre Samoyault at the Musée National du Château de
Fontainebleau and Alain Pougetoux at the Musée National du
Château de la Malmaison greatly facilitated my work as did li-
brarians at the Bibliothèque Nationale, the Archives Nationales,
the Institut de France, the Bibliothèque Thiers, the Bibliothèque
Jacques Doucet, the Bibliothèque Historique de la Ville de Paris,
and the Rothschild Archives in London. Madeleine Walter-Hurel
opened her house to me in Paris, made me part of her family,

loaned me her car, and in every way added immeasurably to my sojourns in France. Françoise and Francis Neher, Christiane Andersson, Karen Bowie, Hélène Hourmat, Rosie Huhn, and Alain Morel enhanced the pleasures of Paris, and Jeffrey Blanchard offered an old friend's hospitality in Rome.

Among the friends and colleagues who read and discussed this manuscript with me, I wish to thank John Goodman and Meredith Hoppin for stimulating comments and conversation about Chapter 1 and Carla Hesse for bibliographical suggestions. Alvar Gonzales-Palacios shared with me his knowledge about the Murats in Italy. My colleagues in Women's Studies, Karen Swann, Ilona Bell, Lynda Bundtzen, Regina Kunzel, and Jana Sawicki all read portions of the manuscript. Jann Matlock was a provocative interlocutor for Chapter 4 in its later stages. Tom Jones at Joe Fawbush Gallery, the staff at Pace Wildenstein Gallery and Metro Pictures, and Jayne H. Baum at Jayne H. Baum Gallery generously shared their resources for Chapter 6. I am extremely grateful to Adrian Rifkin, Tamar Garb, and Carol Duncan for sensitive and insightful readings of the entire manuscript. When portions of the manuscript were presented as papers or published as articles, I received helpful comments and suggestions from Alex Potts, Christopher Baswell, Linda Nochlin, Tamar Garb, Paul Holdengraber, Elizabeth McGowan, E. J. Johnson, Hartley Shearer, Richard Brilliant, Lynn Hunt, and Mary Stieber.

The Powers Fund and the Center for the Humanities and Social Sciences at Williams College funded portions of the research and writing of this book, which was also nurtured along the way by my colleagues' interest and support. Williams College partially subsidized the cost of color reproduction. Librarians at the Clark Art Institute, staff at the Clark Art Institute Slide Library, and librarians at Sawyer Library responded to my every query. Sybil-Ann Sherman, the art department secretary, and Patricia LeClaire, the slide library coordinator at the art department, provided special assistance while I was chair of art history. My co-chair, Barbara Takenaga, consistently lightened my load. To Edward Sullivan, who loaned me his office at New York University the summer I finished the final draft of the manuscript, and to the fine arts department there for making me feel welcome, I owe a special debt. It has been a pleasure to work with Judy Metro, senior editor, and Cynthia Wells, senior production editor, at Yale University Press, and I gratefully acknowledge their help and support. Brian Wallis provided expert editorial assistance and Sarah King excellent photographic research, with unending good humor. In the final stages, Elizabeth Levine and Rachel Lindheim generously helped with proofreading.

If there is anyone who deserves to be singled out for influencing my professional life and work, it is Linda Nochlin, who made me want to be both an art historian and her friend. I had the good fortune to be her student in the summer of 1971 and

to read "Why Have There Been No Great Women Artists?" six months after it first appeared. I have been enriched by her intellect, acumen, and irreverence ever since. I also want to thank Robert L. Herbert, who, as my dissertation advisor and academic cicerone over the years, has shown an unparalleled devotion to his students and has shared a wealth of knowledge, of which I am but one of numerous beneficiaries. Most important, my parents gave me unlimited sustenance to write this book. The research for Chapter 3 was begun shortly before my father died, and his history, as well as my own, shapes its contours. My mother continues to support me in ways I never imagined possible, not the least of which is keeping my articles on her coffee table for too long. In his understated way, my brother Stuart has been a source of strength. I wish to thank Mary McLeod, Lila Abu-Lughod, Kenneth E. Silver, and Leslie Carter for long-term sustenance, at once intellectual, practical, and immeasurable. Special thanks also to Mirka Beneš, David Eppel, Christine Kondoleon, Fatimah Tobing Rony, Julie Weinberg, Francesco Passanti, and Angela Zito for sustaining friendship. To my nephews, Sam and Aaron, and to my students, I am ever grateful for proof that being an academic is worthwhile.

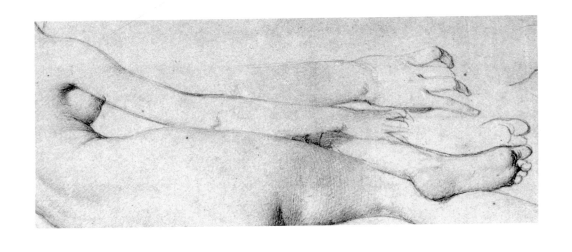

RETRACING

THE

SERPENTINE

LINE

line holding meaning

. . . a back in whose supple flesh runs a delicious serpentine line.
—Théophile Gautier on the *Grande Odalisque* (1855)

And make no mistake: under that line which seems so calm, there is ardor
contained by the will not to deviate from the route laid out *a priori*.
—Charles-Louis Duval (1855)

Ingres's line and the term *serpentine,* which frequently describes it,
so automatically connote the sensual that reference to the qualities
of grace and softness has become integral to any understanding of
Ingres's style. By the mid-nineteenth century, Ingres's serpentine
line, along with the anatomical distortion that is its corollary, de-
lighted all but the most intractable critics. In the twentieth century,
it most often has been described as a formal innovation anticipat-
ing the work of Matisse and Picasso. Analysis of how and why
Ingres's signature line came to embody his formal achievement is a
crucial component of this book. By exploring how a formal device
has been used to construct meaning, this book reveals the way in
which the focus on Ingres's aesthetic achievement has masked and
continues to mask historical and theoretical concerns, at once de-
temporalizing and depoliticizing them. Using the historical to
posit the theoretical, my analysis recasts this aesthetic achievement.
The result is surprising: it demonstrates why a conservative, white,
male artist, whose works supposedly objectify women's bodies,
might be of interest for a feminist art historian.

As a feminist who instinctually enjoys the sensual properties of
Ingres's work, my own response has always been at least ambiva-
lent, if not laced with prohibition. This mistrust arises not because
Ingres's works are somehow too erotic and therefore improper, but
rather because of gendered assumptions that make them suspect.
Why is it that most of Ingres's eroticized bodies are female? How

is it possible for any self-respecting feminist to ignore the critique that Ingres's paintings reduce women to their bodies? Or the corollary that such works were intended for and consumed by men?

The relationship between pleasure and serpentine line, and the question of whose pleasure is at stake, becomes vexed as soon as we look at associations among serpentine line, the sensual, and the female body. Although the term *serpentine line* had surprisingly little currency in the nineteenth century, its sensual properties were endlessly invoked in the critical writings about Ingres's work. The term itself (as *figura serpentinata*) was first introduced in the Renaissance, and like the classical term *contrapposto*, it passed into the general neoclassical tradition without the significance it had had for Michelangelo and the artists of the sixteenth century. When serpentine line again became a popular topic for discussion in the eighteenth century, its most conspicuous appearance was in William Hogarth's *Analysis of Beauty* (1753). Hogarth's treatise introduced an explicitly gendered reading of serpentine line, one which, at least in part, informed Ingres's productions. A number of Hogarth's pronouncements in the chapter entitled "Of Lines" indicate that the female body is the best suited to convey the particular beauty associated with serpentine line; they also appear to chronicle some of the most familiar features of Ingres's art:

> There is an elegant degree of plumpness peculiar to the skin of the softer sex, that occasions these delicate dimplings in all their other joints, as well as those of the fingers; which so perfectly distinguish them from those even of a graceful man; and which, assisted by the more softened shapes of the muscles underneath presents to the eye all the varieties in the whole figure of the body, with gentler and fewer parts more sweetly connected together, and with such a fine simplicity as will always give the turn of the female frame, represented in the Venus, the preference to that of the Apollo.[1]

As the introduction to the French edition of 1805 explains, Hogarth's text "attempts to show through numerous examples that the serpentine line is the real line of beauty and that undulant forms most pleasure the eye." Like his sixteenth- and seventeenth-century predecessors, Hogarth sought to link serpentine line to grace and to the ornamental. At the same time, he emphasized that "windy lines are as often the cause of deformity as of grace."[2] The conjunction of these seemingly disparate qualities suggests that Ingres may have felt that his license with anatomical forms had the blessing of High Renaissance, and notably Mannerist, tradition.

The relationship between deformity and grace seems especially significant when studying an artist whose most famous painting of a nude, the *Grande Odalisque*, is

known for having too many vertebrae (see fig. 15; plate 2).[3] Ingres did add extra lumbar vertebrae to the back of the *Grande Odalisque*. Without them, it would be impossible to retain the curve of the back and to keep the figure's head up. But more interesting than their presence itself is the process by which these extra vertebrae, originally disparaged as anatomically incorrect, came to denote Ingres's formal genius. Ingres's reputation as a neoclassicist, and subsequently as a proto-modernist, has tended to obscure the fact that the anatomical distortions in his paintings could displease as well as please. Even at the height of his fame, Ingres's body types provoked such expressions of visceral disgust as to suggest that the relationship between serpentine line and horror is fully as important for a consideration of Ingres's work as the relationship between serpentine line and pleasure. Thus, one of the central arguments of this book will be that the widespread enthusiasm about Ingres's eroticized bodies by the mid-nineteenth century depended upon the general perception that line successfully controlled the sensual. Sanctified by the neoclassical ideal and the modernist canon alike, Ingres's line was invoked to naturalize equations between the sensual, deformity, and the female body.

When I began this book, I set out to expose the gendered assumptions that made serpentine line, with its complement of sensual attributes, the signal mark of Ingres's achievement. My intent was not to resurrect any notion of an essential feminine, but rather to reveal the ways in which gender, and the feminine in particular, has been constructed. Mindful of those constructions and the real restrictions they imposed, I wanted to think about women's possibilities for agency and pleasure. In the process, two things became increasingly clear: any analysis emphasizing gender questions unsettles gendered assumptions by revealing their inherent instability; second, any gendered analysis, and the gendered assumptions it of necessity reveals, is complicated, if not at times eclipsed, by other forms of difference. In looking at Ingres's *Achilles Receiving the Ambassadors of Agamemnon* (fig. 1; plate 1), for example, I saw that the proposed equation of serpentine line with female bodies initially was confused by application of that line to male bodies and then was further complicated by assumptions about sexuality. As another instance, the surprising surplus of sensual qualities in the portrait the *Baronne de Rothschild* (fig. 32; plate 4), in which color usurps the customary role of line in Ingres's work as the primary vehicle of the sensual, only made sense in the context of stereotypes of both ethnicity and gender.

In exploring the *effects* of a formal device, I focus on sensualized classicism as a distinct, and hitherto neglected, phenomenon, with important ramifications for nineteenth- and twentieth-century aesthetics. I want to demonstrate how the sensual reconfigured neoclassicism in the late eighteenth and the nineteenth century and how that reconfiguration set in motion a crisis in definitions of masculinity. If

this crisis was linked to a rigidification of sex roles, it also affected the way images looked and the language used to describe them. My approach is meant as a long-overdue corrective. On the one hand, the desire to cast Ingres as the heir to David and Ingres's work as the embodiment of neoclassicism has obscured the profound changes in style and subject matter wrought by his art. On the other, the assumption that Ingres's sensualized body is a beautiful body fails to address distortion and the frequent perception that this body is beautiful and strange at the same time.

This book then is a response to the simplistic equation of neoclassicism with stoicist heroics and to the difficulties of theorizing female spectatorship and women's pleasure. Central to my historical argument are the contradictions inherent in the change from the revolutionary hero to the postrevolutionary sensualized nude and the larger difficulty of representing a viable ideal body, male or female, which could allay contemporary anxieties about masculine identity. Although the alliance of Ingres's line with the sensual and with the female body is crucial to my discussion, I argue that it is the radical redefinition of the male body in the wake of the French revolution that ultimately is responsible for the increased emphasis on the female nude in the nineteenth century. This shift is nowhere more apparent than in the work of Ingres.

Another of my aims is to refashion the feminist critique of the 1970s, which dismissed paintings like the *Grande Odalisque* as *femmes-objets,* by presenting evidence to show that women actively collected and appreciated eroticized nudes in the early nineteenth century. This historical argument contravenes the traditional feminist view of Ingres's work and of representations of women in general. It demonstrates that although the erotic invariably is constructed as "feminine," eroticized bodies can be male as well as female. My analysis calls into question the assumptions that erotic imagery always has been the sole province of men and that pleasure in looking has been an exclusively male prerogative. Beyond this, however, my overarching concern is with the contradictions inherent in assumptions about pleasure and meaning. I have aimed to use historical analysis to enable the theoretical. While the demise of the heroic male body and its links to postrevolutionary France can be taken as one of the principal historical arguments of the book, the ambiguities in gender occasioned by ephebic male bodies (see, for example, *Achilles Receiving the Ambassadors of Agamemnon, Martyrdom of Saint Symphorian,* and *Paolo and Francesca*), on the one hand, and very sensual female bodies (see the *Grande Odalisque* and the *Baronne de Rothschild*), on the other, also are connected to a methodological argument about pleasure and subjectivity.

The exploration of patronage by women and their taste for sensualized classicism is nothing so much as a response to the seemingly endless task of chronicling

how representations of women have reduced them to a group of well-known stereotypes. By analyzing a variety of ways through which women were involved with the representation of eroticized bodies—as patrons, collectors, and critics—I have attempted to show that not only were women equated with sensuality, they also had access to sensuality. My intent in advancing this and other arguments that try to theorize some notion of female agency or subjectivity is to respond to the complex debate that, until recently, made pleasure for women suspect among those engaging in such theorizing. Without developments in feminist theory over the past decade and the expanded possibilities they have provided for language itself, this book could not have been written. The history of my own interest in Ingres's work therefore might serve to introduce the difficulties in theorizing any notion of women's pleasure in looking.

In the early 1980s, whenever I talked about Ingres, a committed feminist historian and friend would reply that she couldn't understand why I worked on this artist. I would tell her of my fascination with the tension in his work between controlling line and sensual flesh. In hindsight, our perpetually stalemated discussion seems to have been an ideological one. I was attempting to assert my pleasure as a woman viewing Ingres's work, when there was virtually no language for doing so. In my friend's eyes, my decision to work on an artist considered to be conservative in artistic as well as personal matters was both undesirable and politically incorrect. Seen against the landscape of feminist thought in the 1970s and much of the 1980s, her implied criticism seems to have been a way of warning me against the perils of subscribing to a male economy of pleasure, so cogently described by John Berger, Laura Mulvey, and others.

The idea that women cannot look at themselves without also being aware of how they may be being looked at was introduced in the early 1970s by John Berger on the BBC television series *Ways of Seeing* and in the popular essay of the same name based on it. In asserting that "to be born a woman has been to be born, within an allotted and confined space, into the keeping of men," Berger outlined the concept that a woman's self is "split into two." A woman "must continually watch herself," he writes. "She has to survey everything she is and everything she does because how she appears to others, and ultimately how she appears to men, is of crucial importance for what is normally thought of as the success of her life. Her own sense of being in herself is supplanted by a sense of being appreciated as herself by another."[4]

At approximately the same time, Laura Mulvey's influential article "Visual Pleasure and Narrative Cinema" appeared in the journal *Screen*. To Berger's argument Mulvey adds a psychoanalytic reading in which woman "stands in patriarchal cul-

ture as a signifier for the male other, bound by a symbolic order in which man can live out his fantasies and obsessions through linguistic command by imposing them on the silent image of woman still tied to her place as bearer, not maker, of meaning." According to Mulvey, this symbolic order structures ways of seeing and pleasure in looking that "masculinize" the spectator position, regardless of the actual sex of the viewer. Inasmuch as mainstream, Hollywood-style cinema "coded the erotic into the language of the dominant patriarchal order," Mulvey argued for nothing less than the destruction of pleasure.[5] In "Afterthoughts on 'Visual Pleasure and Narrative Cinema'" she articulated her position further, by focusing on a female protagonist who "is shown to be unable to achieve a stable sexual identity, torn between the deep blue sea of passive femininity and the devil of regressive masculinity." This "inability to achieve stable sexual identity," said to be "echoed by the woman spectator's masculine 'point of view,'" was taken up in the writings of Teresa de Lauretis, Mary Ann Doane, and others.[6]

These arguments point to the dizzying array of complications in theorizing a notion of female spectatorship and pleasure in looking. De Lauretis's notion of "double identification," in particular, is intriguing because it resists an identification that is inexorably split or entirely "masculine" on the part of the female viewer. Unlike Mulvey, de Lauretis argues that the ambivalence of female desire (moving between "passive femininity" and "regressive masculinity") need not be negative: "the real task is to enact the contradiction of female desire, and of women as social subjects, in the terms of narrative; to perform its figures of movement and closure, image and gaze, with the constant awareness that spectators are historically engendered in social practices, in the real world, and in cinema too." For de Lauretis, for whom "the movement of narrative discourse . . . specifies and even produces the masculine position as that of mythical subject, and the feminine position as mythical obstacle or, simply, the space in which that movement occurs," this "may mean rewriting the story so that narrative, meaning, and pleasure are no longer constructed solely from the masculine point of view."[7]

This book is intended to be a revision of the art historical and feminist stories about Ingres, both of which largely have disallowed pleasure for female viewers.[8] In its focus on Ingres's eroticized bodies, the book tries to structure a certain kind of resistance, one that reclaims pleasure, opposes stereotypes, and gives the lie to formalist reductivism. While I accept de Lauretis's concept of double identification and share her belief that the ambivalence of female desire can be used positively, my project is different from hers. My concern is first with a formal device that has been linked to pleasure and ultimately with the possibilities for pleasure in the transgression of visual codes. Sometimes the effects of this formal device are pre-

dictable: Ingres's serpentine line often does reinscribe stereotypes. At others, they are unexpected: inasmuch as serpentine line not only controls but produces pleasure, it can unleash effects of which the artist never dreamed. Because the probity of Ingres's line, rather than the sensualized bodies it so often defines, has been discussed as the mark of his achievement, speaking about the relationship between serpentine line and pleasure questions not only formal hierarchies but also the assumptions they often obscure.[9]

Primary among the leitmotifs engaged by serpentine line in its meandering through my text is the question of binary oppositions. Given the moral force historically attributed to line and Ingres's role as premier neoclassicist for much of the nineteenth century, it is difficult not to see his line and the sensuous forms it inscribes in oppositional terms. Ingres's paintings and the critical writings about them lend themselves particularly well to an analysis of binary oppositions. The *Turkish Bath* (fig. 56), his last ambitious effort to sum up the "erotic subjects" upon which much of his modern reputation is based, is arguably the work in which his contour line vies most dramatically with protean forms.[10] The very shape of the canvas is enlisted to restrain the ample female forms, whose fleshiness would appear to go beyond real-world anatomy, if not beyond the parameters of fantasy.

When faced with a painting like *Jupiter and Thetis* (fig. 57; plate 7), it is still harder to resist the tendency to dichotomize. Here the inflated frontal torso of Jupiter is overlaid by the aqueous contour in strict profile of Thetis beseeching him. For the feminist historian, the overdetermined oppositions in this painting inevitably suggest the binary relation of sexuality addressed by Michel Foucault, Luce Irigaray, Monique Wittig, and others. Although their interpretations differ, each believes that this artificial binary framework consolidates and naturalizes structures of power. Much of the analysis in this book demonstrates that even when representations attempt to reinscribe them, binary oppositions (nature/culture, inside/outside, hard/soft, male/female, heterosexual/homosexual) are inherently unstable. The fact that binary thought is so central to Western culture as to predispose me to think of Ingres's paintings and the ways they have been discussed in oppositional terms is seriously troubling. It is precisely because this is so that I take such pains to deconstruct the dichotomous thought underpinning Ingres's paintings and the critics' response to sensualized classicism.

Some of Ingres's own works suggest sexual indeterminacy. The figure in *Bather of Valpinçon* (fig. 55) entirely lacks distinguishing sexual characteristics; in the *Grande Odalisque* they are minimal at best. In still other instances, Ingres would appear to unglue binary oppositions by divorcing sex from gender.[11] In the figures of Achilles and Patroclus (*Achilles Receiving the Ambassadors of Agamemnon*) and

again in that of Saint Symphorian (*Martyrdom of Saint Symphorian*, fig. 46; plate 5), Ingres unusually uses serpentine line to describe men. Ingres's art, offering as it does a range of works in which the artist sometimes appears to assert sexual difference and sometimes to deny it—or even to suggest that sex and gender are not the same thing at all—lends itself particularly well to an analysis of binary oppositions and their changeability.

Through both historical and theoretical analyses, I have tried to unsettle oppositional and stereotypical thinking: to show how and why binary thought is constructed, to note instances in which it falls apart, and to put pressure on it to do so. My analyses of specific paintings show the ways in which ethnic, gender, and sexual stereotypes function as strategies of domination, while my analyses of neoclassical and modernist critical discourse reveal the ways in which both rely on binary thought to guarantee sexual difference. The perceived need for line to control the sensual and the constant invocation of line's moral, intellectual, or creative force are nothing so much as attempts to neutralize the horror of difference through recourse to the universal. That very neutrality is itself gendered and finds its analogue in the dual neoclassical and modernist imperative for an ideal that eschews the sensual and the real, while it simultaneously naturalizes equations between the sensual, the female, the deformed, and the bestial. As the opening quotation from Charles-Louis Duval suggests, Ingres's line functioned to control the sensual. This study shows how the sensual qualities of that line unavoidably destabilized the distinctions between masculine and feminine, real and ideal, life and death, that it was meant to secure. And it is this notion of destabilization that structures possibilities for feminist subversions of those tenacious, and intensely disturbing, equations between sensuality, deformity, bestiality, and the female body.

Virtually any consideration of oppositional thought has to take into account the related notions of essentialism and constructionism, which themselves are often thought of as a dichotomy. Essentialism is usually understood as a belief in "the invariable and fixed properties which define the 'whatness' of a given entity." The idea that men and women, for example, are identified as such is based on essences at once transhistorical, eternal, and unchanging. Constructionism, on the other hand, posits that a constellation of cultural, social, psychical, and historical differences constitute the subject. These differences, including sexual difference, are not innate but experiential. Unlike essentialism, which is often linked to biology, constructionism elaborates a linguistic phenomenon, in that the names applied to objects are held to be determinants of their existence in the mind. Convinced by the arguments of Diana Fuss and Luce Irigaray, among others, I am suspicious of abolishing the notion of essence.[12] Indeed, when essence is taken to an extreme, as it is

in Ingres's *Jupiter and Thetis,* it can actually have the effect of caving in under the weight of meaning with which it is invested. I will take this line of argument in discussing what critics perceived to be the failure of Canova's so-called heroic works and of Ingres's *Martyrdom of Saint Symphorian.* I will employ it again, to decidedly different effect, in exploring the potentially subversive qualities in the work of Cindy Sherman and Kiki Smith.

Of the many aspects of my own experience that shaped the contours of this text, primary among them is the fact of being a woman who became a feminist and an art historian in the 1970s. My own frustrations about representations of women and the depressing prognoses they suggested about women's pleasure determined my decision to recast formalist readings of serpentine line and my emphases on sensualized classicism and female agency. In applying feminist strategies to historical materials, I have hoped to produce results that might be useful for thinking about how feminist theorists and artists are currently grappling with ways to represent the female body. The argument of this book attempts to structure a certain kind of resistance to dominant discourse by abrading binary oppositions. The stakes in such an inquiry are high for anyone who has experienced or continues to experience discrimination by systems grounded in oppositional thought. Precisely because this is so, the final chapter shows how a number of very powerful recent images, which push binary thought to its logical extremes, grow inexorably from the discourse about Ingres's bodies.

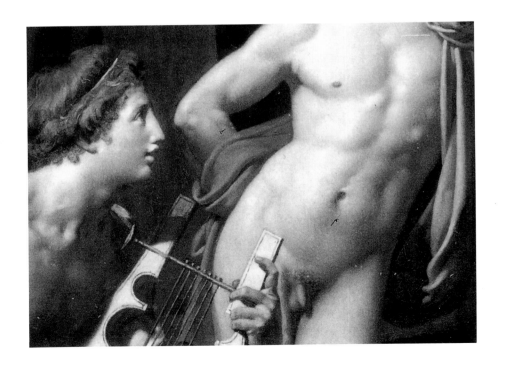

CHAPTER 1

PROFILING

HOMOEROTICISM:

ACHILLES

RECEIVING

THE AMBASSADORS

OF AGAMEMNON

One of the most striking features of Ingres's work is his objectification of women's bodies. Again and again, Ingres uses serpentine line to equate sensuality and the female form. But in his *Achilles Receiving the Ambassadors of Agamemnon* (fig. 1; plate 1), it is men who are represented through the sensual, serpentine forms Hogarth found to be most persuasively embodied in female bodies.[1] This chapter explores what happens when Ingres uses serpentine line to describe male bodies. *Achilles,* it appears, was not only a vehicle for the sensual but also a vehicle for homoeroticism (in this case, an implied homosexual relationship between the painting's protagonists, Achilles and Patroclus). While this reading of Ingres's early work may seem inconsistent with his later fetishism of the female body, it should be recalled that *Achilles* was part of a distinctly postrevolutionary style which preferred a sensualized male body to a heroic one. Although the artist may have intended serpentine line to function as it did when representing female bodies, his sinuous forms do not, indeed cannot, have the same effect, simply because Achilles and Patroclus are men.

As an entry in the competition for the coveted Rome prize, Ingres's *Achilles* was a place for the twenty-one-year-old artist to show how well he had learned the lessons of his teachers and, at the same time, to assert his independence from them. In creating this work, Ingres drew on a wide range of visual and literary representations, most notably the painting of David and eighteenth-century translations of Homer's *Iliad.* But Ingres transformed these models, first by conflating their historical and mythological vocabularies and then by positioning his own figures within a complex bipartite composition that, among other things, differentiated between two types of men. Ingres's purpose in emphasizing this dichotomy,

I would argue, was to represent the fact that in the distinctly postrevolutionary world, men, unlike women, could choose between *negotium* (action) and *otium* (leisure).[2] By choosing a bipartite composition for a narrative featuring men and by differentiating between the two sides in ways that overdetermine oppositional thinking, Ingres also sets in motion other messages about gender and sexuality which complicate the very gender binarism he would appear to inscribe.

In 1801 Ingres won the Rome prize for *Achilles Receiving the Ambassadors of Agamemnon.*[3] The subject, from Book 9 of the *Iliad,* was supplied by the Academy and defined as "the moment when the ambassadors sent by the Greeks to Achilles find him withdrawn to his tent with Patroclus, amusing himself by singing the exploits of heroes on his lyre."[4] In Ingres's painting, the ambassadors are offering Achilles lavish gifts from Agamemnon, in an effort to persuade him to take up arms against the Trojans. On the left side of the painting, Achilles, still holding his lyre, is rising to meet the ambassadors while Patroclus looks on behind him. On the right, Ingres has lined up the ambassadors, with Odysseus, draped in a red toga, heading the group that includes Phoenix to his left and Ajax on the far right of the painting. Barely visible behind Phoenix are the heads of two other figures, most likely the heralds Eurybatus and Odius. The shadowy female figure in the tent behind Achilles is perhaps the captive Briseis, whose possession is disputed by both Achilles and Agamemnon in the *Iliad.* Her presence as a female captive recalls the abduction of Helen, the event responsible for the bad fortune of the Achaeans in battle and for the current impasse as well.

In adopting a bipartite composition for this painting, Ingres drew on a representational tradition extending back at least to Charles Le Brun's *Queens of Persia at the Feet of Alexander* of 1662 (fig. 2).[5] In that work, public and private realms were juxtaposed, creating a dialectic between "heroic" masculine subject and suppliant female subjects that subsumes the opposition between conquerors and conquered. Ingres was also undoubtedly aware of the eighteenth-century progeny of Le Brun's composition, such as Lagrenée the Elder's *Death of the Wife of Darius* of 1785 (Paris, Louvre). But by far the most famous of the bipartite compositions that influenced Ingres were David's *Oath of the Horatii* (fig. 3) and *Brutus* (1789; Paris, Louvre), works in which the men's rigid stoicism provided a startling contrast to the attitudes of grief-stricken women.

Ingres's composition ostensibly reprised this model. The sinuous forms of Achilles and Patroclus on the left are contrasted to the hard, muscled bodies of the ambassadors on the right; the relaxed, private realm of Achilles' domestic setting is countered by the active urgency of civic life. This bipartite structure is underscored by the tiny figures in the middle ground. The more active one, on the right, is identified with the ambassadors: he throws the discus, a pastime proper to warriors

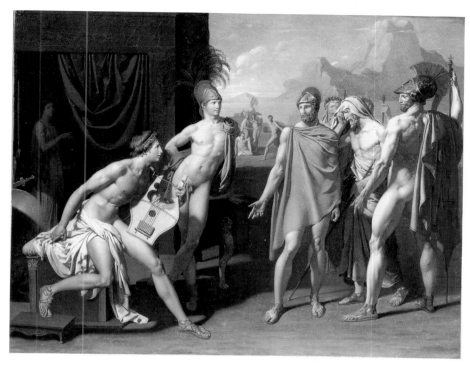

1. Ingres, *Achilles Receiving the Ambassadors of Agamemnon*, 1801. Oil on canvas, 113 × 146 cm. Ecole nationale supérieure des beaux-arts (ENSBA).

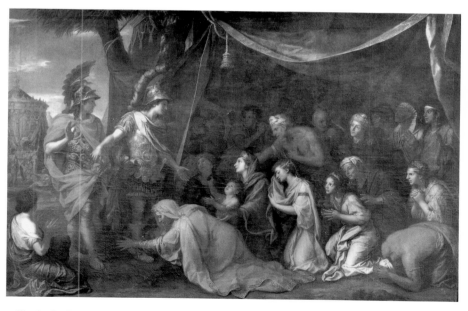

2. Charles Le Brun, *The Queens of Persia at the Feet of Alexander, Tent of Darius*, 1662. Oil on canvas, 298 × 453 cm. Musée de Versailles (R.M.N.).

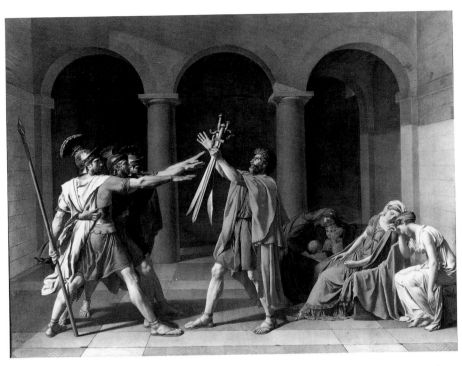

3. Jacques-Louis David, *Oath of the Horatii*, 1784. Oil on canvas, 330 × 445 cm. Louvre, Paris (R.M.N.).

at leisure. The idle figures at the left, on the other hand, echo the cheesecakey postures of Achilles and Patroclus. Even the landscape, with craggy mountains juxtaposed to a domestic interior, is articulated in binary terms. But Ingres's work, though clearly bipartite, cannot be described as simply a representation of "feminine" and "masculine" worlds. For one thing, both of these "worlds" are dominated in this painting by men. Indeed, the social sphere that Ingres created in *Achilles* is surprisingly rich in the possible self-representations it affords them. Its purposeful variety of physiognomies, body types and rhetorical gestures derived from ancient models recalls David's *Death of Socrates* (1787; New York, Metropolitan Museum). And yet Ingres's principal debts were to other, later Davidian compositions that virtually contradict the exhortations to action, or negotium, characterizing David's famous stoic compositions of the 1780s.[6]

Ingres's *Achilles* was more directly a response to David's major postrevolutionary statement, the neo-Grec *Intervention of the Sabine Women* (1799) (fig. 4), itself a crucial departure from the ethos of negotium.[7] Ingres not only adapted specific poses from the *Sabines*—his Ajax is a more muscle-bound version of David's spear-wielding warrior—he also embraced wholeheartedly the tradition of the heroic male nude that had been reintroduced by David. Within this tradition, however,

Ingres intensified the distinction between Romulus, on the right, and Tatius, on the left, in David's *Sabines* by dramatically distinguishing the musculature of Ajax from the sinuous figures of Achilles and Patroclus.[8] Although it appears that Ingres differentiates between two markedly different conceptions of the ideal male nude—the heroic, embodied by Ajax and the ambassadors, and the mythological, embodied by Achilles and Patroclus, he actually united these two types, much as David had done in the *Sabines* and in his unfinished *Death of Bara*, 1793 (fig. 5). David's *Bara* was probably an unresolved response to the large number of works by his students that included languorous male nudes with distinctly homoerotic overtones.[9] Paintings like Anne-Louis Girodet's *Sleep of Endymion* (fig. 6) and Jean Broc's *Death of Hyacinth* (Poitiers, Musée) abjure the master's somber antiquity and the canon of virility that has traditionally been associated with David's history paintings of the 1780s, preferring instead the ideal of mythological nudity articulated in the widely disseminated writings of Johann Joachim Winckelmann on ancient art.[10]

While the body of Ingres's Achilles conforms to Winckelmann's mythological ideal, his iconographic representation denies aspects of the multifaceted hero as described in the *Iliad*. This is in part because of Ingres's heavy reliance on David's

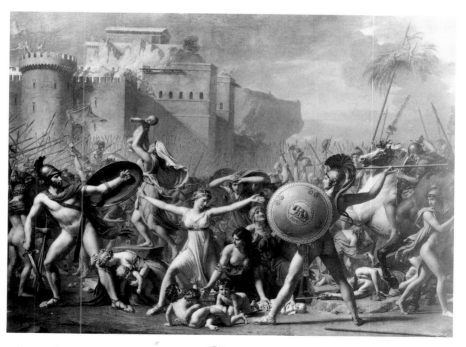

4. Jacques-Louis David, *Intervention of the Sabine Women*, 1799. Oil on canvas, 385 × 522 cm. Louvre, Paris (R.M.N.).

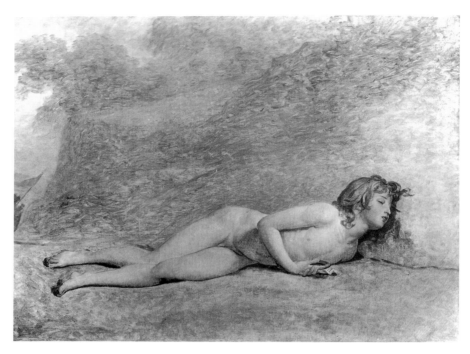

5. Jacques-Louis David, *Death of Bara*, 1794. Oil on canvas, 119 × 156 cm. Musée Calvet, Avignon.

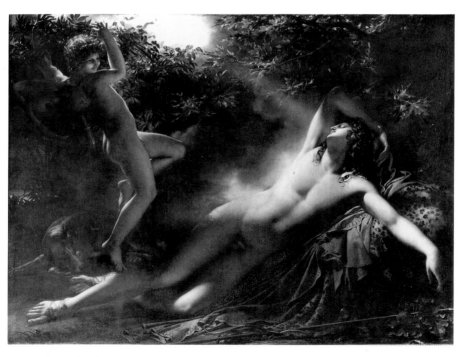

6. Anne-Louis Girodet, *Sleep of Endymion*, 1791. Oil on canvas, 197 × 260 cm. Louvre, Paris (R.M.N.).

Paris and Helen of 1788, a painting regarded as a kind of aberration in that artist's work from this period because it emphasizes the sensual in preference to the heroic (fig. 7).[11] Given Ingres's emphasis on binary oppositions in *Achilles,* his decision to draw so heavily on *Paris and Helen* is extraordinarily significant. Not only do the two works both rely on the *Iliad* for their subject matter, but both thematize the conflict between love and patriotism. In each, the lure of the private world, with its erotic possibilities, triumphs over the responsibilities of public action.

In the *Iliad,* Paris frequently serves as a foil to Achilles. While Achilles is presented as a hero, Paris, who seized Helen from Menelaus and transported her to Troy, is described by Homer as a coward. Ruled by love rather than courage, Paris is repeatedly associated with Aphrodite.[12] It is Aphrodite, for instance, who makes possible Paris's escape from Menelaus by whisking him from the field of battle to the bedchamber. Madame Dacier, the foremost eighteenth-century translator of the *Iliad,* notes that Homer describes that chamber, where Paris meets Helen, as saturated with exquisite perfumes: "It is thus that Homer paints the bedchamber of a prince less suited to war than to love. One doesn't smell these perfumes at all in the tent of Achilles."[13] Homer's symbolic use of the lyre also points up the differences between Paris and Achilles: in Book 3 of the *Iliad,* Hector opposes Paris's skill with the lyre to warlike valor; Achilles' lyre, on the other hand, is part of the spoils he won through fighting. And in a note explaining how Achilles "sang about the great exploits of the heroes," Dacier opposes Achilles' "noble and warlike" music to the "soft and effeminate" music played by Paris.[14]

Despite Ingres's fidelity to these distinctions between Paris and Achilles, his interpretation tends to flatten certain nuances that differentiate the characters in the *Iliad.* In Homer's text, Achilles' perfect beauty coexists with a notion of large physical stature that is not borne out by his depiction in Ingres's painting. Again and again in the text, Achilles is said to resemble Ajax. Yet Ingres specifically contrasts the serpentine definition of Achilles' body to the massive bulk of Ajax's figure, suppressing Achilles' supreme prowess in favor of a particular conception of bodily beauty. While this representation is grounded in both Winckelmann's mythological canon and a cultural distinction between public and private, its real subtext is the homoerotic relationship between Achilles and Patroclus.

With regard to this complex relationship, David's *Paris and Helen* has something more to tell us about Ingres's representational choices in *Achilles.* The similarities between figural postures and settings in the two paintings are obvious. In fact, the poses of Achilles and Patroclus so closely echo the tightly interwoven male and female body parts of *Paris and Helen* that it is tempting to interpret this in itself as Ingres's deliberate suggestion of homoerotic bonding. But any congru-

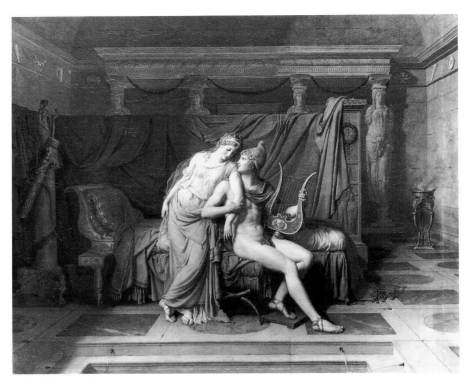

7. Jacques-Louis David, *Paris and Helen*, 1788. Oil on canvas, 146 × 181 cm. Louvre, Paris (R.M.N.).

ency between the two works is strictly provisional since there is as much evidence in the paintings to suggest their differences as there is to support similarities. Achilles is identified with the domestic and the erotic in Ingres's painting, but only because Achilles' stubbornness makes him choose love over patriotism at this juncture; his status as a hero is never truly called into question. David's Paris, on the other hand, shows a clearly deprecatory attitude toward the "feminine."

With its caryatids and "feminine" Ionic order, David's painting contrasts sharply with the simpler structure of Ingres's work. While David's subtle use of setting and posture of the figures highlights the sexual relationship between Paris and Helen, Ingres's *Achilles* is much more about split loyalties. In contrast to Paris, whose weapons hang at the opposite end of his room, Achilles has his right hand on a plectrum, while his sword and shield stand between him and the female captive. Rising to meet Odysseus and the emissaries, Achilles is caught between private and public worlds, between self-interest and patriotism. In this sense, Ingres's painting is a sort of pictogram, representing the opposition between otium and negotium. Complicating this binary structure, however, is the triangular sexual configuration

at the center of *Achilles Receiving the Ambassadors of Agamemnon.* Achilles and Patroclus are unquestionably the principal figures, but the presence of the female captive is crucial. In formal terms, Ingres has done everything possible to bind the three figures together. The composition connects Achilles axially to first one figure, then the other. The captive is literally and figuratively outside the homosocial world of men; at the same time, she justifies that world's existence.[15] Like Helen, who provides a rationale for the war between the Trojans and the Achaeans, the female captive legitimizes bonds between men by providing a rationale for Achilles' decision to remain with Patroclus instead of returning to battle. She also functions as a reassuring sign of heterosexuality in a scene that strongly suggests homoeroticism, perhaps even "homosexuality."[16]

The suggestion of a homosexual relationship between Achilles and Patroclus in the *Iliad* has elicited controversy since antiquity. The classical scholar Bernard Sergent cites authors from the fifth century B.C. who believed there was a sexual aspect to the friendship and others who did not. Kenneth J. Dover's pioneering study on Greek homosexuality asserts that reticence was de riguer in homosexual behavior during Homer's time; so long as public behavior was decorous, the actual existence of a homosexual relationship could only be known by the participants. Nevertheless, contemporary scholars are still divided about the relationship between Achilles and Patroclus. Most recently, the classicist David M. Halperin has suggested that we look at these disagreements in light of the difficulties the classical Greeks faced when trying to graft their own sexual categories onto the Homeric texts. "So long as we, too, continue to read the *Iliad* in the light of later Greek culture," Halperin warns, "to say nothing of modern sexual categories—we shall continue to have trouble bringing the friendship between Achilles and Patroclus into sharper focus."[17]

Ingres certainly interpreted the relationship of Achilles and Patroclus in light of his own understanding of the daily life of classical Greeks. In one way at least, Ingres's composition draws on ancient pictorial sources, namely those Greek vase paintings which represent the superiority of a warrior in terms of his homosexual behavior toward youths. Ingres's presentation of the figures of Achilles and Patroclus suggests the *erastes/eromenos* paradigm often depicted on ancient vases. The role of the *erastes,* or active partner, was generally reserved for the older, powerful man, while the *eromenos,* or passive love-object, was most often depicted as a youth. In a typical Attic red-figure cup, this mentor-pupil relationship is indisputable (fig. 8). This relationship is complicated in the case of Achilles and Patroclus by Achilles' superior valor, which confers upon him the active role generally associated with the chronologically elder partner, who in this case is Patroclus.[18] In the

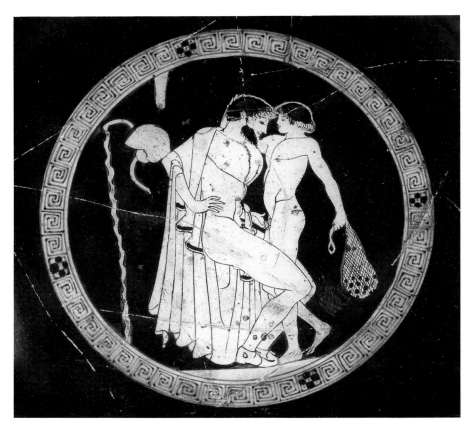

8. Brygos Painter, *Man Courting Boy,* ca. 500–480 B.C. Red-figure cup. Ashmolean Museum, Oxford.

Sosias cup, we see the helmeted figure of Achilles bandaging the slightly older, and therefore bearded, Patroclus (fig. 9). Ingres would seem to allude to the sexual nature of the relationship, and the erastes/eromenos model, by suggestively positioning the lyre so that Achilles' hand seems about to grab Patroclus's genitals. And in a provocative visual double entendre, the lyre's curvaceous form rhymes with the shape of Patroclus's torso, implying the possibility for more than one type of playing. The fact that Patroclus's form resembles two well-known ancient sculptural types, that of the *Apollo Lykeios,* who is shown at rest, and often leaning on a lyre, as well as that of Skopas's *Pothos,* who embodies unfulfilled desire, only reinforces a reading of the sexually charged relationship between Achilles and Patroclus.[19]

Despite his use of original Greek sources, Ingres's attitudes toward antiquity were shaped largely by literary and pictorial conventions of the late eighteenth century. The edition of the *Iliad* that Ingres owned, first published in 1764, was edited

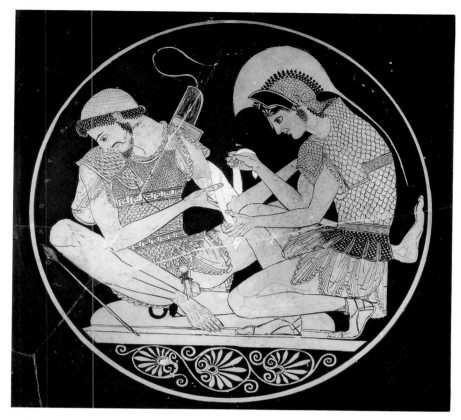

9. Sosias Painter, *Achilles Binding Up Patroclus's Wound*, end of sixth century B.C. Red-figure cup. Antikensammlung, Staatliche Museen zu Berlin. Photograph by Ute Jung.

by Paul-Jérémie Bitaubé, who considered homosexuality a normal feature of Greek society at the time of Homer. He excused the "excesses" of Homeric Greek society, saying, "It's in a half-civilized society that we find a more energetic display of passion and feeling, and there has never been a people more sensitive than the Greeks."[20] Although Bitaubé does not specifically mention homosexuality in his introduction, he is constantly at pains to convince the reader not to take offense at Greek social mores. When Bitaubé reveals his own view of the relationship between Achilles and Patroclus, the assertion of homosexuality is veiled. In explaining Achilles' extreme grief at Patroclus's death, Bitaubé cites a scholar who identifies the characteristic trait of savages as being their disdain for women: "The man whose sole merit resides in his strength and his courage views his woman or wife [*femme*] as an inferior creature and treats her with disdain." Bitaubé follows this excursus with a reference to Achilles' feelings for Patroclus; Achilles must have

thought: "We only have one friend and he is worth all the mistresses in the world!"[21]

By the mid-eighteenth century, numerous scholars had cited the startling intensity of Achilles' feeling for Patroclus, and Bitaubé rehearses them all: in Book 16, Achilles wishes that he and Patroclus might put off destruction so that "we alone might break the holy citadel of Troy"; in Book 19, after Patroclus's death, Achilles' grief is so consuming that he refuses to eat, drink, sleep or have sex; also in Book 19, Achilles' mother, Thetis, finds him lying in the arms of Patroclus, "crying shrill"; in Book 23, after a visit from Patroclus's ghost, Achilles arranges to have the bones of his friend put in a golden amphora where they will eventually be joined by his own;[22] and in Book 24, Achilles, completely intent on revenge, neglects Briseis when she is returned to him.

Pictorial conventions also conveyed the intensity of feeling between Achilles and Patroclus in no uncertain terms. Among the many painted scenes of the *Iliad* by artists of the late eighteenth and early nineteenth centuries, the most outstanding examples are the representations of Achilles grieving over the dead body of his "beloved companion." Flaxman's version (fig. 10), like many other examples, shows Achilles' grief in a fashion that cannot help but conjure up representations of two other deathbed scenes from the *Iliad,* the oft-repeated Andromache mourning the death of Hector (see fig. 11) and the less common Briseis mourning the dead Patroclus. What is arresting about Flaxman's fidelity to these other representations, and this is true of the textual examples as well, is that the way that Achilles grieves for the dead Patroclus is precisely the way Greek women respond to the deaths of male warriors.[23]

If this resemblance to conjugal modes of relationships has fed scholarly inclinations to find a sexual component in the friendship between Achilles and Patroclus, Ingres's emphasis on their beautiful and youthful male bodies might seem to confirm such readings. In late eighteenth-century imagery, death immortalized a striking number of young boys, ranging from the heroic Bara to the androgynous Endymion to the ill-fated Hyacinth, struck down by a discus hurled in jealousy. In Ingres's *Achilles,* the beauty of the male bodies, made even more youthful to conform to the ephebic ideal, is frozen by the viewer's foreknowledge of their fate: the premature deaths of Patroclus, Hector, and Achilles in the flower of their youth. In this context, the figure of Ajax seems a deliberate reference to the *Pasquino* group, a work presumed to be antique in the late eighteenth century and thought by many to represent Ajax and the fallen Patroclus (fig. 12). Patroclus's figure, with its exaggerated contrapposto and bent right arm, also recalls the ephebic Capitoline *Faun* (later known as *The Marble Faun*), an important Greek marble that was one of the Napoleonic spoils delivered to Paris in the triumphal procession of July 1798 and

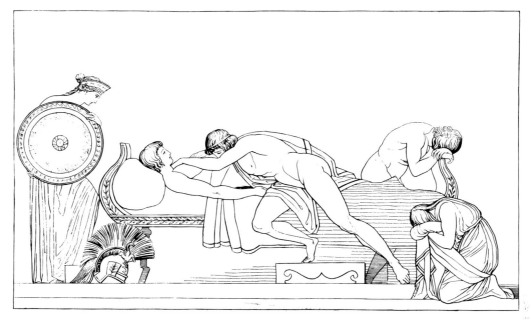

10. Tommaso Piroli after John Flaxman, *Thetis Bringing the Armor to Achilles,* ca. 1790. Line engraving, 19.9 × 29 cm. plate.

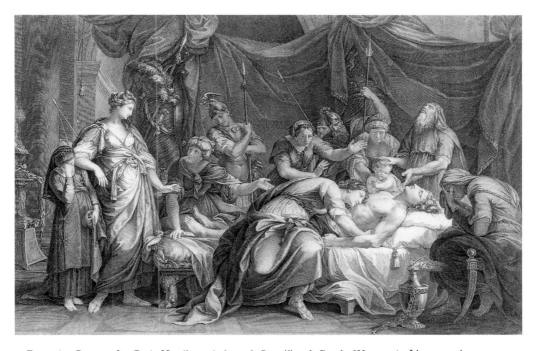

11. Domenico Cunego after Gavin Hamilton, *Andromache Bewailing the Death of Hector,* 1764. Line engraving, 39.7 × 61.2 cm. plate. Yale Center for British Art, New Haven, Gift of David Bindman.

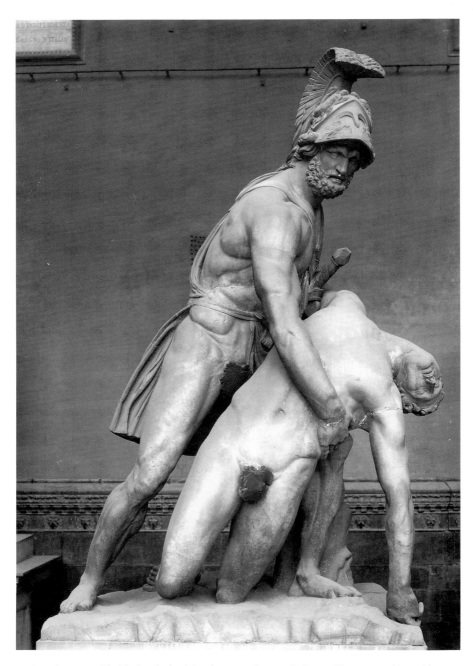

12. *Pasquino* group. Marble, height (with base): 253 cm. Loggia dei Lanzi, Florence. © Alinari/Art Resource, New York.

displayed from November 1800 to 1815 at the Louvre, where Ingres is sure to have seen it.[24]

Homer's text also underscores the ideal of youthful beauty. In Book 20, for instance, Priam announces, "Of what can be seen on the body of the young dead warrior, everything is beautiful." And later, Achilles laments the decay of Patroclus's corpse, saying, "Yet I am sadly afraid . . . that flies might get into the wounds beaten by bronze in his body and breed worms in them, and these make foul the body, seeing that the life is killed in him, and that all his flesh may be rotted." Achilles' goddess mother, Thetis the silver-footed, hastens to reassure him. "My child, no longer let these things be a care in your mind. I shall endeavor to drive from him the swarming and fierce things, those flies which feed upon the bodies of men who have perished; and although he lies here till a year has gone to fulfillment, still his body shall be as it was, or firmer than ever." Here death paradoxically preserves youth from decay in the service of an ephebic, homoerotic ideal.[25]

Achilles' and Patroclus's serpentine contours and smoothed-over bodies not only express this ideal of everlasting youthful beauty but also support the placement of the figures outside the public, "masculine" realm. Interpreting the "feminized" bodies of Achilles and Patroclus is a difficult task. On the one hand, they must be taken to represent a Winckelmannian ideal of male subjectivity and freedom that had its roots in the revolutionary period, in works like *Bara*. Figures like *Bara*, and I might include here Achilles and Patroclus, functioned as the summa of the ideal. At the same time, inasmuch as a work like *Bara* came to be associated with the Terror, one can imagine a certain ambivalence about this body type as the conveyor of civic ideals. There are also difficulties of reconciling civic ideals with sexual desire, as Alex Potts has argued. Indeed, in Ingres's painting the erotic qualities of Achilles and Patroclus may be said to be complicated, even enhanced, by the way that they must be contained, restricted to a youthful ideal by their imminent demise. They may be complicated too by the ways in which enthusiasm for Winckelmann's ideas shaped relationships between men in David's studio. The ambivalence about these bodies may be seen in a different light as well. In consigning Achilles and Patroclus to the realm of the private, Ingres would appear, at least in part, to consign them to the inferior status of women in a way which might not be that different from the *Paris and Helen* after all. For, in some sense, the insistent differentiation of Achilles and Patroclus from their male counterparts on the right does have the effect of linking them to the domestic and the sexual, as is the case with Paris in David's painting. But more than that it is a sign of their erotic relationship.[26]

The differentiation of Achilles and Patroclus from the active warriors on the right likely also registers prescriptive attitudes toward homosexuality in the late eighteenth century. In fact, the homoerotic ideal, with its uneasy mixture of civic virtue and desire, might be as difficult to separate from attempts to restrict women's freedom as from attempts to inscribe heterosexuality. As late as the 1750s men were executed for homosexual behavior, and sodomy was only decriminalized in 1791.[27] As recent scholarship on political pornography during the revolutionary and postrevolutionary period has shown, there was a booming literature equating sexual disorder with public disorder. A number of illicit newsheets, with a taste for politically charged sexual gossip, contrasted "healthy men"—the new patriots of the revolution—to "defective and effeminate" ones. Nonetheless, to simply equate Achilles and Patroclus with the feminine would be ideologically ingenuous. Such a reductive reading is precluded not only by the shadowy figure of the female captive and by the split between characters and their allegiances in the painting, but also by the fixed nature of gender roles during the late eighteenth century. In numerous other painted versions of this scene, including several works from the same Rome prize competition, a bipartite composition is also employed but without the exaggerated serpentine forms of Ingres's Achilles and Patroclus. Gottlieb Schick's lost painting bears at least a hint of the serpentine body type in the figure of Patroclus, but it is still a long way from Ingres's languid figures (fig. 13). In addition, Ingres's version of the scene is one of the few compositions to include a woman.[28]

The absence or subservient presence of women in this scene has important ideological ramifications. The manner in which women are depicted or not depicted brings into focus what the classical scholar John J. Winkler describes as the "politics of space—the role of women as excluded from public male domains and enclosed in private female areas." According to Winkler, Homer "inescapably embodies and represents the definition of public culture as a male territory."[29] This concept takes on particular relevance for Ingres's painting (and for painted scenes of the *Iliad* in general) when we look at changing concepts of gender in postrevolutionary France.

In the aftermath of the Revolution, the rights of citizens were framed in very pointedly gendered terms in the new Civil Code (or, as it was later called, the Napoleonic Code), a document that was in the process of being drafted at the very moment that Ingres was competing for the Rome prize. Most of the code's articles affecting family life and the rights of women were not new; in fact, many of the underlying principles could be traced back to the ancien régime. But whereas class distinctions had given upper-class women certain privileges prior to the Revolution, under the Civil Code, gender became the sole determinant of women's rights. In short, the Civil Code tried to ensure the complete subordination of women to

men. So extreme was this tendency that feminists writing later in the century claimed that the social position of nineteenth-century women in France was more subservient in some ways than that of a slave in classical times. This perspective gives unexpected weight to the indefinite presence of the female captive in Ingres's *Achilles*. As the only figure in the painting to inhabit an interior space (and a domestic one at that), the female captive underscores the fact that women were excluded from the public realm. As men, Achilles and Patroclus might choose to withdraw from the public realm, but it is undeniably theirs by right. By the same logic, in works such as Ingres's *Achilles* and David's *Oath of the Horatii*, women are also placed outside the register of speech. As silent witnesses to men's deeds, women paradoxically provide the rationale for the masculine warrior ethos in these paintings.[30]

Ingres's *Achilles* embodies the essential contract of the Civil Code: the husband vows to protect his wife, while the wife pledges to obey her husband. The covert references to Achilles' conjugal feelings and obligations in Ingres's painting mirror the complex intersection of personal and political loyalties found in the *Iliad*. In a speech responding to Odysseus, Achilles compares Menelaus's feelings for Helen to his own for Briseis: "Do they alone love their wives, these sons of Atreus? Any

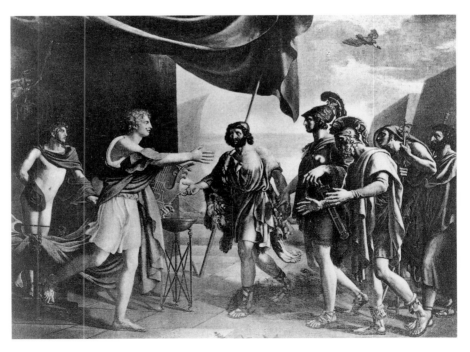

13. Gottlieb Schick, *Achilles Receiving the Ambassadors of Agamemnon*, 1801. Oil on canvas, 105 × 138 cm. Location unknown.

man of courage and sense values his own and cares for her, as I loved mine." And further on, Achilles describes himself as "called by heart to marry a wedded wife, a fitting companion, and enjoy in peace the wealth of my aged father." Yet Achilles experiences similar protective impulses toward his "dear friend" Patroclus. Responding to Patroclus's despair over the fate of the battle, Achilles refers to him as a child, and in Book 28 he declares to his mother, "Let me die soon, since I was not there for my friend. . . . Not to Patroclus was I a light, nor to the rest." Passages such as these make it clear that the friendship between Achilles and Patroclus is modeled on the very patterns of kinship and sexual relations that define Achilles' concubinage with Briseis, Menelaus's marriage to Helen, or, perhaps the closest parallel, the relationship between Hector and Andromache.

In Ingres's painting, such congruencies are reinforced through a series of binary oppositions, principal among which are the splitting of spatial realms and differentiation of body types. Given the centrality of binary thought to Western conceptual systems, any reading of *Achilles* tends to reinscribe those stereotypical notions of what is "masculine" and what is "feminine." It is easy to succumb to historical determinism in such a case and to equate domestic space and serpentine line with the feminine. However, any interpretation of this painting that reinscribes sexual dualism overlooks the fundamental power relationships that lie at the heart of all binary structures of thought. If we regard Ingres's representation of Achilles and Patroclus (and the whole left side of the composition) as feminine, we negate the crucial fact that the two warriors are first and foremost part of the masculine world. Such an interpretation also underplays the male privilege that ensured men the freedom to easily move between states of otium and negotium in postrevolutionary French society.

Ingres has positioned Achilles and Patroclus in clear light, their bodies molded into a foreground frieze along with the ambassadors. They are part of, but distinctly separate from, the space of both the female captive and the Myrmidons at rest. But while both the captive and the Myrmidons are confined to the margins of the masculine sphere, the first through domesticity and the second through leisure, they remain dependent on the actions of the men. Thus, several of the Myrmidons stop in their tracks and look at the men in whose hands lie their fate and that of the Achaeans and the Trojans. In short, if Achilles and Patroclus are "feminized," in order to suggest their possibilities for leisure and their sexual relationship, their power as men is nowhere questioned. The kinship relations evoked to describe their relationship reinforce male solidarity and the very power relations that engender binary thought, principally the subjugation or exclusion of women.[31]

Although Ingres's painting inscribes male power through an insistence on binary oppositions, it simultaneously reveals the impossibility of stable gender identities.

Every binary category that appears to fix gender as masculine or feminine is, in this picture, countered by indeterminacy. If Patroclus, for example, is clearly located in the private realm, his position on its very edge nonetheless makes him a sort of transitional figure. Achilles, too, is linked not only to his "beloved companion" and to the female captive but also to the Myrmidon throwing the discus (whose pose he replicates). Moreover, Achilles is also bound to Ajax by his ambiguous gaze. Within the context of male desire, this gaze, along with their mirrored poses and their exaggeratedly different body types, animates a relationship between Achilles and Ajax that is fully as provocative as that between Achilles and Patroclus.

Pushing this point further, one might challenge the binary organization simply by noting the equal attention to threesomes in this composition. The triangular arrangement of the captive, Achilles, and Patroclus on the left is counterbalanced by the figures of Odysseus, Phoenix, and Ajax on the right. But far more interesting is the way in which Odysseus functions as a hinge connecting Achilles and Ajax, on the one hand, and Achilles and Patroclus, on the other. If the placement of Odysseus serves to underline Achilles' choice between otium and negotium, it also emphasizes the way in which Ingres's careful orchestration reinforces binaries through a hierarchy of space (positioning Achilles, Odysseus, and Ajax in the foreground and the captive, Patroclus, and Phoenix in a distinct zone behind them). Paradoxically, Ingres's binary strategies coexist with a vast array of more complex relationships—homoerotic, homosexual, homosocial, heterosexual, master/slave, paternal/filial—for which the figure of Odysseus serves as a fulcrum. In other words, the ways in which the definition of bodies, age, space, occupation, and sexuality intersect with stereotypes of masculine and feminine give this picture a complexity that goes well beyond oppositional thought.

To the list of ambiguous sexual identities, we might add that of the female captive. To be sure, her placement denotes her subservience; at the same time, Ingres, in one of his typically astonishing distortions, strangely masculinizes her figure. This is symbolized by her left hand, which in effect becomes a phallus by virtue of its abnormally low placement and of its formal echoing of the hilt of Achilles' sword. Even more curious is the way her pose, gazing toward the viewer with right hand raised, uncannily replicates that of the artist at his easel.[32] In fact, her pose is virtually identical to the one Ingres later adopted in his *Self-Portrait* of 1804 (fig. 14). What does it mean for Ingres to identify himself with this subjugated but phallically empowered figure?

Through his identification with the captive in his first major work, Ingres adopts a contradictory position—simultaneously deferential and pivotal—in relation to the ancient world whose heroes had been so stunningly brought to life by

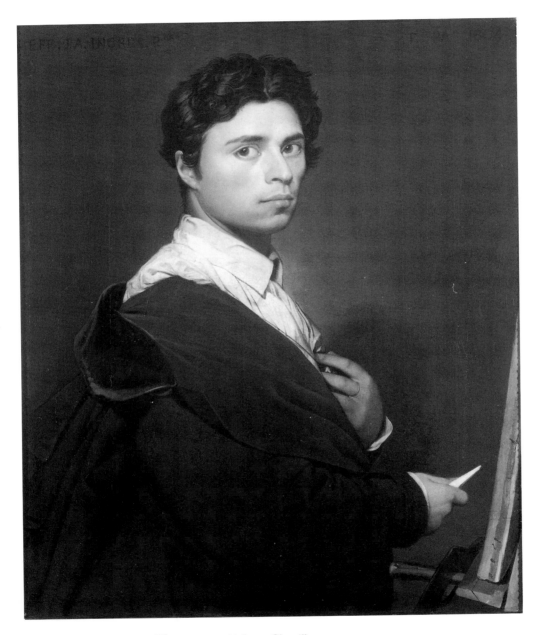

14. Ingres, *Self-Portrait*, 1804. Oil on canvas, 77 × 61 cm. Chantilly, Musée Condé. Lauros-Giraudon.

his mentor, David. By restructuring his teacher's works, one after another, the twenty-one-year-old Ingres had made a bold and competitive bid for legitimacy as a history painter and as an upholder of the values of the classical world. At the same time, Ingres boldly repictured the ancient world in a distinctly postrevolutionary way. Engaging the tradition of bipartite composition and cross-breeding it with novel conceptions of the nude male form, Ingres dramatically foregrounded sexual difference. If the opposition between otium and negotium that he created divested classicism of radical revolutionary politics, it nevertheless situated men squarely in the worlds both of leisure and of action.

Ingres envisioned a world that simultaneously guaranteed and produced sensual pleasures for men as a reward for their presence in the public world. But the ambiguous gender identities of Achilles, Patroclus, and Briseis are also underscored by other elements on the left side of the painting that imply a wild, barely contained threat. This, too, relates to the increasing polarization of gender roles in the late eighteenth century and to the significant role classicism assumed in this process. The leg of the chair behind Patroclus has a snarling head and the ship's prow above his left shoulder is also animallike. In short, the private realm, as embodied here by woman and the unnamed homosexual relationship between Achilles and Patroclus, is a threat that needs to be squashed by the no-nonsense men on the right. Unintentionally, then, Ingres would appear to have laid out the conclusion that Winkler culls from Sappho: "Men are perhaps unwilling to see their values as erotic in nature, their ambitions for victory and strength as a kind of choice. But it is clear enough . . . that men are in love with masculinity and that epic poets are in love with military prowess."[33]

Certainly it is remarkable that the erotic component is given such full expression in Ingres's early painting. But his attempts to redefine the classical male nude were, in the end, surprisingly shortlived. After *Achilles,* Ingres primarily confined his efforts at depicting sexual otherness to the bodies of women. For, as the nineteenth century progressed, the urge for stable gender identities only grew stronger. In *Achilles Receiving the Ambassadors of Agamemnon,* Ingres's serpentine line ultimately destabilizes the binary oppositions it appears to foreground, through its attempts to represent both a homoerotic ideal and a homosexual relationship. Subsequently, this sensuous line was most often employed in the manic and endlessly fascinating, if ultimately futile, project of attempting to enact stable gender identities on the female body.

The *Grande Odalisque* is among the most famous of Ingres's productions, precisely because it uses serpentine line so dramatically to sensualize the female body (fig. 15; plate 2). For the same reason, it is an image that has troubled some nineteenth- and twentieth-century viewers.[1] One of the most startling facts about the painting is that it was commissioned by a woman. In addition to raising questions about who commissioned and collected erotic paintings in the early nineteenth century, this information engages notions of female spectatorship and "feminine" taste that complicate assumptions about pleasure and power.

The *Grande Odalisque* was commissioned not by just any woman, but by Caroline Bonaparte Murat, the youngest of Napoleon's three sisters. In 1800 Caroline Bonaparte married Joachim Murat, then Bonaparte's aide de camp—a man whose image as a dashing, if slightly sinister, military officer was later immortalized in Gros's *Battle of Aboukir* (1806; Detroit Institute of Art) and *Battle of Eylau* (1808; Louvre). Under Napoleon's regime, Joachim and Caroline Murat ruled as king and queen of Naples from 1808 to 1815. Queen Caroline commissioned Ingres to paint the *Grande Odalisque* in 1814. The work was intended as a pendant to an earlier Ingres painting, now lost, the so-called *Sleeper of Naples*, painted in 1808 and purchased in Rome by Murat in 1809 (see fig. 16).

The contrasts between the two paintings are plain: the reclining nude female in the *Sleeper* is shown frontally in a posture of sleepy languor; the seated nude woman in the *Grande Odalisque* is seen from behind and directs her gaze, at least in part, toward the viewer. Although it would be difficult to argue that the *Grande Odalisque* forecloses voyeurism, the openness of the pose of the

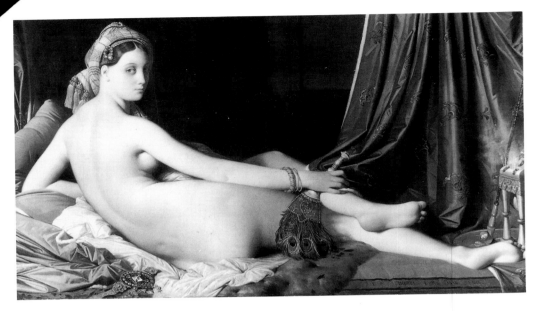

15. Ingres, *Grande Odalisque*, 1814. Oil on canvas, 91 ×
162 cm. Louvre, Paris (R.M.N.).

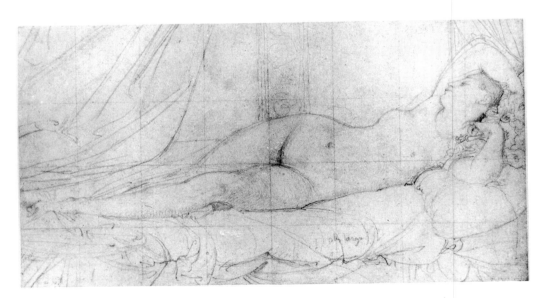

16. Ingres, *Reclining Odalisque* (drawing for lost *Sleeper
of Naples*). Graphite, 12.4 × 22.2 cm. Private collection.

woman in the *Sleeper* and her apparent obliviousness to being viewed provide a distinct alternative to the demure subject of the *Grande Odalisque*. Certainly such oppositions are frequently found in pendants; Murat himself owned two strikingly different versions of *Cupid and Psyche* by Canova, the one horizontal and unabashedly carnal, the other vertical and more restrained (figs. 17 and 18).[2] Given such precedents already in the king's collection, it is certainly plausible that the queen meant the *Grande Odalisque*, like the standing version of Canova's *Cupid and Psyche*, as a chaste antipode to its unabashedly sexy pendant.[3]

Inasmuch as the *Grande Odalisque* forms a pendant to the *Sleeper*, which the king had purchased five years before, it seems most likely that the new painting was intended as a gift for Murat. And, given the king's well-known predilection for works of art depicting an aloof sensuality (works for which Mario Praz long ago coined the term "erotic frigidaire"[4]), it also seems clear that the *Grande Odalisque* was entirely consistent with the king's tastes. But the problem with this presumption is that it effectively evacuates the queen's agency either in commissioning the painting or in enjoying it herself. The tendency to construct female agency solely in relation to men does more than circumscribe Caroline Murat's role, it denies an entire constellation of relationships existing between imagery and patronage in which women played a dominant role. How then do we talk about this gift to the king commissioned by the queen? In exploring this question, I hope to suggest, first, how Caroline Murat's gift might be read as a statement of gender politics of sorts and, second, how the image attests to important relationships among women, the artists they patronized, and the works that were produced.

We might begin by asking if in its time the *Grande Odalisque* was a naughty painting, inappropriate for a queen to devise. This is a very difficult question to answer. But fortunately for our purposes, some primary evidence survives regarding the reception of its pendant. In a letter Ingres wrote in 1815, in a vain attempt to buy back his *Sleeper of Naples*, he speculates that his patrons might regard the picture as a bit outré: "This painting may seem a little too voluptuous for this court [so I propose] to make another one of an entirely different subject, religious or otherwise." Given the self-serving purposes of his letter, Ingres may be granted a certain amount of exaggeration or dissembling, but there is little doubt that for him the question of appropriateness centered on the distinctly sensualized character of the painting.[5] In specifying the court as the potentially offended audience, Ingres did not anticipate greater or lesser offense would be taken by either gender. Still, it is tempting to think that Ingres had the queen's taste in mind, or that of other women of the court, since the king's earlier art purchases, including Canova's reclining *Cupid and Psyche* (fig. 17) made clear that he did not find voluptuousness inappropriate.

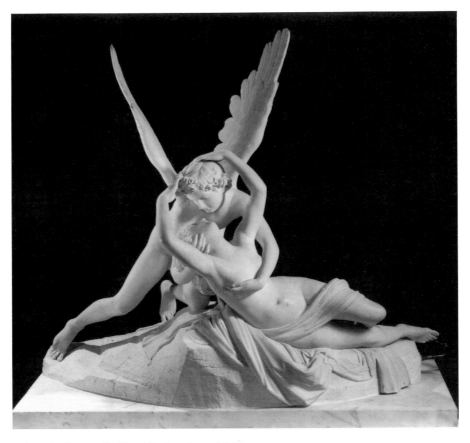

17. Antonio Canova, *Cupid and Psyche*, 1787–93. Marble,
155 × 168 cm. Louvre, Paris (R.M.N.).

In addition, there is evidence, again in the form of a letter from Ingres, that the *Grande Odalisque* called into question the propriety of the queen herself—and by extension that of the artist. Ingres wrote to the ambassador to Naples, "Some kind people, of whom there are many in this world, have spread the word that I intended to depict Mme Murat in this painting. This is absolutely false; my model is in Rome, it's a 10-year-old girl who modeled, and besides, those who knew Mme Murat can judge me."[6] Given that the letter focuses on the issue of verisimilitude, it seems strange that Ingres claims that the model for this bizarre but definitely adult body was a ten-year-old girl. Less puzzling perhaps, but also problematic, is the claim that *knowing* Mme Murat somehow would be enough to dispel the accusation that she was the subject of the *Grande Odalisque*. Ingres's double disclaimer attempts to deny the picture's sexuality, first by making the model prepubescent (therefore not-yet-fully sexed), and second, by assuming that a vaguely suggested

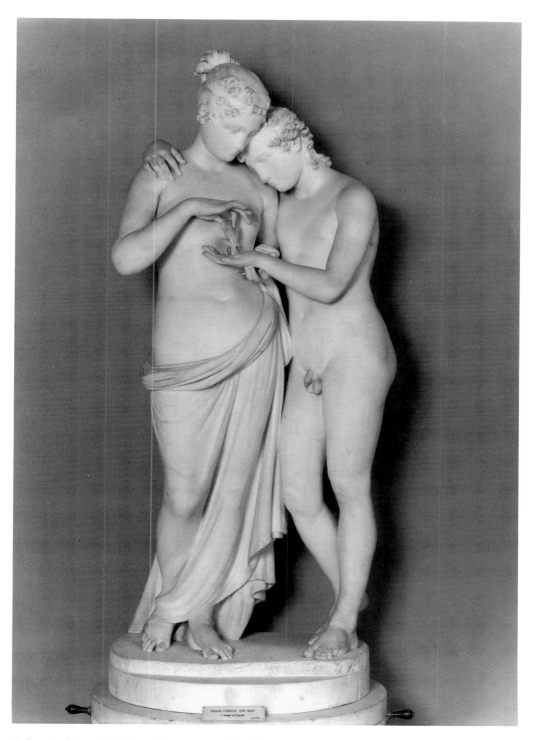

18. Antonio Canova, *Cupid and Psyche*, 1796–1800. Marble,
150 × 68 cm. Louvre, Paris (R.M.N.).

moral persona effectively cancels the possibility of representation as a sexed being. Behind the gossip that the *Grande Odalisque* might portray Caroline Murat lurks the transgressive potential of the sexed female body.

Certainly the clearest and most stunning contemporary example of the dilemmas posed by female agency and sexed bodies, however, was provided by Caroline's older sister Pauline. In 1808 Pauline had caused a minor contretemps by commissioning and apparently posing for Canova's *Paolina Borghese as Venus Victrix* (fig. 19). The rumor that the divine Pauline posed nude for this statue is a constant subject in the literature about Canova and the princess. Even the eminent art historian Gérard Hubert, in his scholarly study *La Sculpture dans l'Italie Napoléonienne*, felt the need to detail the positions of early nineteenth-century scholars on the matter.[7] His catalogue of moralizing points of view is of interest today primarily because it is symptomatic of both the desire for certainty about woman's sexual propriety and the universal titillation caused by illicit sexual imagery. The ongoing fascination with the sex lives of royalty and art patrons is encapsulated by the near-legendary status critics have accorded Pauline Borghese's putative retort to a skeptical *dame d'honneur*. When asked whether she actually posed nude for the sculptor, the sitter supposedly responded that Canova's studio was well heated. The shock that greeted Borghese's bold reply, much like the decision to have herself represented as Venus,

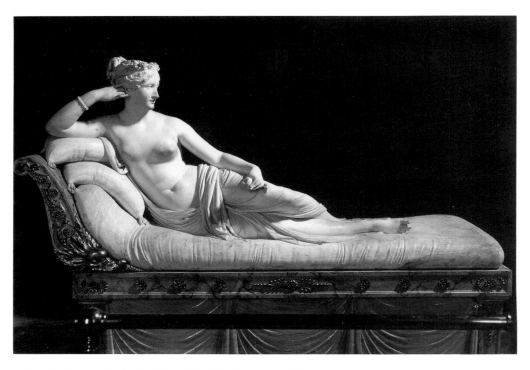

19. Antonio Canova, *Paolina Borghese as Venus Victrix*, 1804–08. Marble, 160 × 200 cm. Galleria Borghese, Rome. © Alinari/Art Resource, New York.

the goddess of love (and not Diana, as Canova had proposed), was overwhelmingly linked to the belief that reference to a woman's sexual behavior was inappropriate in the public realm.[8] This subtext of transgression contributed, at least in part, to the work's extraordinary popularity. The triumphant public reception of the finished sculpture was described at the time by Quatremère de Quincy:

> The *Venus Victrix* has just enjoyed a new triumph at the Palazzo Borghese, where it was exhibited for a limited time to the public. The procession of amateurs from Rome as well as from abroad continually pressed around it. Daytime visits could not sate their admiration; they got permission to study the statue at night, by torchlight, which, as you know, accentuates and allows one to see the smallest nuances in the handling, and also shows up the smallest faults. It was necessary to set up an enclosure, to protect the work from the crowd which constantly pushed against it.[9]

As my brief discussion of the responses to *Paolina Borghese as Venus Victrix* suggests, we need to broaden our field of inquiry in order to determine what nineteenth-century viewers considered appropriate in representations of women commissioned by women. How was artistic taste and patronage defined during the Consulate and the Empire?[10] By way of an answer, I would suggest that there was a pictorial language during this period that was created in large part by women. This pictorial language included a dialogue among works of art in which new commissions were planned as responses to previous commissions. In commissioning the *Grande Odalisque,* for example, Caroline Murat initiated a dialogue with other works of art similar to the competitive spirit Ingres assumed in making the painting. But in suggesting a parallel between rivalries among artists and rivalries among patrons, my goal is neither to reinscribe linear histories nor to offer some sort of alternative "female" taste as a complement to the extant history of largely "male" taste. Rather, my intent is to show how the introduction of gender confounds the binarism imbedded in these very ways of thinking. In outlining a model for a history of patronage predicated on female agency, I am positing a relationship among a group of odalisques commissioned by women in the early nineteenth century. This series creates a genealogy of masterworks capable of being read both within a history of female patronage and the traditional history of male artistic creation.

This brief history of early nineteenth-century odalisques might begin with David's *Mme Récamier* (fig. 20) and include Gérard's portrait of the same sitter (fig. 21), Canova's *Paolina Borghese as Venus Victrix* (fig. 19), and Ingres's *Grande Odalisque* (fig. 15; plate 2). The clear formal connections between these works immediately endow the Récamier-Borghese-Murat progression model with an internal

20. Jacques-Louis David, *Mme
Récamier,* 1800. Oil on canvas,
174 × 224 cm. Louvre, Paris
(R.M.N.).

21. Baron François Gérard,
Mme Récamier, 1805. Oil
on canvas, 225 × 148 cm.
Musée Carnavalet, Paris. © 1995
Artists Rights Society (ARS), New
York/SPADEM, Paris.

logic. Yet, at the same time, the generic logic of the model makes this particular grouping arbitrary. Other iconographic examples could easily be included, for instance, Prud'hon's well-known *Portrait of the Empress Josephine* (1805, Louvre) or even the curious nude miniature under glass of the infant king of Rome on the lid of a small box (Château de Malmaison). The fact that this model has such flexibility and variety does not deny its legitimacy, but, rather, argues for the strength of the formal connections among these images. In addition, the close personal ties among the patrons of these works suggest that a deliberate iconographic dialogue was being enunciated through the works themselves.

Socializing between Mme Récamier and the Bonaparte sisters began at least as early as 1800, so it is quite possible that Caroline Murat and Paolina Borghese were aware of Mme Récamier's portrait commissions from David in that year. And, whether or not they were aware of these specific works, it is clear that the three women shared a standard of artistic taste and participated together in the social activities of the royal court. Like Mme Récamier, Caroline Murat and Paolina Borghese were represented by David in his *Sacre de Napoléon* (1806; Louvre). Also like Mme Récamier, Caroline Murat commissioned a painting of herself from Gérard, that tireless portraitist of *napoléonides;* in this, her most famous portrait, she appears with her children (fig. 22). Mme Récamier and the Bonaparte sisters also shared in the widespread enthusiasm for Canova's works. Not only did Paolina Borghese owe her audacious portrait as *Venus Victrix* to Canova, but the Murats, her sister and brother-in-law, followed the lead of other napoléonides and had him sculpt their own conventional portrait busts. Finally, Mme Récamier, friend and muse more than patron to Canova, inspired at least two works by him, and he is said to have given her the first version of his *Three Graces*.[11]

In order to understand more specifically how this network of artistic patronage functioned, we might look at the activities of this circle of patrons and artists in 1813, the year in which Caroline Murat commissioned the *Grande Odalisque*. Canova was in Naples that winter to model the portraits of Caroline and Joachim Murat.[12] During Canova's absence, Mme Récamier arrived in Rome and set up a salon that included among its regular guests the painter Granet and the director of police in Napoleonic Rome, Baron Norvins, both of whom had had their portraits painted by Ingres. Shortly after Canova's return, Mme Récamier summered with him at his house in Albano and then traveled to Naples at the invitation of the king and queen. That spring, Paolina Borghese lived at the Murats' villa in Portici for five months. Meanwhile, in Rome on December 4, 1813, Ingres was married to Madeleine Chapelle, the cousin of Josephine Niçaise-Lacroix, who was engaged to Ingres's friend, the architect François Mazois. It was Mazois, an intimate of the royal family, who introduced Ingres to the queen of Naples.[13] As a result of these

22. Baron François Gérard, *Queen Caroline and Her Four Children*. Oil on
canvas, 217 × 170 cm. Musée National du Château de Malmaison. (R.M.N.).

interconnections, in February Ingres visited Naples for the first and only time. There, he saw his *Sleeper of Naples* hanging in Murat's private apartments, and he may actually have crossed paths with Mme Récamier. Ingres returned to Rome several months later with commissions from the Murat family for the *Grande Odalisque,* a portrait of Caroline Murat, and a portrait of the royal family.[14]

Caroline Murat's motivations in commissioning the *Grande Odalisque* may also have been affected by the circumstances surrounding the commission of its pendant, the *Sleeper,* two years earlier. In 1808, the year that Ingres painted the *Sleeper of Naples,* two other important works were completed: Canova's marble version of *Paolina Borghese as Venus Victrix* and Ingres's *Bather of Valpinçon* (fig. 55). Canova's sculpture was exhibited briefly in Rome, then shipped to the Borghese residence in Torino; Ingres's *Bather* was sent to Paris for its mandatory review by the Academy. But the *Sleeper of Naples* mysteriously remained in Rome, where the following year Murat purchased it from an exhibition in the *sale del Campidoglio.*[15] Given the links between these three works, is it any wonder that in creating a pendant for the *Sleeper* five years later, Mme Murat or Ingres decided on an odalisque seen from the back? Might we view her commission as an in-family joke about her sister's scandalous portrait in the round? Could we see it as a sly comment on her husband's tastes, or his reputed affection for her sister? Might we view Ingres's role as reiterating the formal concerns of his *Bather,* while creating a pendant to the *Sleeper of Naples*? Were the *Grande Odalisque* and the *Sleeper of Naples,* taken together, intended to offer differing viewpoints and thereby vie with the three-dimensionality of sculpture like Canova's?[16]

On one level, the progression from Mme Récamier's famous portraits by David and Gérard to Paolina Borghese's portrait as Venus by Canova to Caroline Murat's commission for the *Grande Odalisque* may seem obvious or oversimplified, the stuff of art history survey courses. But as an aspect of the history of patronage, it is less obvious and has broader implications. While Mme Récamier, Paolina Borghese, and Caroline Bonaparte have hardly been consigned to oblivion, their roles as art patrons have been virtually subsumed by their quasi-mythic personae.

For Mme Récamier and Paolina Borghese, it was their beauty, above all, that was legendary; for Caroline Murat, it was her supposed lust for power. In each case, the woman was believed to have the ability to incite crowds. Numerous eye-witness accounts report how Mme Récamier literally stopped traffic in London; in Rome, Paolina Borghese's statue as *Venus Victrix* needed to be protected from the crowds desperate to see it. After the fall of the emperor, Caroline Murat was considered so dangerous that she, alone among the napoléonides, was forbidden to live south of Trieste. Central to the representation of all three women was the force of their sexuality. If the sexual charms of Mme Récamier were enhanced by her puta-

tive purity, those of Paolina Borghese were boosted by her celebrated availability. And, as for Caroline Murat, hers was regarded as a case of sexual charms gone awry as she entered the public realm.[17]

Famous images of these women perpetuated their particular myths and ensured that Mme Récamier and Paolina Borghese were considered the undisputed beauties of their time. Mme Récamier purportedly preferred Gérard's more sensual portrait of herself to David's classical image,[18] and Paolina Borghese enhanced her sexy public image by having herself represented by Canova as *Venus Victrix*. Caroline Murat's portraits do not highlight her sensual charms as singlemindedly as do the famous portraits of Mme Récamier and Paolina Borghese. Although from all reports Caroline Murat was quite attractive, she was also a mother of four, and she was often pictured with her children (see fig. 22).[19] She also generally was regarded by her contemporaries as an ambitious woman who was the power behind the throne. Mme Cavaignac wrote, "Madame Murat especially had a mania to rule." In a letter to Metternich, Count Neipperg, who led the Austrian advance guard into Naples in 1815, referred to "the queen, who is much more the king of this country than her fool of a husband."[20] As for the queen herself, caught in the bind between positive and negative stereotypes of womanhood, she apparently alternated between the roles of self-effacing and devoted wife and powerful political figure in her own right. The king's power to rule had been seriously compromised in favor of his wife by Article 4 of the Bayonne treaty of July 15, 1808. In this treaty Napoleon transferred his brother Joseph to Spain and ceded the realm of Sicily to Joachim Murat. In doing so, however, he stipulated "the eventual rights of succession of Queen Caroline" and declared that "the transfer of land had been made specifically in her interest."[21] The difficulties inherent in this proviso had direct repercussions. Correspondence between La Feuillade d'Aubusson, *Ambassadeur du chef de famille,* and the emperor indicates that Murat placed restrictions on the queen so that she would not interfere with government.[22] Lurking beneath this conflict between king and queen were the contradictions that bound Caroline Murat, contradictions inherent in being a woman in the private *and* public realms.

During the Napoleonic Empire a woman in the public arena was regarded as unnatural. The pithiest statement about that monstrous misfit—the powerful public woman—was offered by Napoleon in speaking of his sister Caroline: "She has Cromwell's head on a pretty woman's body."[23] In this context, it is particularly interesting to examine Ingres's portrait *Queen Caroline Murat,* a painting that is surprising on virtually every level (fig. 23, plate 3). By any standard, the royal commission was an important one for Ingres. Along with the *Grande Odalisque* and a projected portrait of the Murat family, it represented crucial patronage at a time when Ingres's French patrons were leaving Rome. Missing since 1814, the painting

was rediscovered by an art dealer in 1987 and was reproduced in print for the first time in 1990.[24] As unusual as its provenance is its format, a less-than-life-size, full-length standing figure set in an interior, with a landscape seen through the window. But perhaps the most striking and unusual feature is that in this portrayal of a female monarch the ideology of domesticity is not dominant.

What has not been noted in previous discussions of this new-found work is the painting's relationship with another portrait by Ingres, *Bonaparte as First Consul* (fig. 24). In fact, *Queen Caroline Murat* bears such an uncanny resemblance to the 1804 portrait of Napoleon that they could almost be pendants were it not for the great disparity in their sizes and the ten-year difference in dates of execution. The composition of the two works is similar, with the figure positioned between a table and a flanking chair and a curtain parted to reveal a landscape. Furthermore, both paintings are executed in a precise, quasi-miniaturist manner that to some extent belies their scale.[25] By clearly recalling the earlier painting of her brother, the portrait of Caroline Murat emphasizes her relation to Napoleon as well as her own role as autonomous ruler. In Ingres's painting, Caroline Murat is represented in a much more decisive pose than in the watercolor that served as his source for the setting, Clarac's maternalistic *Caroline Murat and Her Children at the Royal Palace in Naples* (fig. 25). The queen's role as ruler is admittedly qualified in Ingres's picture, however. Unlike Napoleon, who points to a decree on the table in his portrait, Caroline marks a place with her finger in a small book next to which is a diminutive bell. Nevertheless, the associations with her brother's image are reinforced by the viewing angle and the elongated body of the queen, which, much as in Bronzino's *Portrait of a Young Man* (c. 1540; Metropolitan Museum of Art), lend a slight superciliousness to her even gaze and suggest a powerful public personage.[26] Ingres's comparably assertive image was, in some sense, a statement of public truth in 1814, a year in which Caroline Murat actually ruled Naples as regent during her husband's absence. Paradoxically, though, in suggesting the existence of an ongoing Napoleonic dynasty at the very moment of its actual collapse, the portrait also served as a supreme statement of wish fulfillment.[27]

There is no evidence to suggest that Caroline Murat was involved in the conception of her portrait. Nor do we have any indication of the queen's response other than Ingres's brief mention of her unspecified dissatisfaction.[28] But even if the queen were directly responsible for the way she was depicted by Ingres and she was satisfied by the result, it is still difficult to separate that notion of agency from stereotypes about powerful women as unnatural. This is an issue I would like to develop in discussing the *Grande Odalisque,* a case in which there is a great deal of evidence to suggest that the image did indeed please its patron.

23. Ingres, *Queen Caroline Murat,* 1814. Oil on canvas,
92 × 60 cm. Private collection.

24. Ingres, *Napoleon Bonaparte as First Consul,* 1804. Oil on canvas, 227 × 147 cm. Musée d'Art Moderne, Liège.

25. Charles-Othon-Frédéric-Jean-Baptiste, Comte de Clarac, *Caroline Murat and Her Children at the Royal Palace in Naples.* Watercolor. Formerly collection G. B. Spalletti Trivelli, Rome.

In commissioning the *Grande Odalisque,* Caroline Murat exhibited the same taste for highly sensualized imagery that had been evinced earlier by Mme Récamier and Paolina Borghese in their portraits by Gérard and Canova. Given the evidence that women liked this kind of imagery, the existence of a painting like the *Grande Odalisque* is hardly surprising. Even if our own "shock" about Caroline Murat's commission is due to lingering Victorian attitudes, questioning the significance of women's commissioning sexy images of female nudes during the early nineteenth century can hardly be reduced to ahistorical prudery. I would argue that the commissions of sensualized portraits by Mme Récamier and Paolina Borghese were rather less shocking than Caroline Murat's commission for the *Grande Odalisque.* Given the scandal surrounding the *Venus Victrix,* this may seem a bold statement at first. But there is a difference between the commissioning by women of images in which they *appear* to define themselves as they have generally been constructed—as sexual objects—and the actual consumption of those images by women. It is precisely because Paolina Borghese's image comes to stand for a real-life persona considered sexually outré that the *Venus Victrix* has a greater power to shock than Gérard's portrait of Mme Récamier. Paradoxically, the very fact that the *Grande Odalisque* is not a portrait of a famous personage gives the image a more incendiary dimension. Here, the powerful female patron cannot be reduced to a sexual object, as is the case with the portraits of Mme Récamier and Paolina Borghese. The commission for the *Grande Odalisque* thus raises the question of woman as the consumer of an erotic image in slightly different terms.

In exploring the question of the "feminine" taste for such sensualized imagery, what turns out to be most surprising about works like the *Venus Victrix* and the *Grande Odalisque* is the potential collision of female agency and sexed bodies. This dangerous mix is less troublesome when clearly defined social roles conform to their stereotypic representations, as when Mme Récamier's depiction as a Napoleonic beauty is linked to her public image of mythic virginity or when Paolina Borghese's representation as a vamp is used to support her mythic infidelity. But the ability to use cultural representations to transgress proper feminine behavior, particularly as realized by Princess Paolina and Queen Caroline, began to inform the ways that images commissioned by them were perceived. In other words, as soon as female agency acquired connotations of power and control—control over one's body, power over a state—the imagery itself constituted a threat.

Any history of female patronage must address the historically specific development of what has been called feminine taste. In considering "le goût féminin" during the Empire, for instance, we might consider the art historian René Schneider's descriptions of anacreontism or alexandrianism, stylistic terms for an art that he

claims appeals especially to women. Schneider defines *anacréontisme* as "a taste for mythology at once graceful, tender and voluptuous, . . . for form that is pretty, often to the point of being mannered." He further points out that

> the inspiration for this taste comes from eastern Greece, on the one hand, from the Greece of Anacreon of Teos and Sappho of Lesbos, who lived in the sixth century, and, on the other, from the Hellenistic and Greco-Roman epochs, when the Alexandrian spirit held sway. The Empire's greatest enthusiasm is for the period after the death of Alexander, when Hellenism, tired of epic but accustomed to Roman conquest, abandoned itself to the sweetness of life in the privileged sites of Asia Minor, Egypt, and Campania. This was a time of charmed fables in which Eros played the central role, ingenious abstractions, and pastorales in which rusticity was nothing more than an assortment of clichés. France, living out its own imperial epic, not only resembled the Alexandrian epoch but consciously evoked it.[29]

Anacreontism, as Schneider elucidates it then, is virtually synonymous with our notion of sensualized classicism. Although Schneider first applies the term to Canova, he quickly notes its relevance to the work of Girodet, Prud'hon, Gérard, and Chaudet. The concept might also be used to describe much of Ingres's art, including the *Grande Odalisque*.

Central to any discussion of anacreontism is the quality of grace. The term is key to Schneider's conception and it appears with some frequency in the Ingres literature as well. While the *Grande Odalisque* was not publicly exhibited in Italy when it was painted, its pendant was shown in Rome, where it was purchased by Murat in 1809. In praising the *Sleeper of Naples,* Filippo Aurelio Visconti, co-editor of *Il Museo Chiaromonti aggiunto al Pio Clementino,* singled out grace as its preeminent quality: "The vivaciousness, the grace, with which the life-size sleeping nude woman is painted is worthy of admiration."[30] However, it is in the critical writings about Canova's work that grace is most often evoked, usually in contradistinction to beauty. For example, Quatremère de Quincy, whose influential roles as doyen of neoclassical doctrine and Canova champion are well known, summed up the principal merits of Canova's art.

> I do not hesitate to say that he possesses two great talents, that of giving life to his figures and that of grace. Of the latter one can say that in sculpture it is sometimes more beautiful than beauty itself.[31]

Leopoldo Cicognara, whose notions of beauty and *grazia* are very close to those of Canova, made a similar distinction:

I must admit that while the perfect fills us with the greatest admiration, we are inclined to love and prefer the graceful.[32]

Grace is often juxtaposed with the real (*il terreno, la vie* . . .), as opposed to the ideal (*il bello ideale, le beau idéal*) with its connotations of abstraction from the real world. For Quatremère, "la grâce" and the ability "to give life to his figures" were Canova's principal merits. Like many of his contemporaries, Quatremère linked grace and sentiment. Discussing the four works that Canova exhibited in the Salon of 1808, he described the *Penitent Magdalene* as "a morsel of nothing but feeling" and continued:

> Who is to say if it isn't precisely this grace which enchants us in his works, the languid poses, the amiable physiognomies, those graceful movements, those soft forms and the pleasant handling of the marble that distinguishes his work and which one admires in his group of *Cupid and Psyche*.[33]

In describing Canova's *Venus Italica* (fig. 28), the poet and sometime critic Ugo Foscolo also emphasized the capacity of grace and the real to heighten feeling:

> But it seems as if Canova feared the awesome competition with the art of the Greek sculptor; so he embellished his new goddess with all those graces which breathe a "je ne sais quoi" of the earthly, but which more easily move the heart, which, like the statue, is made of clay.[34]

Although the taste for anacreontism and the qualities of grace, lifelikeness, and feeling it embodied was not the sole province of women, Schneider hastens to inform us that

> naturally it is among women especially that the contagion spreads. Canova, Chinard, Prudhon are the favorites of Mesdames de Groslier, Récamier and Regnault de St-Jean-d'Angély. Gérard is equally seductive for them. . . . But the most taken with this art is the wife of the master himself: Josephine. She has made Malmaison a sanctuary of *alexandrinisme*, where her innate taste for abandoned grace is joined by both the mythological sentimentalism of the late eighteenth century and Campanian Hellenism.[35]

Schneider has a monolithic conception of feminine taste, a taste ultimately rooted in biological essentialism. For women, Schneider claims, the appeal of anacreontism is natural ("naturally it is among women especially that the contagion spreads") and innate ("her [Josephine's] innate taste for abandoned grace is joined with mythological sentimentalism").[36] For men, on the other hand, it is a relief from the rigors of war:

When the troops return from a campaign, they enjoy the distraction of graceful and amorous mythology at home. The Emperor commissions Callamard's statue *The Wounded Hyacinth* (1811). Murat is pleased to exhibit two groups of Canova's *Cupid and Psyche* (1802) in his château at Villiers.[37]

Thus, if anacreontic taste in women resembles nothing so much as a biological urge, in Schneider's view, in men it is more like cross-dressing, a chance to throw off one's boots and rest from the ardors of unremitting maleness.

The dangers intrinsic to a notion of "feminine" taste that complements the "masculine" have been amply demonstrated by recent feminist scholarship.[38] As a diehard constructionist, sensitive, I hope, to the dangers of abolishing difference, I would like to shift the question of feminine taste away from notions of the natural. Rather, what interests me about the taste for anacreontism among privileged women is the possibility it afforded them to experience sensual pleasure. There is much evidence to suggest that many women did in fact purchase and commission anacreontic works (as did men: witness Murat). Josephine's collection, for instance, contained many striking examples of *anacréontisme,* including Canova's standing *Cupid and Psyche, Hebe,* the *Dancer,* and *Paris,* Cartellier's *Modesty,* Antoine-Denis Chaudet's *Cyparisse,* Bosio's *Love Shooting an Arrow,* Jeanne-Elisabeth Chaudet's *Young Girl Feeding Chickens* and *Young Girl before the Statue of Minerva, Sacrificing the Gifts of Love,* Guérin's *Anacreon Rekindling Love,* and Constance Mayer's *Repose of Venus.* Based on watercolor views of the installation of Josephine's collection and a precisely documented catalogue published during the empress's lifetime, we know that her collection was eclectic, with a strong bias toward old masters and modern paintings.[39] We also find that Josephine's own acquisitions outweighed the gifts to the collection. These acquisitions were generally made for Josephine in her own name, and only sometimes "under the auspices of Napoleon."[40] Whatever the case, we can conclude that Josephine played a major role in forming the collection and that it is a fair index of her taste. Though the empress certainly had artistic advisors—her curator at Malmaison was no less a personnage than Alexandre Lenoir, the founder of the Musée des Monuments Français—we can still recognize Josephine's taste. Like taste in general, it simply was conditioned by what others thought.

It is more difficult to speak about Caroline Murat's taste. In most instances her own purchases of artworks cannot be readily distinguished from her husband's. There are some notable exceptions, however, including three extant works by Ingres. Besides the *Grande Odalisque,* we know that Caroline Murat personally acquired the first oil version of *Paolo and Francesca* (fig. 26), the *Betrothal of Raphael* (ca. 1813; Baltimore, Museum of Fine Arts), and her own portrait of 1814.[41] The

26. Ingres, *Paolo and Francesca*, 1814. Oil on canvas, 35 × 28 cm. Musée Condé, Chantilly. Lauros-Giraudon.

genre scenes are particularly interesting for our discussion because, along with the *Grande Odalisque,* they serve as indexes of the queen's anacreontic taste.

Certainly Ingres's many repetitions of the *Paolo and Francesca* theme, all of which "depict the instant of their 'innocent love,'" warrant the rubric *anacreontic.*[42] The series as a whole conforms to Schneider's criteria for anacreontic works: they demonstrate "form that is pretty, often to the point of being mannered" and they are also "beautiful fables in which the best part is reserved for Eros itself."[43] The paintings all show the moment when a kiss between the diminutive figures interrupts their reading; most of them focus exclusively on this romantic moment, while others also show the intrusion of the jealous Malatesta, who slays them for betraying him. Although no fan of Ingres's "taste for the Middle Ages," the critic Edmond About clearly appreciated the role of passion in *Paolo and Francesca* when he quipped, "Paolo is not a man, he's a kiss."[44] By extending Schneider's notion of anacreontism to encompass works associated with genres other than history, we begin to see the continuities between neoclassical and romantic, classical and orientalist, orientalist and *troubadour.*[45] Anacreontism promotes the strange mix of aesthetic opposites that shaped Ingres's hybrid classicism, helping to explain, for example, how he could recast his neoclassical *Sleeper of Naples* as the exoticized *Odalisque with Slave* (fig. 34). Finally, the composite nature of anacreontism also helps to explain the constant oscillations between the moral and the voluptuous in Ingres's work and to make clearer the apparent contradictions in these works and in the writings about them.

Some idea of the wide currency of this "sensualisme antique"[46] in late eighteenth- and early nineteenth-century aesthetic theory can be gleaned by looking at the critical response to Ingres's noted contemporary, Canova. When Ingres first came to Rome in 1806, Canova was the *premier artiste napoléonien.* For young Ingres, whose ambitions for fame and fortune depended on Napoleonic patronage, Canova was a key role model, nearly as significant for his development as David. Even a cursory look at the Canova criticism suggests the tremendous importance the Italian critical climate had on the evolution of Ingres's thought and work. In particular, Isabella Teotichi Albrizzi's contemporaneous writings about Canova raise crucial questions, keenly relevant to Ingres's work, about anacreontic taste and female agency.[47]

One of the most interesting early writers on Canova, Isabella Teotichi Albrizzi (1763–1836), was a prominent figure in Italian literary circles. She was painted by Vigée-Lebrun and she corresponded with the noted poet and critic Ugo Foscolo; her husband was Conte Giuseppe Albrizzi, an avid Canova collector. Albrizzi's monograph on the sculptor's work was published first in 1809 and then in an expanded version in four volumes between 1821 and 1824.[48] She was also one of the

few women writing at this time who directly engaged questions, central to our study, about eroticized neoclassical bodies.

Like Ugo Foscolo, but unlike many of her French contemporaries, Albrizzi awarded paramount importance to the expression of feeling, even at the risk of disturbing absolute beauty.[49] Her description of Canova's *Venus Italica* (fig. 28) demonstrates this dilemma. Through her use of highly sensualized language, Albrizzi exemplifies the primacy she and many of her contemporaries accorded to the sensory:

> Since it is true that great passions alter and, I would say, almost disfigure the delicate and particular features of beauty, it seems fair that they should be forbidden in Art; but isn't there a humble desire to please (for pleasure), to enjoy, to love and perhaps to be loved, which contradicts this desire, and has the effect of augmenting it and making it even dearer? Isn't it perhaps such a feeling that invites us to prefer a less attractive but more animated face to another that neither says anything to the spirit, heart, or imagination nor demands anything from them? It seems that Canova himself took this qualification seriously and attempted to warm the face of his most beautiful Venus with the divine fire that courses through her veins. (1821, vol. 1, 33).[50]

Distinctive about this description is Albrizzi's obvious difficulty in trying to secure a place for sensory pleasure within the nether regions of the ideal. This aspect takes on particular relevance as we begin to examine her responses to the sensualized body and, particularly, the way these responses address sexual difference.

In the introduction to the first edition of *Opere di scultura e di plastica di Antonio Canova*, Albrizzi clearly sets out her intent to speak of the feelings *(i sentimenti)* aroused in her by Canova's works. She states her hope that the baring of her own responses will stimulate similar feelings in the reader: "I aim at nothing more than to rekindle, if possible, in some way, in those of you who by chance will read my descriptions, those same feelings, that the sublime creations of the greatest Genius of our time in the realm of the fine arts, have awakened in my soul" (1809, i).[51] In this passage Albrizzi does not cast her own response or those of others in gendered terms. But in elaborating her aim later in the text, Albrizzi awkwardly situates the question of sexual difference between two passages that apparently work to deny it:

> Although I am not arrogant enough to think that my way of thinking is unique (even if self-love deems every peculiarity a source of pride), I wish to delude myself, because of whatever similarity of heart or mind may tie us together, that it does not displease you or those who by chance will think as I do in this re-

gard. . . . As far as self-love is concerned, since men, under the powerful and re-
assuring guise of someone else's self-love, generally are indulgent toward a sex
by being more generous than just, I will let my own self-love feel fully at home.
(1809, iv)[52]

Albrizzi's pattern of denial and assertion, alternately evoking a communal gen-
derless experience and a fully gendered one where sexual difference is the sole de-
terminant of viewer response, suggests the slipperiness of her notion of difference.
In her description of Canova's *Theseus,* she suggests that men and women react dif-
ferently to the *bello ideale* embodied by the sculpture. What is more, she suggests
that sexual difference inheres in the very terms used to describe specific concep-
tions of beauty: "The figure of Theseus is ideally beautiful. There is great energy in
the musculature, the members are robust, heroic nobility inhabits his entire being
and especially the features of his face. Every man who sees him wants to resemble
him; and every woman feels in her bosom the heart of Ariadne" (1809, xiv; 1821,
vol. 1, 61–62).[53]

Albrizzi's response to *Venus and Adonis* (fig. 27) also poses the question of sexual
difference in the most explicit terms. Although both men and women will admire
the group, women, she asserts, will like it less, because it is Venus, rather than
Adonis, who displays more affection:

> Adonis, about to bid her farewell, already takes a step as if to leave, embraces
> her and gazes toward her. But what a surprise! His arm doesn't tighten around
> her waist, his eyes don't really look. She breathes the warmest affection; he, un-
> grateful, expresses the cold feeling of gratitude. This delightful group will cer-
> tainly be admired by both sexes; but women will like it less. Not even in marble
> can they stand to inspire a weaker sentiment than they feel! If a woman had
> conceived this beautiful group, it is clear that Adonis would have the sentiment
> of Venus, and Venus that of Adonis. (1821, vol. 1, 130)[54]

Albrizzi's observation that women will not tolerate a response from men that does
not equal their own depth of feeling obscures the fine line between representation
and social behavior; Albrizzi also implies a causal link between women's and men's
capacity to feel. Indeed, she seems to say that men owe something to women, who
simultaneously embody and stimulate feeling. In other words, there is a societal
need for a "feminine" taste.

Albrizzi's complex understanding of the possibilities inherent in gendered view-
ing impelled her, at least in part, to recast the construction of the feminine. In-
forming her dual contention that sexual difference not only determines different
responses but gives rise to different works of art, is the question, what would hap-
pen if women controlled the means of representation? In no uncertain terms, she

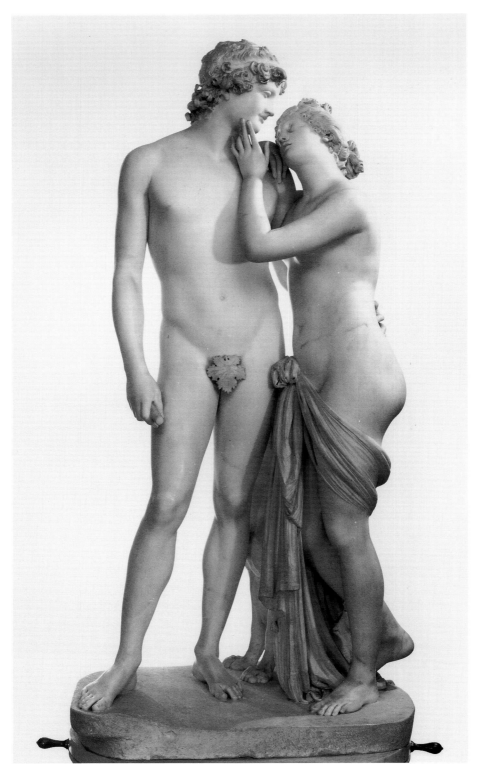

27. Antonio Canova, *Venus and Adonis*, 1789–94. Marble,
185 × 80 × 60 cm. Musée d'art et d'histoire, Geneva.

insists that the results would be different. But almost immediately, she undercuts her own heretical imaginings. Asserting that "la Madre d'Amore" (Venus) is generally recognized to be the less successful figure in the sculptural group *Venus and Adonis,* Albrizzi denies the very notion of difference she has just advanced. Later, when she notes that the goddess's overly suppliant attitude seems to interfere with her sensual charms, Albrizzi once again provocatively addresses women:

> It is generally agreed that people prefer Adonis to the Mother of Love in this group, despite the seductive softness of her musculature, the superhuman form of her face, and the affection which fills her heart and does so much to make her face beautiful. Could it be perhaps because Venus is pleading? Oh, what a lesson for my sex! Gentle women, what would become of you, if Venus, through begging, lost her charms? (1821, vol. I, 129–31)[55]

To all appearances, Albrizzi's conclusion urges woman to guard against the dangers of sacrificing beauty and its sensual appurtenances, by preserving her dignity. The fact that Albrizzi should wish sensual pleasure to predominate in a figure of Venus may be predictable. But that she should make the subject of sensual pleasure preeminent in her descriptions, and that she could assume such pleasure was not only stimulated but enjoyed by women, is astonishing. These bold assertions, engaging at every turn the question of female agency, are of course riddled with contradictions. But what is unique and empowering in Albrizzi's writing is her ability to push the neoclassical concept of *i sentimenti* in order to engage the issue of sexual difference.

Some of Albrizzi's contemporaries shared her fascination with the sensual aspects of Canova's work. In a letter to Albrizzi, Ugo Foscolo details his own encounter with the *Venus Italica.* Breathlessly, Foscolo describes how his infatuation with the marble goddess gave way to kisses and, as he tells his correspondent in total confidence, even a caress.

> Now I must—and I wish I had no paper left—but unfortunately I must, in a state of trembling—and I am not one to tremble—speak to you of Canova's Venus. What can I say? What can't I say? . . . I have visited, and revisited, and loved, and kissed, and—don't let anyone know—I even once caressed, this new Venus. In my opinion, it doesn't matter if I go back to see her; no matter how taken by her I am, I can't go out in that flood of water through which the Arno went walking in Florence the other evening: no matter how much my heart is full of the beautiful simulacrum of that Goddess.[56]

While no less steamy, other critical responses to artworks from Foscolo and his male contemporaries often contain assurances for the reader that the critics' love for these marmorean beauties is purely chaste. Describing a visit to the Countess

d'Albany during which he was struck dumb by Canova's sculpture the *Muse*, Foscolo writes of "a virgin mouth over which I would have sighed slightly but would not have dared to kiss."[57]

Foscolo's descriptions, blending as they do a confessional and rationalizing mode, cannot help but assume a moral cast. The same is true of Vittorio Barzoni's paean to Canova's *Hebe* in which the author's infusion of the spiritual deliberately short-circuits sexual feelings: "At the heels, at the ankles, under the soles of the feet, on the fingers, everything is made sweeter by the greatest softness, and everything seems to be informed by a celestial spirit. . . . Daughter of Juno and of CANOVA, sensitive simulacrum of an invisible being, how beautiful you are! Even with your beauty, you are far from seducing me with pleasurable charms, rather you transport my soul to the region of perfect understanding."[58] To rescue himself from the temptations of the too fleshy, too worldly realm of pleasure, Barzoni invokes the power of reason. In opposing "pleasurable charms" to "the region of perfect understanding," the critic resorts to those binary modes of thought that have traditionally equated men with reason and women with pleasure.

Whether Albrizzi's male contemporaries succumbed to the charms of Canova's statues, as occasionally happened to Foscolo, or whether they transcended them, as did Barzoni, they always strove to maintain sexual difference in the face of constant oscillations between the sensual and the spiritual. The sensuality that attracted these critics to Canova's works was frequently enhanced, perhaps even encouraged, by the lifelikeness they found there. Foscolo's distinctions between Canova's *Venus Italica* and the *Medici Venus* (fig. 29) make this clear. Of the *Medici Venus*, Foscolo writes, "I didn't know how to tear myself away from her: nevertheless it was devout and wondrous adoration, nothing more." But of the more recent work, he says, "When I saw this goddess of Canova, I immediately sat down next to her, with a certain respectful domesticity, and finding myself once more alone with her, I sighed with a thousand desires, and a thousand memories in my soul." Finally, Foscolo declares that the beauty of both Venuses—one divine, the other human—suggests paradise. "In short," he concludes,

> if the Venus de' Medici is the most beautiful goddess, this sculpture that I look at again and again is the most beautiful woman; one makes me hope for Paradise in the next world while the other entices me to believe in Paradise even in this valley of tears. As for the work, it is distinguished by the voluptuous attitude of the neck, the affectionate modesty of the face and eyes, and the lovable movement of the head; but, even if voluptuousness, modesty and love are celestial endowments, through which this miserable and sad nature of ours sometimes experiences something of the divine, at the same time they are gifts redolent of humanity.[59]

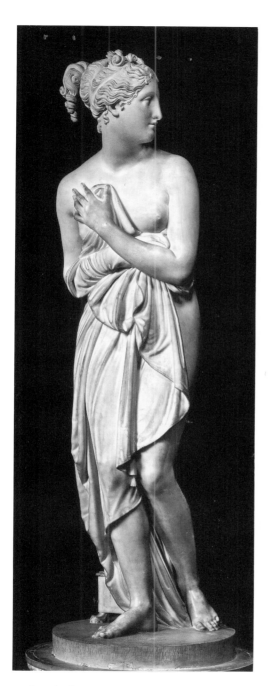

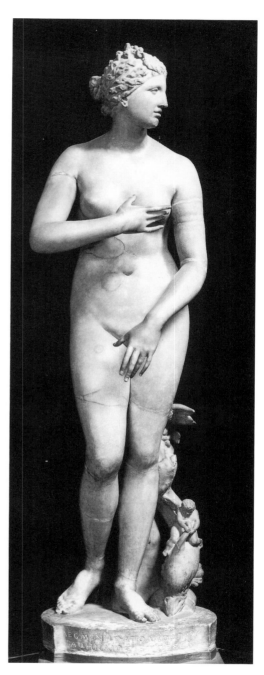

28. Antonio Canova, *Venus Italica*, 1804–12.
Marble, height: 172 cm. Galleria Palatina, Florence.
© Alinari/Art Resource, New York.

29. *Medici Venus*. Marble, height: 153 cm.
Uffizi, Florence. © Alinari/Art Resource,
New York.

Foscolo's description suggests that the distinction between the terrestrial and the celestial, the *real* and the *ideal*, can be as complicated as that between the sculptures and what they represent.[60] The critic De Latouche actually seems to posit an ideal of the real. Observing that Canova's *Paolina Borghese as Venus Victrix* is extraordinarily lifelike, De Latouche also notes that she presents "a series of perfections" only conceivable in Canova's creations: "She looks real. The sculptor of Venus seems to have borrowed for his chisel something of the sweetness of his compatriot Titian's brushes. The grace with which the shoulders and neck are joined, the lines of the torso, the mannered finish of the limbs, form a series of perfections that cannot be studied too much and for which it is difficult to find a model anywhere but in the work of Canova himself."[61]

These assessments, in which idealist abstractions are supposedly embodied in the compelling lifelikeness of Canova's sculptures, have the effect of rationalizing fantasies of possession and legitimizing them through the abstract qualities inherent in "the ideal" or "the divine." This is particularly true of the tendency among these critics to detail anatomical parts in the form of a progressive caress. Foscolo's passage on the *Muse* reads like a fantasy courtship, complete with a statement of honorable intentions: "And yet she didn't even open her mouth; and as soon as I was able to utter softly several words, she responded so that no one understood us. Ah, if I could take liberties! . . . I would swear to kiss her only on the forehead; but my lips would gel, because that is a Muse sculpted by Canova."[62] Not only does the virgin mouth of the *Muse* deter Foscolo from anything more than a chaste kiss on the forehead, his sexual fantasy is cut short by representation itself. His ecstatic description shows quite clearly how the idealized forms of representation functioned as a site of fantasy.

Albrizzi's writings display similarly conflicted intentions. When she cautions prudence in the face of Canova's statue *Endymion* (fig. 30), her reference to "this perilous youth" ("questo giovane pericoloso") signals the dangers posed by the carnal, the ultimate deviance from the ideal: "Pretty women, who have souls naturally inclined to love, look at this dangerous youth, but pass him by, and don't look at him for too long. Juno and Diana were goddesses, they were immortal. Be wary of unequal nuptials" (1821, vol. 1, 105–06).[63] But if Albrizzi's cautionary note draws coyly on the disparity between gods and mortals (reminding us of Foscolo's distinctions between the *Medici Venus* and the *Venus Italica*), she makes clear that these differences refer directly to herself and other viewers. Foscolo and other male critics generally displace these distinctions onto the statues themselves. Even more striking though, is the sheer variety of sensual pleasure she allows women. If they can swoon over *il bello ideale* as represented in Canova's *Theseus*, they can just as easily

experience pleasure in viewing graceful male bodies. In her comments on *Paris*, Albrizzi argues that the graceful youth was as deserving of the apple as Venus:

> Paris was beautiful like a God: so said Homer, and it seems that only Canova heard him, or understood him. What gentleness, what grace, what simplicity, what harmonious proportions! Oh most beautiful Paris! To you among all Canova's creations, to you everyone would offer that apple, that you keep for Venus: if there were not only one perfect beauty who faces you; but here, among all the marvelous creations of your Sculptor, who could ever dare to choose? (1821, vol. 1, 135)[64]

Female bodies can excite these sensations in women viewers as readily as male bodies, as Albrizzi shows in her appreciation of the *Venus Italica*:

> . . . and blurred in the pretty and seductive attitude of someone who is just at that moment coming out of the water; when the freshest limbs to exude water offer to the eyes a vagueness which awakens an inexpressible voluptuousness. . . . What can I say of the sweet laugh that springs from the lips; of the neck, of the chest that so beautifully rises, a restrained stemlike mass; of the back, whose soft curve rises toward the shoulders, and most gently descends to the waist? The eye eager for celestial pleasure feeds on such beauty without satisfying its hunger, while the marble, no longer cold or inanimate, appears softer. (1821, vol. 1, 30, 34)[65]

Such descriptions, even with their contradictions, have a boldness in their frank assertion of pleasure that would be remarkable even in twentieth-century women's writing about art.

The ambiguities engendered by Canova's art make more sense once we recognize the prominent roles of sexual difference and fantasy in representation. Such contradictions crop up in the more qualified assessments of his work just as they do in the outpourings of erotic fervor. Those very sensualized qualities perceived to be the distinguishing features of Canova's art often produced an unsettling anxiety in his viewers. This potentially productive nervousness lurks beneath Albrizzi's repeated assertions and gainsayings of sexual difference, in Foscolo's continuous vacillation between fantasies of possession and protestations of chastity, and in the disappointment with Canova's "heroic works" most vividly expressed by the German critic Ludwig Fernow.

Fernow's writings on Canova, first published in 1806, distinguish themselves from the chorus of contemporary panegyrics by their harsh assessment that Canova's works simply were unable to measure up to the ancient monuments.[66] Al-

though "the study of the antique had developed his [Canova's] feeling for beauty, and guided him toward the ideal," Fernow claimed, "the lofty purity to which it is carried in ancient art probably appeared too severe, too cold and inexpressive to the soft and sentimental tenderness of his character more inclined to the pleasing than the powerful" (163). Fernow first makes this argument in a lengthy description of Canova's reclining *Cupid and Psyche* (fig. 17), a work in which Fernow claimed the artist "displayed the peculiar bias of his taste":

> The very choice of his subjects, which always inclined to the sweet, the ten-der and the graceful, and to which his design and execution were exclusively adapted, sufficiently mark the peculiar bent of his genius, and though he after-wards attempted subjects both heroic and pathetic, the unsatisfactory manner in which he uniformly treats them, clearly shows that none but pleasing subjects—the tender forms of youth, the expression of the soft and gentle feelings, which he sought to represent with a finished elegance and almost melting grace—came fitly within his sphere of art. (165)

In Fernow's view, this lack of heroism derives from the feminine quality of the work, at once the strength of Canova's art and its weakness, its "peculiar bent." His complaint about the *Perseus* is explicit on this point: "The head, too, displays as little of the true heroic character as the figure. It has a feminine vacant self-satisfied expression, directly opposed to the boldness and strength of an heroic na-ture" (295).

According to Fernow, even Canova's most heroic work, the *Boxers,* resembles nothing so much as a couple of common porters when compared with the *Fighting Gladiator* (Villa Borghese), which inspired it. Not only do all of Canova's "heroic works" (Fernow specifies the *Boxers,* the *Hercules and Lychas* (fig. 31), the full-figure statue of *Napoleon,* the *Perseus,* and the *Mars Pacifer*) fall short of the ideal, they suffer from serious errors in proportion. Fernow finds, for example, that "the vio-lent and unnatural attitude of the Hercules—produces a horrible impression, and one quite incompatible with beauty." At the same time, "our dislike of the work is considerably increased by the clumsy figure of Hercules himself, whose forms and proportions, with all their colossal vulgarity, are disfigured by incorrectness and ex-aggerations of all kinds" (173). Similarly, Canova's *Napoleon* has "a chest too broad and protruding, giving heaviness to the upper part of the body—the body itself, too long—the hips too narrow to support the body, or to give the lower limbs a firm position—and badly formed feet" (299).

The staunch neoclassicist critic Quatremère de Quincy was troubled by such criticisms of Canova's work and immediately defended the sculptor from Fernow's accusation (saying, "he has too much talent not to have people who envy him").

30. Antonio Canova, *Endymion*, 1819–22. Marble, 93 × 185 cm. Devonshire Collection, Chatsworth. Reproduced by permission of the Chatsworth Settlement Trustees. Photograph courtesy Courtauld Institute of Art.

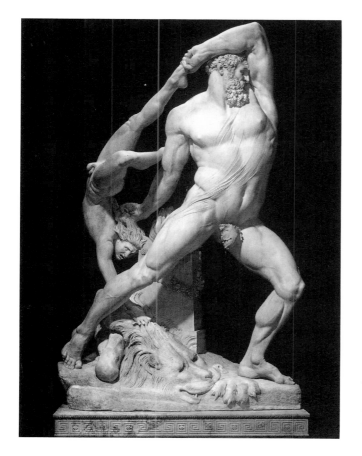

31. Antonio Canova, *Hercules and Lychas*, 1795–1815. Marble, height: 335 cm. Galleria Nazionale d'Arte Moderna, Rome. © Alinari/Art Resource, New York.

But Quatremère's rejoinder rested more on the artist's eagerness to respond to his critics than on the success of the works themselves.

> Nonetheless, Monsieur Canova wanted to respond to this objection, as it behooves a man to reply to criticism, that is, by means of works that disarm it. . . . For about ten years he has devoted himself to great subjects, which demand the most vigorous style, the greatest strength in drawing, and all the daring of the most skilled chisel. . . . No matter what his success, one can conclude that at least he is not afraid to measure himself against any style or subject; and this noble effort inspired by disinterested ambition, which takes on the most arduous tasks solely for the reward of competing in all the arenas open to the genius of art, suffices to give a lofty idea of the artist's noble character, of the elasticity that inspires his talent, and of the results that one can expect from it.[67]

Quatremère's defensive tone and tendency to displace the critique through a sort of character check show once again the level of anxiety that accompanied any lavish praise of Canova's work. Indeed, if we follow Schneider's argument that the taste for this kind of art is innately feminine, we might say that it is found lacking. But this is too simple a reading. The dismissal of the feminine goes hand in hand with the threat it seems to pose to masculinity: the feminine can be rescued, even enjoyed, if the clear boundaries of sexual difference remain intact.

In this context we can begin to understand the complex sexual symbolism invoked in Canova's appeal to Murat to legitimate his *Boxer Cregas*: "As early as 1802, when Canova, desirous of striking the French school at its core, that is to say at the Institute, wanted to make it a gift of the Boxer Cregas, popping with muscles, to prove to the French that he was not only suited to the graceful, he thought of Murat, the prince of energy, to present the work at a session of the Beaux-Arts."[68] Thus, the warrior himself provides the warranty for the imagery he inspires. And it is as a measure of the contradictions about heroic imagery that the anxiety about Canova's art needs to be addressed.

The attraction of anacreontic imagery for French viewers and patrons cannot be disassociated from the effects of revolution at home and unremitting war abroad or from the ways in which women increasingly lost credibility in the public sphere under the evolving Empire. Schneider summarizes the anxieties implicit in a "feminine" art:

> Now here's a feminine artist, feminine in spite of the colossal, of the Hercules and Lychas and of the Boxer, feminine to the tip of his chisel. Woman reigns in his oeuvre, which she has moreover spontaneously adopted: Josephine, Marie-Louise, Elisa, Pauline, Caroline, Mme Récamier, Mme de Staël-Corinne, Mme de Groslier, Mme Vigée-Lebrun, the Countess Albany, all of them recognize

and love themselves there. Hair, ears, extremities are attended to in detail and with coquetry. The eye and the hand slide over the round, soapy forms, without encountering any of the projections of life—muscles, folds, or veins. Adolescence and ephebi beguile him as much as woman, androgyny attracts this emasculated modeling: the sleeping Nymph is a barely disguised reminiscence of the Hermaphrodite. He likes alabaster, which is less male than marble.[69]

For Schneider this is a world in which the familiar binary oppositions anchoring sexual difference have been set on their head, first by invoking an extended pleiad of powerful women, then by conjoining adolescence, androgyny, and women. The spectre behind his list of empresses, artists, and *salonnières* is nothing less than the reversal of order itself, signified by women's control of the means of representation.

What is represented by the feminine here is the antithesis of the heroic: the emphasis on detail, round and vaporous forms, furtive eyes, slippery hands, forms devoid of muscles, folds or veins. It is a world from which "masculine" heroism has been expunged. If the masculine exists at all in Schneider's description, it is defined solely by negation, in opposition to what it is not. A "plastique emasculée," it has lost the capacity to signify the masculine ("féminin en dépit du colossal"). A similar thing seems to happen in much of the nineteenth-century criticism of the works by Canova that he discusses. Despite the urge to codify sexual difference through the recourse to strategies of opposition, even the most exaggerated signifiers of the masculine in Canova's work—the *Hercules and Lychas,* the *Boxer*—are not convincing.

Ingres would seem to have experienced a similar anxiety about "the expression of force and energetic character." In his various series, he frequently chose to depict the moment of "innocent love" to the exclusion of other narrative episodes that were originally part of the project. For instance, despite repeated mentions in his notebooks, there is no evidence that Ingres ever undertook a composition for *Hercules and the Pygmies.* Ingres's predilection for "innocent love" also helps explain his failure to complete the pendant murals of *The Golden Age* and *The Iron Age* for the Château of Dampierre, where he worked for ten years on the idyllic scene while barely beginning its fearsome counterpart. But there are instances in which Ingres tried to express force and energetic character: the overdetermined binary oppositions in a work like *Achilles Receiving the Ambassadors of Agamemnon* is certainly one example; the inflated torso of the king of the gods in *Jupiter and Thetis* is another (fig. 57; plate 7). The exaggerated musculature in the *Saint Symphorian* (fig. 46, plate 5), which was criticized almost to the point of ridicule, similarly betrays anxiety about sexual difference. If the sensual was suspect in representations of the male body, it was often naturalized as a sign of difference in representations of the female body.[70]

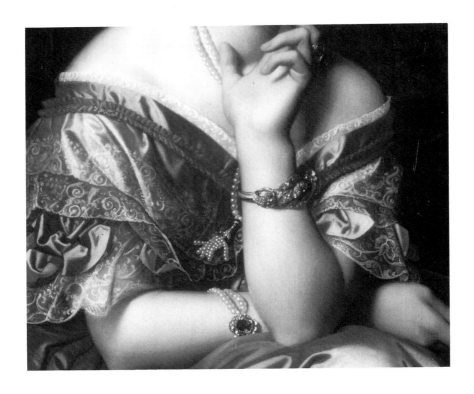

In memory of my father and grandparents

In the wake of a visit to Ingres's studio in 1848, the critic L. de Geffroy commented at length on the artist's recently completed portrait, the *Baronne de Rothschild* (fig. 32; plate 4). Geffroy's fulsome references to the sumptuous color, glittering jewels, and iridescent fabrics of the picture initially seem jarring, even shocking, as descriptions of the portrait of a respectable upper-class woman. "At first glance," Geffroy writes,

> this portrait is somewhat of a surprise. The eye needs to get used to the luxurious reds which assault it; but, once accustomed to them, the eye never tires of admiring their precision and richness. The viewer, captivated by this unexpected color, is reminded of earlier portraits by the artist, in which the perfect drawing, the utter truth of the gestures, the study of details pushed to the limit, sufficed, even in the absence of color, to create such remarkable works, that finding these qualities magnified and brought to completion here the viewer does not hesitate to pronounce this work first-rate.

Geffroy's rhapsodic appreciation of textures and materials, as he continues, has the same effect: "The dazzling shoulders project amply from the dark velvet of the cushions. And the fabrics! To be sure, they are Venetian and would not have disgraced the shoulders of a doge."[1]

For this romantically inclined critic, color and texture convey sensuality, much as serpentine line does for more neoclassicist critics. Further, these distinctly orientalist excesses make perfect sense in the context of ethnic stereotypes. The coded discourse of

sensuality that Geffroy employs is, in fact, typical in contemporaneous representations of Jewish women. Despite its extraordinary evocation of excess, Geffroy's account is in many ways unremarkable. Like many art critics of his day, Geffroy takes for granted the importance of resemblance; he appreciates the beautiful drawing and delicate modeling; he repeats clichés about artistic freedom; and, in concluding, he proclaims the greatness of French painting and its moral responsibilities.[2] Also, like most representations of women, his description of the baroness's portrait vacillates between a discourse of sensuality and a discourse of respectability. Nonetheless, when we consider more closely Geffroy's attitude toward gender, we realize that something is odd. The lengthy description of the sitter functions as a kind of checklist that we might label "features not usually found in Ingres's portraits of women":

> The artist's model, seated on a divan, faces front, as if she were engaged in an attentive little chat, with knees crossed, the left lightly supporting her chin, the right arm thrown across her body with abandon, and holding a closed fan. On her head is a black velvet *petit-bord,* attached behind and decorated with two white feathers that fall to right and left, framing a head of hair with bluish glints like the wing of a crow. . . . Two large eyebrows *à l'orientale* are outlined on her forehead, whose finish glows and, in like manner, her eyes sparkle with life and wit. Nothing is sweeter and at the same time more intelligent than this gaze which is surely that of a woman endowed with wit. Nothing is more lifelike than this head.[3]

Geffroy was fascinated by the sitter's animation: her knees are crossed, as he describes it, as if she were posed for an intimate conversation, her eyes are sparkling with life. None of Ingres's other female society portraits elicited such remarks.[4] But the distanced, marmorean beauty so characteristic of Ingres's portraits of women is nowhere to be found in this work (see e.g., *Mme Moitessier,* fig. 33). No other portrait sitter by Ingres bends forward as this figure does. None curls her fingers in such an energized spiral. Nor, for that matter, do any of his other portraits have the warm flesh tones we see in the face of the *Baronne.*

To be sure, these distinctive features coexist in Geffroy's description of the portrait with more predictable ones. Comments like "nothing is sweeter and at the same time more intelligent than this gaze which is surely that of a woman endowed with wit" merely rehearse the social graces desirable in an upper-class woman. But what are we to make of phrases like "a head of hair with bluish glints like the wing of a crow" or "two large eyebrows *à l'orientale*"? In their resemblance to the sensualized descriptions of the *Grande Odalisque,* these remarks conjure up the world of

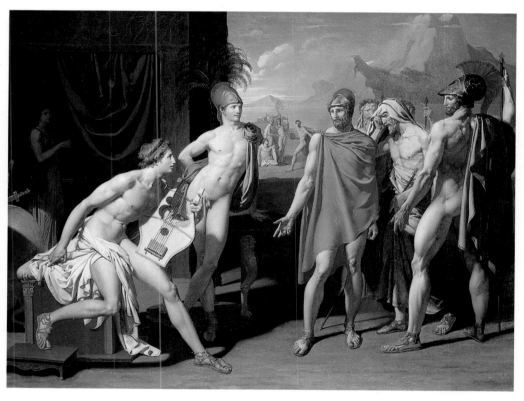

1. Ingres, *Achilles Receiving the Ambassadors of Agamemnon*, 1801.
Oil on canvas, 113 × 146 cm. École nationale supérieure des
beaux-arts, Paris (ENSBA).

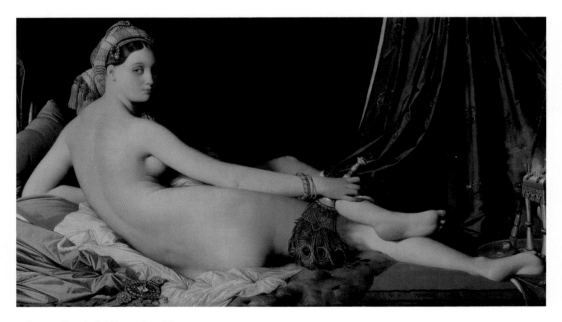

2. Ingres, *Grande Odalisque,* 1814. Oil on canvas,
91 × 162 cm. Louvre, Paris (R.M.N.).

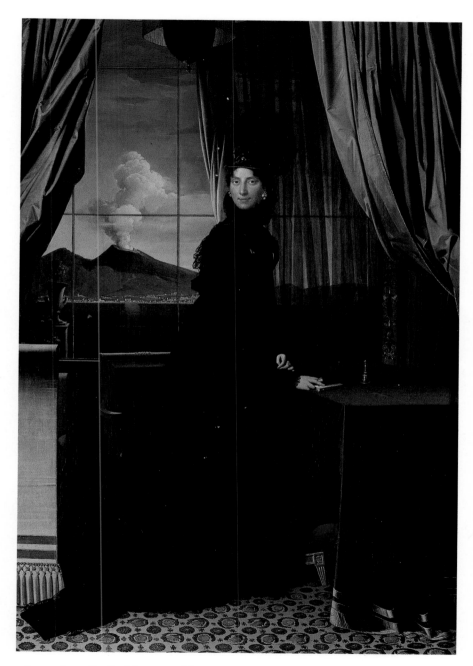

3. Ingres, *Queen Caroline Murat*, 1814. Oil on canvas,
92 × 60 cm. Private collection.

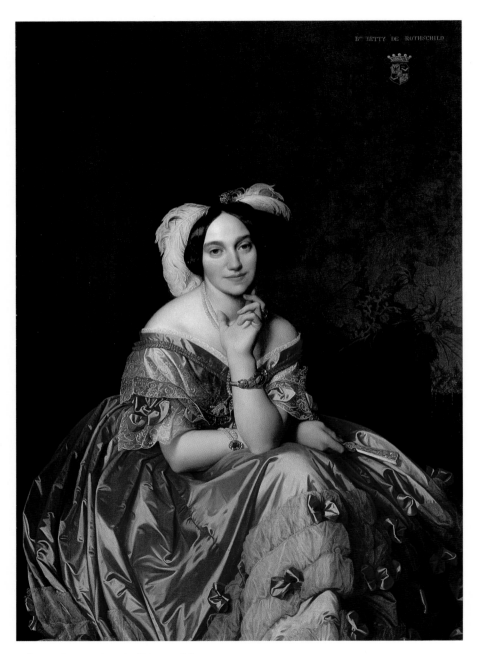

Bᵉ BETTY DE ROTHSCHILD

4. Ingres, *Baronne de Rothschild*, 1848. Oil on canvas, 142 × 101.5 cm.
Private collection, Paris. Photo Routhier. Studio Lourhel.

5. Ingres, *Martyrdom of Saint Symphorian*, 1834. Oil on canvas,
407 × 339 cm. Cathedral of Autun. Courtesy of Editions Gaud.

6. Philippe Curtius, *Sleeping Beauty.* Wax
and pigment, life size. Courtesy of Mme Tussaud's, London.

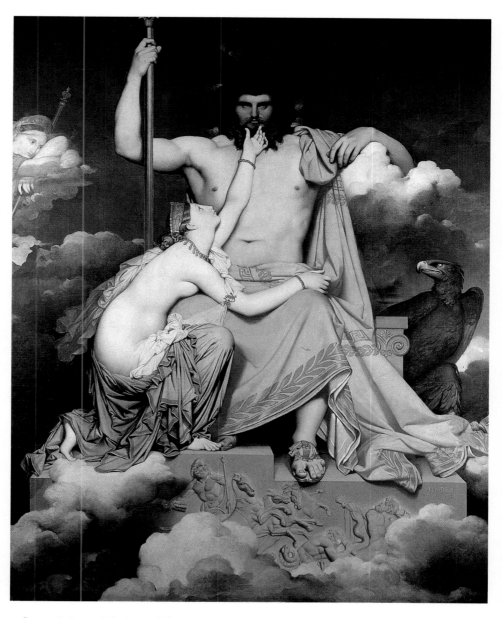

7. Ingres, *Jupiter and Thetis*, 1811. Oil on canvas, 327 × 260 cm. Musée Granet, Palais de Malte, Aix-en-Provence. Photograph by Bernard Terlay, Aix.

8. Cindy Sherman, *Untitled #250*, 1992. Color photograph,
127 × 190.5 cm. Courtesy of Metro Pictures, New York.

32. Ingres, *Baronne de Rothschild,*
1848. Oil on canvas, 142 × 101.5 cm.
Private collection, Paris.

33. Ingres, *Mme Moitessier,* 1851. Oil
on canvas, 147.5 × 101.5 cm. National
Gallery, Washington, D.C.

the harem rather than that of the well-bred Western home, the realm of the nude rather than that of the formal portrait. They signal that we are dealing with a "type" that is distinctly different from Ingres's other models. As Geffroy's orientalist vocabulary makes clear, that type is Semitic.

It is not simply that the baroness was a Jewish woman but that she was the quintessential Jewish woman. What family in France, indeed in all of Europe, could represent "the Jew" more than the Rothschilds? And what Jew could be more of a Rothschild than the baroness?

Betty (née Bethsabée) de Rothschild was both a daughter and a wife to Rothschild bankers. Her father was Salomon de Rothschild, founder of the Austrian branch of the Rothschild bank; her husband, James de Rothschild, was founder of the French branch. In other words, Betty de Rothschild was tied by bonds of blood or marriage to two of the five Rothschild sons whose financial empire girdled England and Western Europe.[5] Due to their massive corporate success, the Rothschilds were often subjects of fierce anti-Jewish sentiments. Referring to a train derailment on a railroad line owned by James de Rothschild, a contemporary observer put it this way: "If his railroad goes well, it's the Compagnie du Nord. If his railroad goes relatively well, it's the Compagnie Rothschild. If his railroad goes badly, it's the Rothschild railroad. If his railroad goes very badly, it's the railroad of the Jew Rothschild."[6] Pamphlets published at the time of this particular accident in 1846, two years before Ingres completed his portrait of the baroness, employed predictable stereotypes. Baron James was "the king of the Jews," "the new royalty of the bank vault," "the high priest of the god of the nineteenth century—Money." According to these pamphlets, James de Rothschild directed not only the stock exchange but the government as well.[7] Such views were voiced by representatives of the entire political spectrum: socialists who sympathized with the workers, disempowered aristocrats who resented new money, the Catholic church, and liberals who, like the socialists, identified the Rothschilds with government. Although these attacks do not compare to the virulent anti-Semitism of the Dreyfus Affair, the grumblings and accusations of aristocrats and socialists like Leroux and Toussenel show the remarkable persistence of anti-Jewish attitudes in nineteenth-century France.[8]

Name-calling was less common in reference to the baroness. Even if she had detractors, they would scarcely have maligned her in the terms reserved for the baron simply because the stereotypes for women were different. Jewish women were typically cast as biblical heroines and conceived as virtuous, maternal figures, possessing a rare, spiritual beauty. Although representations of Jewish women and of Old Testament scenes in general declined in the early nineteenth century due to the antibiblical position of Enlightenment philosophers, they experienced a renas-

cence of sorts with the advent of Romanticism. In her new guise, the biblical heroine symbolized not so much moral virtue as oriental beauty.[9]

Most verbal representations of Betty de Rothschild follow the virtuous model appropriate for a married woman and an aristocrat and resemble those of her non-Jewish peers. One pamphleteer sympathetic to the Rothschilds described her as "the Queen, his august wife, so worthy of a mission which she has always filled with religious devotion."[10] Other contemporaries found her "rather pretty and very polite" (Maréchal de Castellane) or a "veritable *grande dame,* and full of distinction in her manners" (Eugène de Mirecourt) and commented that "just out of her nursery she does the honours of her house as if she had never done anything else" (Lady Granville).[11] The baroness, in sum, was the model upper-class wife prescribed by the clichés of respectability. But when one looks more closely, it is apparent that representations of the baroness exceed the oxymoronic discourse of the powerful married woman. They draw on the vocabulary of sensuality common to Geffroy's description and to contemporaneous stereotypes of Jewish women. This discourse is encapsulated in the remark by Lady Granville, wife of the British ambassador to Paris, that the baroness was "a pretty little Jewess." The comment may seem innocuous at first, the addition of an innocent religious qualifier in describing a woman regarded by many as ideal. After all, the Rothschilds, unlike many wealthy Jewish families, were practicing Jews.[12] But the words "pretty little Jewess" mean quite a bit more.

Jean-Paul Sartre once noted that there is in the phrase "a beautiful Jewess" a "very special sexual signification, one quite different from that contained in the words 'beautiful Rumanian,' 'beautiful Greek,' or 'beautiful American,' for example." He continued, "This phrase carries an aura of rape and massacre. The 'beautiful Jewess' is she whom the Cossacks under the czar dragged by her hair through the streets of her burning village."[13] In the language Sartre analyzes, Geffroy's discourse of sensuality has been pushed to its logical extreme, the obsessional discourse of orientalism. The apparently casual allusion to "pretty little Jewess" signifies sexuality in much the same way as do the blinding reds, brilliant jewels, and arched eyebrows of Geffroy's description.

We do not need biographical anecdotes to suggest that stereotypes of Jewish women informed Ingres's portrait and Geffroy's response to it. Not only did French stereotypes of Jews have a long and indelible history, but, by the 1840s, the will to typologize was close to maniacal, as evidenced by the popularity of *physiologies,* pocket-sized books which offered pseudoscientific portraits of contemporary social types. The physiologies catered to a mass audience. Each one was different from the others, yet given their standardized paperback format and marketing as a uniform collection, reassuringly the same. Although less concerned with ethnic images than with social or professional classifications, the physiologies, as a stereotyping

network of sorts, functioned in much the same way as do the representations of Semitic women that are of concern to us. In each case, purported mimesis is subordinate to the *déjà-écrit* and *déjà-lu* (what has already been written and what has already been read); narrative and history evaporate. Both produce a system of difference whose primary purpose would seem to be to make otherness immediately recognizable. But even when ostensibly funny, ethnic and racial stereotypes had none of the lightheartedness that characterizes the physiologies. If the physiologies created an illusory diversity based on the exclusion of nonbourgeois types, their function, according to Walter Benjamin, was to fabricate a reassuring world that denied the discomfort of the modern urban crowd. While ethnic and racial stereotypes are also rooted in exclusion, unlike the physiologies, they have a tenacious history as strategies of domination. In the case of stereotypes of Jewish women, domination—sometimes explicit, sometimes implied—is always sexual and always that of men over women.[14]

In the 1840s public representations of the sensualized female Jew were so profuse that protests were lodged in the Jewish press.[15] Even Balzac produced offending material, and we have only to look at his descriptions of female Jews to understand the nature of the affront. Imagine Geffroy's description of the baroness alongside these quotations from Balzac and the shared discursive strategy of their texts becomes clear:

> She was white as snow, eyes like velvet, black lashes like rats' tails, lustrous hair, thick, which made one want to touch it, a truly perfect creature. (Judith in *Le Médecin de Campagne,* 1833)[16]

> Her features offered in its greatest purity the character of the beautiful Jewess: those oval lines so large and virginal which have je ne sais quoi of the ideal and breathe the delights of the Orient, the unalterable blue of its sky, the splendors of its earth and the fabulous riches of its life. She had beautiful eyes veiled by long eyelids, fringed by thick and curved eyelashes. A biblical innocence burst from her brow. Her coloring had the matte whiteness of the robes of the Levite. She was habitually silent and meditative, but her gestures and movements showed a hidden grace in the same way that her words revealed the sweet and caressing spirit of woman. (Pauline in *Louis Lambert,* 1832–33)[17]

> Coralie was the sublime type of the Jewess, the long oval face of a blond ivory tone, a mouth red like a pomegranate, a thin chin like the edge of a cup. Under the eyelids burnt by a jet-black pupil under curving lashes, one sensed a languid gaze where the heat of the desert sparkled. These eyes shaded by an olive circle were topped by arched brows. . . . Such beauty of a truly oriental po-

etry was heightened by the Spanish costume seen in our theatres. (Coralie in *Illusions Perdues*, 1837)[18]

These stereotypes were hardly confined to fiction. In an article about the opera singer Mlle Falcon, Théophile Gautier enumerated the characteristics of "the Hebrew nature": "These are long faces, red mouths, eyes with arched lids, surrounded by a blue circle with a cristalline set with diamonds, a languishing gaze soaked in sunshine where all the heat of the Orient glows." Gautier reprised these stereotypes in *Voyage en Italie*, a novel in which he employs the typical device of playing off the beautiful Jewess against the usurious male Jew: "Probably if one were to enter these houses . . . , one would find, as in the ancient ghettoes, Rebeccas and Rachels of a radiant Oriental beauty, embellished with gold and jewels like Hindu idols, seated on the most precious carpets of Smyrna, in the middle of gold vessels and of inestimable riches heaped up by paternal avarice."[19] Finally, in a more lyrical vein, we have Victor Hugo in *Les Orientales* writing,

What does it matter, beloved Jewess
Breasts of ebony, brow of vermeil!
You are hardly white, nor copper-colored
But it seems that you are gilded by the sun's rays.[20]

If I have purposely multiplied examples, it is to show that this language, repeated often enough, has the effect of a narcotic; the reader is literally enveloped by the sensual world of the text. In Orientalist paintings, the effect is much the same. Even works as stylistically different as Ingres's *Odalisque with Slave* (fig. 34) and Delacroix's *Women of Algiers* (fig. 35) use the materiality of flesh and fabrics, languorous poses, and contrasts of light and dark to ground the myth of the exotic woman as sexually available. The fact that these classic Orientalist scenes, among which we would have to include the *Grande Odalisque*, rely on the same stereotypes as do representations of Jewish women is an index of how stereotypes steamroller differences. Jewish women were often lumped together with Turkish, Greek, and Spanish women. The grouping of radically different ethnic and racial types in Jean-Léon Gérôme's *Snake Charmer* (1880; Clark Art Institute, Williamstown, Massachusetts) never addresses the unlikelihood that they should be in one place at the same time. The effect of this denial of difference is to "reduce the complexity and heterogeneity inherent in a process and its relations to a single, homogeneous (and repetitive function)."[21] Complicating the idea of repetitive function, the British cultural historian Homi Bhabha argues that fixity operates as a sign of cultural, historical, and racial difference by connoting rigidity and lack of change, on the one hand, and disorder and incessant reiteration, on the other. As the major discur-

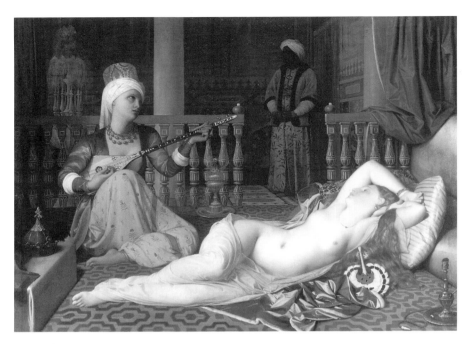

34. Ingres, *Odalisque with Slave,* 1839. Oil on canvas, 72 × 100 cm. Fogg
Art Museum, Cambridge, Massachusetts. Bequest of Grenville L. Winthrop.

35. Eugène Delacroix, *Women of Algiers,* 1834. Oil on canvas, 180 × 229
cm. Louvre, Paris (R.M.N.).

sive strategy of colonialist discourse—or, for that matter, any discourse of power—the stereotype vacillates between what is "in place," or already known, and what must be incessantly repeated. For Bhabha this ambivalence is "one of the most significant discursive and psychical strategies of discriminatory power—whether racist or sexist." Not only does it ensure the repetition of stereotypes in changing historical and discursive situations, it also produces the effect of a truth and predictability that is always in excess of what can be empirically proved.[22]

In mid-nineteenth-century French painting (a prominent site for the repetition of stereotypes), Old Testament scenes were by far the richest source for images of Jews. Given the critics' emphasis on the noble, majestic qualities of biblical patriarchs like Moses and Noah in Old Testament paintings, we might expect to find Esthers, Sarahs, and Ruths depicted as comparably noble biblical matriarchs. Instead, we find representations of these women that opt for an uneasy marriage of the spiritual and the sensual. As history paintings, Old Testament scenes had the advantage of being taken seriously; as works that were both exhibited and discussed by the critics, they also most easily reveal the interface between historical stereotypes and everyday life of the time. An unidentified critic discussing Henri Lehmann's *Daughter of Jephtha* (Salon of 1836), for example, employed stereotypical references to Jews, as does Gautier when he describes the singer Mlle Falcon in this role.[23] The critique of Lehmann's work, published in *L'Artiste*, recites a familiar litany of derisive metaphors:

> This painting gives proof of a deep and special sentiment of biblical poetry; these young women with their large eyes blackened with kohl, their aquiline noses, their red lips, their yellow-amber skin, their bluish-black or gleaming gold hair, their elongated oval faces, their stature, supple and round as the palms of Engaddi, their powerful arms ending in fine hands, achieve the ideal of Hebrew beauty; they remind us of descriptions of Sir-Hasirim in which the poet-king, in order to paint his beloved, opens the jewel case of Oriental metaphors, piles up mountains of spices, and makes lyricism drink at the cup of hashish. Their splendid clothes were colored by tones of rubies, sapphires, and emeralds, sharply contrasted with this yellowish-white of linen, which resembles molten gold. M. Lehmann continues to mine this rich vein.[24]

This tension between the spiritual and the sensual appears at its most dramatic in two very different critical responses to Delacroix's *Abduction of Rebecca* (fig. 36), a painting whose Jewish heroine is drawn from Walter Scott's *Ivanhoe*. Given how frequently the female body was a site for the assertion of male power, it is not surprising that the subject of both painting and criticism is the body of Rebecca. For the critic Guillot, the way Rebecca's body is rendered makes a travesty of the heroine's virtue: "The heavy, common forms of the creature who is stretched out there

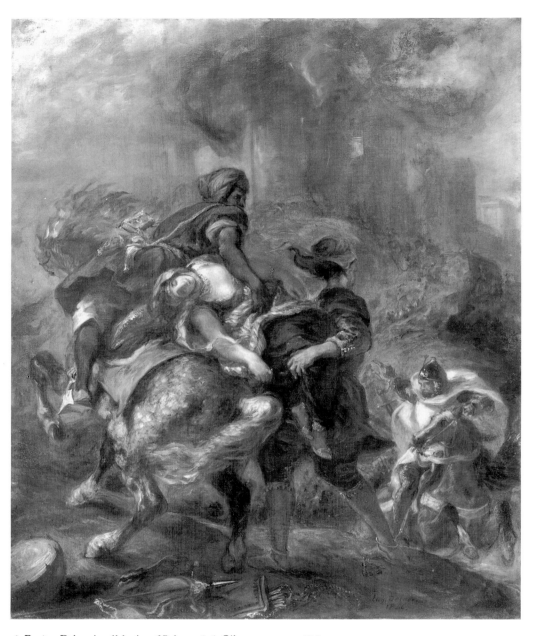

36. Eugène Delacroix, *Abduction of Rebecca*, 1846. Oil on canvas, 100 × 82 cm.
Metropolitan Museum of Art, New York, Wolfe Fund, 1903; Catharine Lorillard
Wolfe Collection (03.30).

37. Théodore Chassériau, *Toilette of Esther,* 1841. Oil on canvas, 45.5 × 35.5 cm. Louvre, Paris (R.M.N.).

is hardly the svelte, chaste lover of Ivanhoe. We are at the abduction of one of those unfortunates who prowl about the camps." Paul Mantz's admiration of the picture focuses on the body as well: "The body of *la belle juive,* marvelous in its suppleness and abandon, shows extraordinary refinement in its color."[25] In other words, languor bordering on formlessness was appropriate to a depiction of *la belle juive.* Many other works that feature Old Testament Jewish women are overtly seductive, for example, Chassériau's *Toilette of Esther* (fig. 37). Like Delacroix's *Abduction,* these paintings often seem to be about the fantasy of male possession.

Genre scenes of Jews also need to be analyzed in terms of the Orientalizing discourse of sensuality. Delacroix's *Jewish Merchant in Algiers* of about 1840 (Collection R. Lopez, Paris),[26] for example, perfectly illustrates the stereotype used by Gautier in *Voyage en Italie* in which the beautiful, moral female is a foil to the slovenly appearance and turpitude of the male. This cliché resurfaces in discussions of the Baroness and Baron de Rothschild in which her beauty, speech, and graceful deportment often are contrasted to his appearance and behavior. Unlike his wife,

the baron spoke French with an execrable German accent.[27] As for his appearance, the Maréchal de Castellane considered him "small" and "ugly," while the Goncourts described his "monstrous visage, the flattest, squattest, most frightful kind of batrachian face, with bloodshot eyes, swollen lids, a slobbery mouth slit like a piggy bank, a sort of satrap of gold: that's Rothschild."[28] The harshly anti-Semitic Goncourts take us beyond description or stereotype to bigoted caricature.

The commissioned portraits of Baron James, however, demonstrate that stereotypes of money-grubbing Jews simply cannot be reconciled with the physical attractiveness and aristocratic bearing required in high-society portraiture (see, e.g., fig. 38).[29] Equally subject to conventions, commissioned portraits of upper-class Jewish women, like Eisle's of the Baronne de Koenigswarter (fig. 39) from the 1840s or the anonymous portrait of the young Baronne James de Rothschild (fig. 40), for that matter, most often opt for the stereotype of the virtuous woman. What is striking about Ingres's portrait of the Baronne de Rothschild is that it mixes the contradictory discourses of respectability and sexuality. In this respect, it is very much like those images of female Jews in which the positive biblical stereotype exists alongside, or is fused with, a putatively negative sensuality. But Old Testament scenes, genre scenes, and portraits of less aristocratic sitters can more easily accommodate sexual excesses than can portraits of upper-class sitters. It goes without saying, for example, that Ingres's *Baronne* had to represent the respectable woman, while Alexandre Cabanel's painting *Albaydé* (fig. 41), based on the subject of a poem in Hugo's *Les Orientales,* did not.

The conflation of discourses in Ingres's portrait can only be understood in the context of such stereotypes of Jewish women. These offered Ingres the opportunity to develop the sensual in his *Baronne* to a degree that was not possible in his other late portraits. Ultimately, this discourse of sensuality also helps to explain the relaxed pose and greater warmth of the *Baronne* as well as her apparent openness toward the viewer, an aspect that Ingres's other portraits of women lack. If an awareness of nineteenth-century stereotypes helps us to understand the prominence of sensuality in Ingres's painting, it does not in itself explain that prominence. To be sure, stereotypes overdetermined the discourse of sensuality in representations of Jewish women. But how do we account for this sort of representation in a commissioned society portrait, where, as a rule, sexual excess was entirely inappropriate? We might invoke the large role accorded to exoticism during the Romantic period. Moreover, such stereotypes were part and parcel of the Orientalist language Ingres employed so often and with such barely restrained gusto.

Although the critic Geffroy responded to the portrait's sexual excess, he was careful to couch his reaction in the language of color. "M. Ingres has long possessed all the qualities that make a great portraitist. If he continues, as he has just

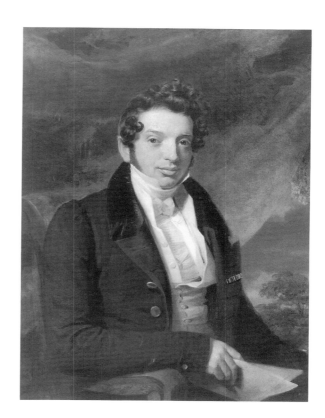

38. Anonymous, *Baron James de Rothschild*. Oil on canvas, 91 × 72 cm. Private collection, New York. Photograph by D. James Dee.

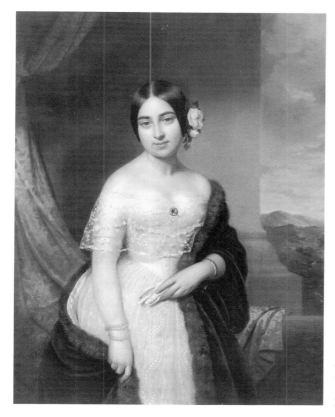

39. Anton Eisle, *Baronne de Koenigswarter*. Oil on canvas, 110 × 86 cm. Private collection, New York. Photograph by D. James Dee.

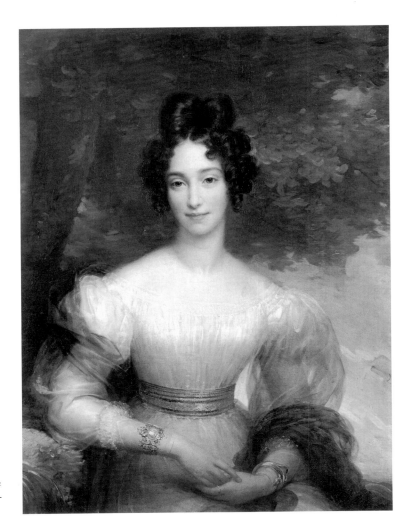

40. Anonymous, *Baronne James de Rothschild.* Oil on canvas, 94.7 × 72 cm. Private collection, New York. Photograph by D. James Dee.

done in the portrait of Mme Rothschild, to add seductive color, his portraits will stand among the most precious monuments of our epoch."[30] For a critic writing for a publication that had many "l'art pour l'art" sympathizers, there was a perfect logic to this reasoning, especially when his touchstone for comparison was Ingres's portrait *M. Bertin* (fig. 47). But "color," as Geffroy employs the term—namely, as an umbrella concept for hue, texture, and ornament—is more than the conceit of a critic whose Romantic leanings led him to discover a new dimension in the doyen of line. Phrases like "this little debauch of color" or "jewels of a thousand colors" or "a most seductive muddle of brilliant fabrics" are formulations of old anti-Semitic stereotypes.

Indeed, Geffroy admired the portrait as much because it embodies stereotypes as because Ingres showed himself to be a sumptuous colorist. While the critic be-

gins by commenting on the overpowering reds in the painting, he continues his appreciation with an unexpected (though never mentioned) anecdote about the sitter's dress. According to Geffroy, the baroness chose to be painted in a blue gown but, after first painting the gown that way, the artist unaccountably changed his mind and made it red. Describing how the new color heats up the general tone of the painting, Geffroy notes that "the blue tints showing through the red and the violets Ingres added to the shadows heighten the richness of the silk." In the end, the critic finds that the new color scheme is integral to the painting's success. His comments are astute: although the color is not likely to have been the same, one has only to think of the *Princesse de Broglie* (1853; Metropolitan Museum of Art) to see how crucial the red is to the tenor of the baroness's portrait. Despite the sensual description of the dress, the portrait of the princess is icy cold. When searching for praiseworthy pedigrees for Ingres's use of color, Geffroy compares the portrait of the baroness to those produced by "the fiery school of Venice." Together with Geffroy's sensuous language, this reference conjures up Gautier's description of that

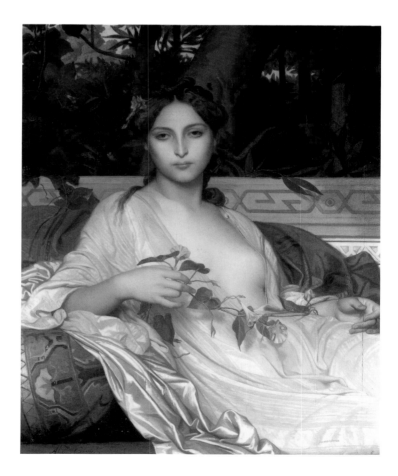

41. Alexandre Cabanel, *Albaydé*, 1848. Oil on canvas, 97 × 78 cm. Musée Fabre, Montpellier. Photograph by Frédéric Jaulmes.

city's Jewish ghetto, where he imagines "Rebeccas and Rachels of a radiant Oriental beauty, embellished with gold and jewels like Hindu idols, seated on the most precious carpets of Smyrna."[31]

This link may be coincidental, but the Orientalist stereotypes in Geffroy's description are not; in fact, they are the foundation for his appreciation of the portrait. "The right arm thrown across her body with abandon," "a head of hair with bluish glints like the wing of a crow," "two large eyebrows *à l'orientale*,"—these elements fall into place as stereotypes of Jewish womanhood. They also account for the critic's obvious delight in viewing this painting: Geffroy's pleasure in the sensuality of the image was as rooted in stereotypes of women in general as it was in ethnic stereotypes. The neat ideological separation between virtuous and unvirtuous women underlying constructions of womenhood in nineteenth-century France initially appears to differ from the conflated Orientalist model operative in most contemporaneous presentations of Jewish women.[32] But this separation is difficult to maintain when one category depends on the other for its very definition. The fact is that sexuality lay at the heart of nineteenth-century definitions of women, whether those categories are dichotomous or fused. In representations of Jewish women, sexual difference was specifically structured by a discourse in which race and ethnicity were intertwined. Not only did this tend to ensure that the discourse of sexuality predominated over that of biblical spirituality, but it also pointed up the relationship between sexuality and control in all representations of women. Withheld or restrained in positive stereotypes, sexuality was unleashed in negative ones—but only so that it could be conquered. In Ingres's *Baronne de Rothschild* contemporary respectable Western woman meets noble biblical heroine, *fille publique* meets *fille exotique.* In Ingres's portrait, ethnic stereotypes are the vehicle for male fantasies of sexual possession. Although minimally counterbalanced by codes of respectability and in general mystified by Ingres's academic style and reputation, the subtext of the discourse of sensuality is the unmistakable availability of women for male pleasure.

Anyone who has looked at Ingres's paintings, and in particular his female portraits, knows that the artist developed a whole set of conventions for highlighting the sensual, including an emphasis on tactile sensations, limp hands, and artfully arranged strands of pearls. But if we compare the *Baronne de Rothschild* to one of Ingres's most sensual portraits, *Mme Rivière* (fig. 42), it is clear that the warm palette and the inclined pose make the *Baronne* a much more accessible image.[33] At the same time, in the context of Ingres's female portraits, Geffroy's assertion that "nothing is sweeter and at the same time more intelligent than this gaze" is undoubtedly correct. The reason is that in the portrait of the *Baronne de Rothschild,* as in other nineteenth-century literary and visual representations of female Jews, spir-

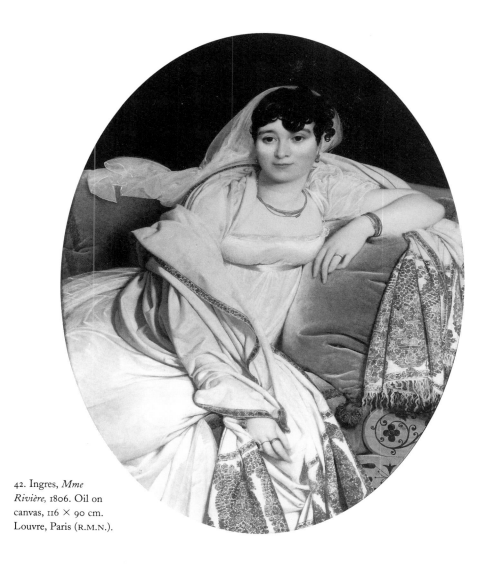

42. Ingres, *Mme Rivière*, 1806. Oil on canvas, 116 × 90 cm. Louvre, Paris (R.M.N.).

itual beauty is conflated with sensual beauty. If the stereotype of spiritual beauty accounts for the critic's reading of intelligence in this portrait, the stereotype of sensual beauty accounts for the warmth, brilliance, and abandon that he finds there. The baroness's Jewishness, with all that it implied in contemporary consciousness, enabled Ingres to push sensuality further than he could in any other society portrait. That the discourse of sensuality should so dramatically dominate Ingres's portrait of a respectable woman is at once a gauge of the power of stereotypes to naturalize difference, a confirmation of the baroness's paradoxically privileged position as twice other, and an exemplar of the ways in which sexuality is the linchpin of gender and ethnicity.

THIS

FLATULENT

HAND:

NINETEENTH-

CENTURY

CRITICISM

When Paul Mantz reviewed Ingres's works at the Exposition Universelle of 1855, his response to the *Grande Odalisque* (fig. 15, plate 2), generally considered to be among the artist's most seductive images, could not have been more different from the hothouse sensuality in L. de Geffroy's description of the *Baronne de Rothschild*:

> The author of *l'Odalisque* has made time and time again figures full of air, round, inflated, that, to use a vulgar comparison, make the mistake of resembling those children's toys, monsters or animals of goldbeaters' skin, light air-balloons that imprisoned air fills from all sides, without concern for form. If one had the patience to examine *l'Odalisque* in this light, one would regretfully conclude, not only that the silhouette of the whole is in questionable taste, but also that the interior drawing is vague, absent, or false.[1]

Like Mantz, other reviewers of this exhibition went well beyond the declaration of Ingres's defects as an artist to outright expressions of revulsion. Charles Laborieu called Ingres "the artist-gravedigger" and remarked that his odalisques "all smell like corpses." Even the *Vénus Anadyomène* (fig. 43), for many Ingres's supreme expression of beauty, was for Laborieu an object of disgust: "[Her] tapering forms seem to come from a meat grinder rather than a brush".[2] The intense physical repugnance registered in Mantz's remarks may initially appear to be diametrically opposed to Geffroy's sensory delight in Ingres's portrait. But, in fact, Geffroy's account also contains expressions of disgust, albeit in a milder form. Although they are so couched in the language of sensuality as to nearly escape notice, the animal similes we noted in Geffroy's paean to the *Baronne de Rothschild* ("a head of hair with bluish glints like the wing of a crow") and in Balzac's description

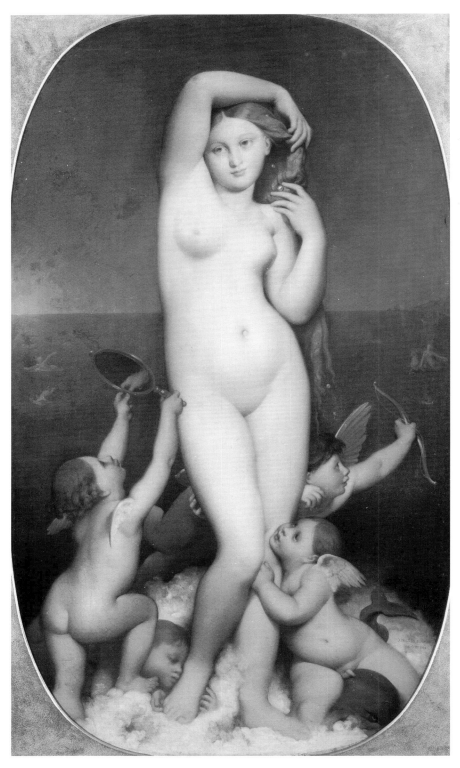

43. Ingres, *Vénus Anadyomène*, 1808 and 1848. Oil on canvas, 164 × 82 cm.
Musée Condé, Chantilly. Lauros-Giraudon. Courtesy Alinari-Scala.

of Judith in *Le Médecin de Campagne* ("black lashes like rats' tails") denote an equal measure of horror, both because of their associations with the unclean and because they confer a sort of hybrid, half-human/half-animal status on the female Jew. While we might be able to dismiss the offensive references to vermin in Geffroy's description of Ingres's portrait as part of a conventional stereotype of the Jewess, this argument hardly would explain why terms of disgust should surface in discussions of such an idealized work as the *Grande Odalisque*.

To explain the horrific associations of a work like the *Grande Odalisque* it is helpful to examine the critical discourse that surrounded Ingres's paintings in the nineteenth century. The complex role of line in sensualized classicism plays a crucial part. At once agent and guaranty of purity, line literally gives form to the neoclassicist agenda for clean and proper bodies. At the same time, it is also the vehicle for the sensual. Inasmuch as the sensual is often linked to deformity, any analysis of Ingres's serpentine line has to take into account the critics' negotiation of the injunction for pure, contained bodies with the sensualized, deformed figures so characteristic of the artist's work. As we shall see, incorporating the sensual into the neoclassical canon could prove difficult even for some of Ingres's staunchest supporters. I want to argue that it is only by acknowledging the reciprocal relationship between pleasure and horror that we can make sense of the critics' responses to Ingres's work and of the intense physical component which often animates them. The horror and pleasure his paintings provoked reveal profound anxieties about the very possibility of representing a pure body. If Ingres's proponents felt the need to distinguish the real from the ideal body, his detractors were concerned with separating the real from the nightmarish imaginary body. But the pronounced visceral nature of both types of responses only makes sense when we recognize their symbolic dimension. Julia Kristeva's influential formulation of abjection is crucial for understanding the powerful fantasies of pleasure and horror shaping both poles of the Ingres criticism. According to Kristeva, abjection is "what disturbs identity, system, order. What does not respect borders, positions, rules. The in-between, the ambiguous, the composite."[3] Perceived as a threat to identity itself, abjection is what the symbolic must reject, cover over, or contain. Not only does it beckon the subject ever closer to its edge, the abject also insists on the subject's necessary relation to death, corporeality, animality, and materiality, concepts intolerable to consciousness and reason. It is in the context of abjection that I will focus on the *Grande Odalisque* and, more specifically, the celebrated extra vertebrae which have become central to the picture's legend.

The critical response to Ingres's work constitutes a remarkable record of aesthetic taste and transition. The *Grande Odalisque* had a decidedly mixed reception when it was first exhibited in 1819 and still produced diametrically opposed re-

sponses as late as 1855, although Ingres's reputation as the leader of the neoclassical school by then was assured. To proponents, the odalisque's attenuated body embodied the most sublime beauty. To detractors, the figure's distortion was so horrific as to conjure up death itself. In the twentieth century, these deformations made Ingres the darling of modernism. In charting the discursive trajectory from the nineteenth century to the present, I intend to restore the centrality of the reciprocal relationship between pleasure and horror to the critical discourse about Ingres's eroticized bodies. It is only by fully understanding that complex, and often contradictory, relationship that feminists can work to subvert equations between sensuality, deformity, bestiality, and the female body.

When the *Grande Odalisque* was originally exhibited at the Salon of 1819, the response of Kératry (the critic credited with first mentioning the odalisque's extra vertebrae) and other critics was generally negative. Ingres was taken to task for moving art back to its infancy and also was criticized for his use of color, described as insipid ("fade"), pale ("blême," "pâle"), and bleached out ("décolorée"), on the one hand, or too stridently of one color, on the other. These qualities were linked to an artistic sect, "les primitifs," a group including several of David's students whose willfully archaic style was born of a particular admiration for Greek vases and the art of the twelfth and thirteenth centuries.[4] There is less unanimity about Ingres's drawing. Some observed that he was an able draftsman; others found his drawing weak overall. Even when critics thought his contours "graceful" or "charming," they often faulted either his modeling, the incorrectness of his forms, or both. More surprising than the negative comments is that there was so little response of any kind.[5]

The sheer volume of critical writing about the Exposition Universelle of 1855 distinguishes it from the Salon of 1819. More than sixty-five reviews of the 1855 exposition discuss the paintings on view and virtually all of them address Ingres's works, many extensively.[6] By this time Ingres was the grand old man of classicism, and his work was frequently compared to that of his professed heroes, Raphael and Phidias. While some critics still referred to the archaism of Ingres's style, the tendency to tie his work to the primitifs was by this time vestigial at best. Ingres's use of color continued to be criticized, but the "one-color" diatribe of 1819 had been replaced by milder charges of "paleness."[7] And though cries of "bizarrerie" still cropped up occasionally, the terms of the debate had shifted from the issues of originality and exaggeration to the viability of classicism itself.

It is important to remember what was at stake for supporters of classicism at this date. Within the context of an exhibition that awarded separate pavilions to Ingres, Delacroix, and Alexandre Decamps (and on the outskirts of which Courbet set up his own Pavillon de réalisme), the overriding question was whether or not

Ingres's art, or even classicism itself, held meaning any longer. It is hardly shocking, then, that the criticism of Ingres was so exaggerated. Ingres's admirers praised his work's "elevation" and "purity" (qualities it was rarely acknowledged to possess when first exhibited), while less enthusiastic critics—Nadar and Baudelaire the most notorious among them—described Ingres's art as overly formal, or so "cold" it reminded them of death.[8] Surprisingly, for the vast majority of Ingres enthusiasts, notions of "élévation" or "pureté de formes" coexisted with *volupté* or grace. Ernest Gebauer's description of the *Grande Odalisque* is typical: "What purity of line! Can one praise sufficiently this graceful pose, these voluptuous contours and this marvelous transparency of flesh in the half-tones?"[9] Guyot de Fère also found Ingres to be "graceful, elegant in his erotic subjects" (among which he noted the *odalisques,* the *baigneuses,* and *Vénus Anadyomène*). "Charming figures with delicate, sweet, and pure forms," de Fère maintained, Ingres's erotic subjects could express nobility and beauty (the head of the *Grande Odalisque*), charm and grace (the *Vénus Anadyomène*), or abandon (*Odalisque with Slave*).[10] Claude Pesquidoux praised Ingres for being "a fanatic and exclusivist worshipper of line and contour" and offered this assessment of the female nudes: "We have more than enough to do in admiring how becoming are the gracious postures, the soft contours, the pure and proper [*correcte*] line, so sweet and melting, of these female bodies."[11]

Such accolades signaled a redefinition of neoclassicism, one in which the eroticized body played a major role. No less crucial a point, they revealed the pivotal role of line in contemporary conceptions of Ingres's sensualized classicism. Ingres's line was described variously as graceful, charming, undulating, or serpentine. Among the sixty-some critics who wrote about Ingres's work on the occasion of the Exposition Universelle of 1855, only two referred specifically to his "serpentine line," and both were avid supporters of the artist. One was the well-known author and effusive Ingres enthusiast Théophile Gautier; the other was a much less familiar critic, Charles-Louis Duval.[12] In each case, the term *serpentine line* was used to describe the *Grande Odalisque,* generally recognized at that time as one of Ingres's masterpieces. Interestingly, the critics set out two very different agendas for serpentine line. For Gautier, the keynote of Ingres's line was its power to sensualize the image; for Duval, it was line's moralizing function. But a polarized reading of these two critics would be somewhat misleading, since they were linked by a central fact: that the sensual had by this date subtly reconfigured neoclassical aesthetics. Even the differences between Gautier and Duval were really differences of emphasis rather than of content. A close reading shows that their descriptive passages have much in common. Both energetically dispute the claims of detractors and are quick to separate Ingres from Romantic tendencies. Both link serpentine line to the "graceful," and both acknowledge the central importance to Ingres's work of the

sensual—Gautier citing its excessive presence, Duval decrying its conspicuous absence.

Gautier's rapturous description of the *Grande Odalisque* (see plate 2) deserves to be cited in full:

> And yet, if ever creature of divine beauty displayed her chaste nudity to the eyes of men unworthy of contemplating her, it is without a doubt the *Grande Odalisque*; nothing more perfect was ever produced by a brush.
>
> Half raised on her elbow buried in pillows, the odalisque, turning her head toward the viewer with a movement full of grace, reveals shoulders of a golden whiteness, *a back in whose supple flesh runs a delicious serpentine line* [my italics], a back and legs whose suavity is of ideal form, feet whose soles have only tread the carpets of Smyrna or the steps of oriental alabaster in the pools of the harem; feet whose toes, seen from above, curve softly, fresh and white as camellia buds, and which seem to be modeled after some ivory statue of Phidias miraculously rediscovered; the other arm, languorously abandoned, floats the length of the contour of the hips, holding in its hand a feathered fan which lets escape, in detaching itself sufficiently from the body to allow virgin breasts of exquisite form to be seen, breasts of a Greek Venus, sculpted by Cleomenes for the temple of Cyprus and transported to the harem of the pasha.[13]

Much like Geffroy's description of the *Baronne de Rothschild,* Gautier's account conveys the overabundant sensuality so characteristic of Orientalist discourse, though without the emphasis on color.[14] His language attests to the seductive power the image had for him. Gautier's response might be taken as one mode of abjection: he is transported by the image, swallowed up by it, even as he asserts its divine beauty and chaste nudity.[15]

Duval's critique could not be more different. Eschewing sensual display, he remarks that color should be avoided in discussing Ingres's odalisques, insisting on the superiority of line:

> One should avoid discussing his *Odalisques* in terms of color for they are conceived in accordance with *the elevated taste of the serpentine line* [my italics], which permits no abrupt contour, no hard opposition in the silhouette of the body, no risqué or awkward movement. A mind so scrupulously applied to the incessant study of exterior beauty can easily dispense with the whims of the palette. . . . Thanks to his hard-working example and to that of his glorious contemporary rivals, we can still understand in France that above all it is important to know how to draw well. The destinies of art are closely tied to this knowledge.[16]

Duval simultaneously asserts that the study of external beauty has no need for the "whims of the palette" and that the destinies of art depend on the ability to draw well. Although these points hardly preclude the appreciation of graceful form so fulsomely subscribed to by Gautier, Duval's emphasis on the moral force of linearity (to the virtual exclusion of its sensual languor) has a certain defensiveness about it. This defensiveness, as we shall see, marks a profound unease with classicism's common configuration of the sensualized body. Duval could be said to exhibit a different mode of abjection from Gautier's, one in which his defensiveness might be taken as a distancing strategy, a means of removing the possibility of threat posed by the sensualized body.[17]

Discomfort with the sensual component of Ingres's art underlay much of the criticism of 1855. I would suggest that this malaise stemmed from the fact that sensuality destabilizes the categorical distinctions between masculine and feminine, real and ideal, and even life and death. But, as the critics will make clear, it is masculinity that is most at risk. What is surprising in the contemporaneous criticism of Ingres's work is that even critics for whom the "elevation" and "purity" of neoclassicism is de rigueur found a way of incorporating that sensualism—often with telltale unease—into the canon of aesthetic virtues. Oddly enough, the aspect of Ingres's bodies about which the critics disagree most is, for want of a better term, their consistency. As we have seen, "softness" is a key concept in Hogarth's equation of serpentine line with feminine beauty. If we also consider Fernow's opposition of the "feminine" to the "boldness and strength of an heroic nature," it is tempting to couple softness with female and hardness with male bodies.[18]

Before we make this leap, however, it is worth recalling that Fernow used the word *feminine* in a passage about Canova's *Perseus*. Indeed, when Fernow laments the dissolution of form and expression in Canova's art, he is virtually blind to sex, if not to gender. His concluding paragraph about Canova's reclining *Cupid and Psyche* (fig. 17) makes it clear that Fernow can just as easily condemn male figures as he can female figures for being "unheroic":

> Both figures are delicately and elegantly formed, though both are too powerless and slender; the faces, as in most of Canova's works of this class, are soft and pretty, but in place of physiognomical expression, present nothing better than that of modern elegance and melting sweetness.[19]

Fernow's description of the figure of Genius in Canova's *Monument to Clement XIII* (fig. 44) goes even further:

> In our day, however, there is never any dearth of amateurs or connoisseurs, who prefer the mellow, the soft, and the melting, to the firm, the severe, and

44. Antonio Canova, figure of Genius in *Monument to Pope Clement XIII*, 1783–92. Marble, 820 × 630 × 254 cm. St. Peter's Cathedral, Rome. © Alinari/Art Resource, New York.

decided—the *fade* and unmeaning, when veiled with superficial charms, to the powerful and the significant; and it need excite little wonder, that many have pronounced this figure a masterpiece of modern sculpture, and account it a happy proof of the delicate refinement of the artist, that his heavenly Genius appears to possess neither bones nor muscles beneath the smooth waxen surface of his body. The exclamation of a French author, "How many modern statues devoid of bones and of nerves only stand out because they are made of stone!" appears particularly appropriate to this genius.[20]

Fernow's overall dissatisfaction may be stronger here because not only is the sex of Genius not clearly defined (not "firm, severe, detached"), it is, by its very nature, indeterminant. In any event, it is clear that soft bodies disturbed Fernow. They disturbed Ingres's critics as well.

Whether the terms *soft* and *melting* are used negatively, as in Fernow's assessment of Canova's figures, or positively, as in Pesquidoux's effusive description of Ingres's female nudes, these characteristics are central to definitions of sensualized classicism. As we have seen in Duval's passage on the *Grande Odalisque,* one crucial

safeguard against the formlessness lurking in the soft and melting was emphasis on line; Ingres's use of history painting was another.

Ingres's historical compositions function as a sort of control mechanism in Guyot de Fère's division of his production into "weighty and austere works" (*Apotheosis of Homer* [fig. 45], *Saint Symphorian* [fig. 46], *Apotheosis of Napoleon, Oedipus*) and "others that seduce and charm" (*Grande Odalisque, Odalisque with Slave, Bather of Valpinçon, Vénus Anadyomène*). Similarly, Debellocq pronounces the large compositions "pure, proper [*correcte*], a little cold," while noting that it is "impossible to find anything softer and more seductive" than the odalisques and bathers. Finally, Gustave Planche remarks that in the *Martyrdom of Saint Symphorian* Ingres "wanted to prove that his exclusive domain was not grace." Planche concludes, "The demonstration is complete."[21]

Yet many critics expressed dissatisfaction with the history compositions, and others felt that the erotic paintings were too erotic. Nowhere was the suggestion that Ingres failed as a history painter more pronounced than in discussions of his *Saint Symphorian*. Though it was lambasted by the critics when it originally was exhibited in 1834, the work was in large part rehabilitated by the Exposition of 1855. Even at that time, however, the painting was not popular with critics. The supposed weaknesses, cited repeatedly, are reminiscent of the failures of Canova's heroic ideal. However, the Ingres criticism does more than reprise the anxieties provoked by sexual difference; it also demonstrates the integral link between sexual difference and the abject in a way that the Canova criticism does not.

The most common complaint about the *Saint Symphorian* at the exposition was that the musculature of the Roman officials was overdeveloped. Nadar observed derisively, "as always, absurd muscular growths and absurd, useless muscles," Du Pays saw "a mad exhibition of musculature in the figures of the two lictors," and Paul Chéron cited "the muscular exaggeration of the lictor."[22] So far, these could be comments about Canova's *Hercules and Lychas* (fig. 31). But in this Ingres criticism the charge of excessive musculature intersects with a host of other complaints that trigger especially visceral responses. Given the rational tone used by most critics, the virulence of these remarks is unexpected at first. Pierre Petroz, for example, couples the shock of the musculature with errors in proportion and an emphasis on details that borders on deformity: "The eye is at first shocked by the prodigious muscular development of the lictors. Their emphatic forms do not effectively conceal odd structural errors. . . . The lictor on the right is not supported by his legs; the shoulder blade of the other is out of all human proportions. Both display such multiplicity of veins, fibers, and details of every sort as to be deformed."[23] Arthur Ponroy describes the *Saint Symphorian* as "a slightly bizarre work" and notes that the muscles of the lictor in the foreground are enumerated

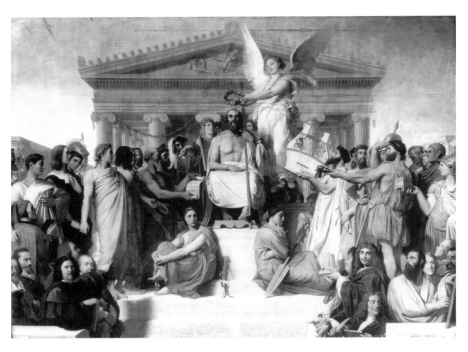

45. Ingres, *Apotheosis of Homer*, 1827. Oil on canvas, 386
× 515 cm. Louvre, Paris (R.M.N.).

with the rigor of a geometer rather than that of an anatomist. Speaking of this figure, he concludes, "But never has soldier and savage had this violet-colored skin, varnished, sponged, and stumped, this robust musculature that resembles anything you please, except living flesh and blood."[24] In his opening remarks on the *Saint Symphorian,* which he dubs "the glory of the French exhibition," Thierry explains that time has rendered obsolete the initial perception of a picture as only a confusion of legs, unequal in length and dented with sinuous muscles. When he observes that the young saint resembles a woman, Thierry suggests that viewers might still experience a form of anatomical confusion, specifically that of sexual identity.[25]

Many of these objections recall Fernow's frustrations with Canova's heroic works. But the complaints voiced by Petroz and Ponroy and Thierry—the observation that a figure's limbs cannot support its weight ("celui de droite ne porte pas sur ses jambes"), the charge that the artist does not capture living flesh and blood ("cette musculature brillante qui ressemble à tout ce qu'on voudra, sauf à une chair vivace et animée par le sang"), mention of the profusion of veins, fibers, and other anatomical details that borders on deformity ("une multiplicité de veines, de fibres, de détails de tout genre qui vont jusqu'à la déformité")—are much more damning than those made by the most severe critics of Canova. Given that only a handful of critics had such extreme responses to Ingres's work, we might be tempted to write

46. Ingres, *Martyrdom of Saint Symphorian*, 1834. Oil on canvas,
407 × 339 cm. Cathedral of Autun. Reproduction courtesy
of Editions Gaud.

them off as the rantings of a fringe group inimical to neoclassicism in any form. But if we look closely, we can see how a certain anxiety crept into the writings of even the most well-disposed of Ingres's critics.

There was, for instance, the Comte de Viel Castel. Although he considered Ingres's cult of the beautiful and elevated to be more pagan than Christian, he applauded the "ravishing chastity" of "voluptuous feeling." At the same time, he hastened to inform readers that the feeling of *volupté* is not the same as the expression of it.[26] Comparing Ingres's "belles odalisques" to Raphael's work, the writer for *Le Coiffeur parisien* found "style, an undefinable grandeur, a feeling of calm and nobility" in the modern paintings. Although he admitted that Ingres could make mistakes, he felt the need to assure his readers that the artist was never vulgar.[27] Finally, Paul Nibelle wrote that Ingres was "proper [*correcte*], avid for purity and the harmonious suppleness of lines," at the same time exclaiming, "what grace and what suppleness . . . what softness." Nonetheless, he noted "a kind of effacement and softness that gets in the way of the energy of the idea, and makes the just appreciation of his oeuvre more difficult than one would think."[28]

Nibelle's qualification echoes a pervasive concern with the formlessness of Ingres's nudes, even when the drawing, anatomy, or other defining frameworks appeared to be faultless. Similarly, the critic G. Pierre remarked, "His anatomy is beyond reproach; but his skin is of a purplish-blue ivory color; neither veins, arteries, nor nervous system lies underneath. His odalisques are cleanly drawn, but they are flat and inert like the figures on Etruscan vases."[29] Here, anxiety about insufficient articulation of the body takes the place of unease about its over-definition. Pierre goes on to compare Ingres's work to that of Gérard and Girodet, artists whom we have already mentioned in the context of anacreontism, though he hesitates to put the author of *Apotheosis of Homer* in the company of those "exhibitors of wax figures."[30] Baudelaire also noted the absence of modeling in Ingres's figures and their resultant formlessness while rehearsing the familiar critiques of the artist's "lifeless flesh" and sometimes only half-human figures: "Let us also remark that carried away by this almost morbid preoccupation with style, the painter often suppresses the modeling or reduces it to invisibility, hoping in this way to give more prominence to the contour, so that the figures give the impression of very correct form at the same time that they are blown up by some soft, inanimate substance, foreign to the human organism."[31] To these complaints, we might add a third familiar one: the *Grande Odalisque* is incapable of standing. According to Georges Niel, "This woman, softly stretched out, at first glance charms the eye. . . . it's only after some time, after repeated examination that one perceives drawing errors incomprehensible from M. Ingres. . . . This reclining woman, who seemed at first so graceful and so beautiful of form, could not stand up because she is so distorted."[32]

Paul Mantz also labeled such defects abnormal and inexplicable, but his discussion of the female nudes does much to show us how these complaints are interwoven:

> Also the structure of M. Ingres's studies of the nude has something abnormal and inexplicable about it. . . . Everyone's seen the little *Odalisque* [*Odalisque with Slave*]. . . . The torso, which is young and delicate, is charming in the top portion of the body; the line is at first seductive and undulating; but it breaks suddenly, it deforms itself and ends as it pleases God. The body of *l'Angélique* [in *Roger Freeing Angelica*] is extremely ungraceful and almost tumescent.[33]

Mantz's choice of language is revealing. What disturbs him about Ingres's female nudes is what is ungraceful, the places where the "seductive and undulating" become "deformed." Not only does Mantz associate Ingres's serpentine line with the "feminine" and childlike (appealing parts of Ingres's bodies are also "young and delicate," "charming"), he makes it clear that the role of line is to reproduce a specific kind of female body. The failure to achieve this ideal is seen as a loss of control that is simultaneously about the breakdown of sexual difference: in the case of the woman in the *Odalisque with Slave* (fig. 34) "it [the line] breaks suddenly, it deforms itself and ends as it pleases God." In *Roger Freeing Angelica* (1819; Louvre) the female body is "almost tumescent." Linked to a swelling more often associated with the male anatomy, this female body is abnormal because *not quite* phallic. With its spectral invocation of impotence, Mantz's comment attests to the masculine anxiety that the anatomical deformations of Ingres's female bodies could evoke. These attenuated bodies, either too hard or too soft, come perilously close to having a power that emasculates. Further on (in the citation with which we opened this chapter) Mantz again suggests the notion of swelling, diseased flesh in a manner recalling the complaints of Pierre and Baudelaire. Likening the figures in Ingres's works to "children's toys, monsters or animals of goldbeaters' skin, light air-balloons that imprisoned air fills from all sides," he concludes that they are "without concern for form." Not only is "the silhouette of the whole . . . in questionable taste" but also "the interior drawing is vague, absent, or false." These comments, along with Laborieu's charge that Ingres was "the artist-gravedigger" whose odalisques "all smell like corpses," combined two themes taken up by other critics: that Ingres's art was a dead(ly) art and that it was comprised of monstrous bodies.

The notion of monstrous bodies in Ingres's work was extended considerably in the writings of Baudelaire, Nadar, and Sand. Like Baudelaire, who described Ingres's figures as "blown up by some soft, inanimate substance, foreign to the human organism," Nadar found something not quite human in Ingres's bodies. His description of Ingres's paintings as "dry and rancid works" is ghoulish enough, but Nadar reserved a special horror for the right hand pictured in *M. Bertin* (fig. 47):

Look especially at the right hand. Look at this fantastic bundle of flesh . . . under which, instead of bone and muscle, there can only be intestines, this flatulent hand whose rumblings I hear! I have dreamed about it, about your horrible hand![34]

Similar physical revulsion characterizes Sand's appraisal of the *Grande Odalisque*:

When I think that I admired, in the infancy of my feeling for the arts, the first odalisque with green outlines and the back of a white bloodsucker . . . I thank God for having opened my eyes . . . for one must be paralytic to fall into such error.[35]

The intense loathing expressed in this critical language—"tapering forms [that] seem to come from a meat grinder," "the back of a white bloodsucker," "this flatulent hand . . . whose rumblings I hear!"—seems unwarranted. It is only through the notion of the abject, which attempts both to name recurring forms of horror and to provide a rationale for their existence, that we can begin to comprehend the horrified responses of these critics. It is the physical dimension of the abject, with its blurring of inside and outside, that animates these critiques. Nadar's terror of being struck down in nervous fits by the hand of *Bertin*, with its gurgling intestines that traumatized him even in sleep, must otherwise be dismissed as aberrant. But Kristeva catalogues a similar revulsion: "Loathing an item of food, a piece of filth, waste, or dung. The spasms and vomiting that protect me. The repugnance, the retching that thrusts me to the side and turns me away from defilement, sewage, and muck."[36] This physical dimension of the abject helps not only to explain the visceral disgust in the Ingres criticism but also to illuminate the repeated references to death. The specter of the corpse—of death in life—lurks behind much of the Ingres criticism. It haunts Baudelaire's description of "figures . . . blown up by some soft, inanimate substance, foreign to the human organism," Ponroy's "robust musculature that resembles anything you please, except living flesh and blood," and Laborieu's "odalisques [who] recall the female waxworks in Curtius's old salon and who all smell like corpses." In Kristeva's somewhat phantasmic description, the corpse represents "the utmost of abjection" for "it is death infecting life. Abject. It is something rejected from which one does not part, from which one does not protect oneself as from an object. Imaginary uncanniness and real threat, it beckons to us and ends up engulfing us." The corpse is intolerable because it shifts the border between life and death into life itself.[37]

As the creator of these images, Ingres himself came to embody the threat of death. "Should it be surprising that we think of death when we are face to face with M. Ingres, the enemy of life, M. Ingres, the artist-gravedigger!" wrote Laborieu. Mantz, chronicling Ingres's weaknesses as an artist, predicted that "poster-

47. Ingres, *M. Bertin*, 1832. Oil on canvas, 116 × 96 cm.
Louvre, Paris (R.M.N.).

ity . . . will not forgive M. Ingres . . . this persistent fright of everything which stands for life, movement, and passion." "It [posterity] . . . will study—with intellectual curiosity, but never with heartfelt sympathy—the unique genius of this master" but "will distance itself from an oeuvre which the large wings of death seem to cover with their sad shadow." Finally, Nadar provided the most memorable formulation of Mantz's view that Ingres's art was cold and lifeless when he described Ingres as "a painter whose chilliness hatches polar bears."[38]

In the most obvious sense, these charges of "coldness" registered an active dissatisfaction with neoclassicism. Time and again, the critics took umbrage at Ingres's eschewal of the real, his notion of the ideal body, or his promotion of a neoclassical style that to their minds was cobbled together from a mix of historical and equally obsolete artistic precedents. For many critics, classicism, when compared to either Romanticism or realism, was dead. But this hardly explains the horror associated with Ingres's "froideur," and the threat of literal death often associated with neoclassicism.

The critics who likened Ingres's pale odalisques to waxworks referred to a visual tradition familiar to every one of their readers, one whose aura of horror might be said to surpass the language of even Ingres's most outraged detractors. Public fascination with waxworks goes back at least to the Revolutionary period, when they were displayed in anatomy cabinets.[39] The focus on the female body in the displays from the eighteenth and nineteenth century is most interesting, particularly the emphasis on reproductive functions, which required the exhibits to show both the exterior and interior of the body. In these anatomical cabinets and pathological museums, one could view the female body in various stages of pregnancy, illustrating potential problems with delivery, or documenting the diseased conditions of reproductive organs. The wax bodies at the Musée Dupuytren, for example, were known for their removable organs and often represented suffering from maladies so disgusting that they ought to have remained secret.[40]

The peculiar history of waxworks in Paris also suggests the powerful links between death and sensuality that were evoked in popular culture at the time by representations of the real human body. When Laborieu describes Ingres's odalisques, he likens them specifically to the female waxworks in Curtius's Salon. ("Neither will we deal with those odalisques that recall the female waxworks in Curtius's old salon and all smell like corpses"—see, for example, fig. 48.)[41] If Curtius is little known today, a hint of his contemporary renown can be gleaned from the knowledge that he was the "uncle" and teacher of the famous wax modeler Madame Tussaud (1761–1850).[42] A physician turned wax modeler, Philippe Guillaume Mathé Curtius (d. 1794) exhibited his *salon de cire,* a collection of "waxen coloured figures of celebrated characters in all stations of life," at the Palais Royal in 1770

48. Philippe Curtius, *Sleeping Beauty*. Wax and pigment,
life size. Courtesy of Mme Tussaud's, London.

(fig. 49). His success was immediate: in addition to the throngs that flocked regularly to the fashionable gardens, the exhibition attracted tourists and royal families from France and abroad. Among his most famous works was a life-size tableau titled "The Royal Family at Dinner." Curtius's work (upon which Marie Grosholtz, later Madame Tussaud, collaborated from as early as 1778) included as subjects not only the wealthy and noble but also intellectual leaders of the Enlightenment. The salon de cire, however, is only part of the story.

In 1783 Curtius established another exhibition space, the so-called *caverne des grands voleurs,* on the boulevard du Temple, a thoroughfare in the increasingly popular entertainment district. Aware of the public's inexhaustible fascination with crime and punishment, Curtius felt that many would welcome the chance to see wax images of the notorious, whose features he would record either before or after their deaths. So correct was his intuition that people fought to get into his cham-

49. *Sallon de Curtius.* Engraving,
10 × 6.5 cm. plate. Bibliothèque
Nationale, Paris.

ber of horrors.[43] By the mid-1780s Curtius consolidated the two collections, moving the salon de cire next to the caverne.

Laborieu was probably thinking about the disturbing mixture of the sensual and the dead when he evoked the salon Curtius in his criticism of Ingres's odalisques. In the late eighteenth century, viewers could open and view the insides of the figure of Thisbe in Curtius's tableau of Pyramus and Thisbe. For an extra fee, they could look under the clothing of Zuleima, a famous seventeenth-century courtesan modeled in wax and covered with human skin. It also was reported that Curtius had a profitable sideline making small groups of licentious figures to decorate aristocratic boudoirs.[44] But it is particularly in the context of the caverne that Laborieu's frequent references to death make sense. When the critic remarks that Ingres's odalisques "all smell like corpses," he evokes not only corpses whose names and crimes have long since been forgotten but the entire cast of persons executed during the French Revolution. In the minds of their contemporaries, Curtius, Tussaud, and their works were as irrevocably tied to the history of the French Revolution and its aftermath as were the paintings of David. It is only by examining the ghoulish relationship between art and life as it played itself out in Curtius's

productions during the Revolution and Terror that we can grasp the visual horror that Laborieu's comments would have communicated to viewers.[45]

The first reported incident in which Curtius's waxworks served revolutionary ends occurred on July 12, 1789, when a crowd, angered by the dismissal of Necker and a rumor that the popular Duc d'Orléans was to be exiled, arrived at Curtius's door demanding the wax busts of these wronged individuals (figs. 50, 51). Mounted on pikes, the heads were paraded through the streets until royal troops opened fire, killing some protesters and wounding others. Shortly after this melee, a demonstrator returned the bust of the duke, only slightly damaged. Six days later, a guard in the Palais Royal gardens found the bust of Necker with its hair burned and its face slashed with sabre marks.

Subsequently Grosholtz or Curtius purportedly took death masks of guillotined heads by order of the National Assembly. Grosholtz was bid in secret to take masks of the king and queen at the Cemetery of the Madeleine (fig. 52). She took a death mask of the assassinated Marat while he was still in the tub where he died (fig. 53).[46] Curtius modeled a tableau of Deputy Lepeletier at the table where his dining was definitively interrupted. These grizzly records of retribution were displayed in the caverne. Sometimes, as was the case with Robespierre, a portrait had to be removed from the salon de cire and redone for the caverne. The pace of events made updating de rigueur.

When Curtius died in 1794 the role of keeping alive his legacy fell to Grosholtz, as did the challenge of maintaining its popularity in a postrevolutionary world. Although she had added portrait figures of the new government leaders during the Directory and in 1801 was commissioned by Josephine to make a portrait in wax of Napoleon, Madame Tussaud set sail in November 1802 for England, where she eventually established her famous London emporium. According to Tussaud, the appetite in England for recent French history was greater than in France.

The comparison to waxworks also helps us to understand the peculiar blend of fascination and horror elicited by sensualized classicism, and by Ingres's paintings in particular. When Pierre describes the *Grande Odalisque* as "a waxwork that is only perverse by intention,"[47] he appears to distinguish it from actual waxworks, implying that they, by contrast, are perverse in and of themselves. What he had in mind can perhaps be elucidated by the French scholar Marie-Hélène Huet, who skillfully identifies the strange movement between life and death as part of the attraction of wax models.

> The perversion inherent in Madame Tussaud's peculiar art . . . is that this art imitates death and that the product of this imitation of death is an imitation of life. . . . Yet this imitation of life is strange only because of the accompanying

50. *Morning of July 12, 1789.* Engraving with aquatint, 15.3 × 10.2 cm. plate. Bibliothèque Nationale, Paris.

51. *Busts of M. D'Orléans and Necker carried to Place Louis XV, July 12, 1789.*
Engraving, 13 × 19.5 cm. plate. Bibliothèque Nationale, Paris, De Vinck Collection.

certainty that one is seeing nothing but an imitation. In the Chamber of the Dead, the illusion of life never brings the dead back to life. On the contrary, one could say of Madame Tussaud that she brings the dead back to death.[48]

In Pierre's formulation, instead of bring the dead back to death, Ingres, who painted the *Grande Odalisque* from a live model, might be said to have created death from life.

The passage immediately following Pierre's charge of perversion is also revealing: "In truth, I do not know in what unheard-of nature the school of Gérard and Girodet have observed reality; in what insipid nightmare they have imperfectly perceived the ideal; but I confess I have never encountered in the most scandalous orgies of romanticism aberrations more notorious, more topical, and more quivering than in this colorless image that is supposed to represent Cupid and Psyche."[49] Pierre finds something so obscene in the works of Gérard and Girodet that he hesitates to compare Ingres to these artists. Yet, in spite of his reservations, Pierre is forced to conclude that Gérard's *Cupid and Psyche* (fig. 54) was the inspiration for Ingres's *Grande Odalisque*. The coupling of waxworks with these two paintings suggests Pierre's hearty distaste for the soft and dangerously fluid bodies so characteristic of sensualized classicism. But his references—to the horror of the "notorious," the "topical," the "quivering," and the "colorless"—are far more specific than a generic horror of the formless and can only be understood in light of the way in which waxworks could both fascinate and horrify their viewers.

The comparison also helps to explain the surprise of a critic like Georges Niel. Looking carefully at the *Grande Odalisque*, Niel discovered that "this woman, softly stretched out," suffered from inconceivable errors in drawing. "This reclining woman, who seemed at first so graceful and so beautiful of form, could not stand up because she is so distorted."[50] Niel's initial perceptions were suddenly reversed by something unexpected and disturbing. Much the same thing happens when a viewer mistakes a wax figure for a human being, only to discover that what seemed alive is actually inanimate. The psychoanalyst Ernst Jentsch addressed this phenomenon in his analysis of Freud's concept of the uncanny:

> The disagreeable impression easily aroused in many people upon visiting wax-museums, wax-works, and panoramas is well-known. It is often difficult, especially in the half-darkness, to distinguish a life-size wax figure or similar figure from a person. Such a figure, for some impressionable individuals, has the power to prolong their discomfort, even after they have decided whether or not the figure is animated. It is probably a matter here of a half-conscious secondary doubt, automatically and repeatedly provoked by the renewed examination and

52. Philippe Curtius or Mme Tussaud, *Heads of Louis XVI and Marie-Antoinette*. Wax and pigment, life-size. Courtesy of Mme Tussaud's, London.

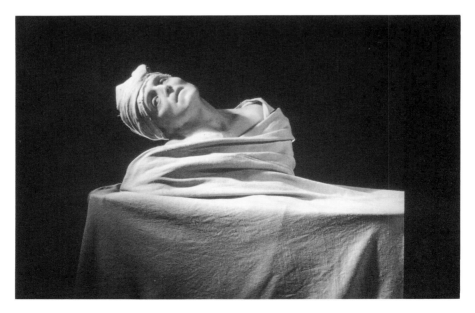

53. Philippe Curtius or Mme Tussaud, *Death of Marat*. Wax and pigment, life-size. Courtesy of Mme Tussaud's, London.

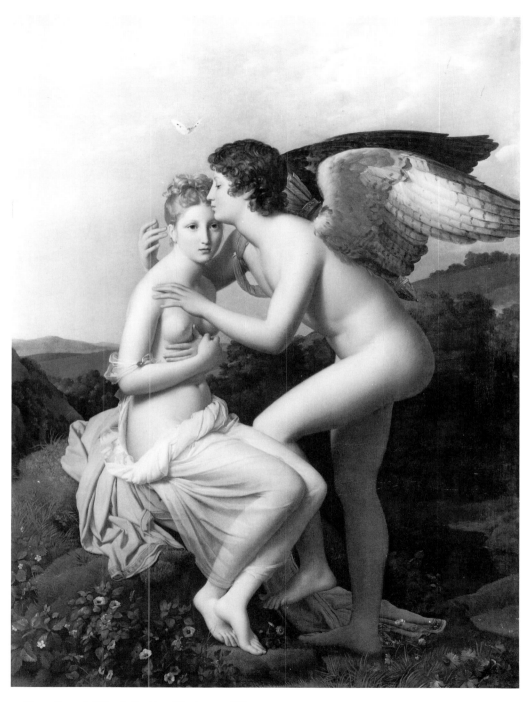

54. Baron François Gérard, *Cupid and Psyche,* 1799. Oil on canvas,
186 × 132 cm. Louvre, Paris (R.M.N.).

observation of the finer details, or perhaps it is only a vivid after-vibration of the recollection of the initial painful impression.[51]

If waxworks have the power to discomfit by producing uncertainty about the real, Ingres's *Grande Odalisque* might be said to produce a similar unease by calling into question the ideal.

One of the immediate effects of the French Revolution was to render virtually impossible the representation of heroic male bodies, which had been given such indelible form in David's famous canvases of the 1780s. The change in David's own art—the Directory portraits as opposed to those of the revolutionary period, the *Sabines* as opposed to the *Horatii*—and the preference for otium over negotium of his followers bear witness to this difficulty. The heroic ideal was reborn with some success in images produced during the Napoleonic period, but its embodiment in neoclassical form was short-lived.

Ingres's odalisques might be said to continue the impulse to value otium over negotium. They bear all the signs of the mythological nudes of the 1790s and they reap much of the criticism previously reserved for Canova's insufficiently heroic male figures. But much like Fernow's frustration with what he perceived to be Canova's failure to represent the heroic, the disgust of Ingres's most virulent critics was applied equally to female and male, mythological and heroic bodies. If the odalisques elicited abjection for some, for others it was summoned by the overmuscled lictors surrounding Saint Symphorian and by the formless hands of that otherwise solid embodiment of the bourgeoisie, M. Bertin. At issue here was a profound crisis of confidence concerning the representation of the male body, an anxiety promoted by bodies that were either too soft or too hard, no matter what their sex. In sum, we find two different modes of horror elicited by Ingres's bodies, the threateningly seductive or the just plain threatening.[52]

Petroz's writings make these points clear. His dissatisfaction was provoked by both the overmuscled figures in the *Saint Symphorian* and the body of Paolo (in *Paolo and Francesca*), whom he described as "the lover who is stretched out and deboned with a passionate languor."[53] Although in these two cases Petroz was criticizing male bodies, he adopted an oppositional strategy more often used to differentiate the male figure from an other. As an example of masculine anxiety, Petroz's reference to a body that is "deboned," or not erect, suggests in an especially vivid way that definitions of the masculine lie at the heart of binary thought. A similar point can be made about the instability of binary oppositions in two themes that are gendered female in these criticisms. Both are outgrowths of the loss of clarity about representing the male neoclassical body: the first, a heightened anxiety about the sensual; the second, the preoccupation with death. These two themes are intertwined, and their relation would have been unthinkable without the ways

in which conceptions of the hero (and, by extension, neoclassicism itself) were tainted by associations with revolutionary violence.

The association of sensuality and death, unquestionably one of the most dramatic expressions of the abject in the Ingres criticism, finds its clearest formulation in Pierre's and Laborieu's comparisons of Ingres's odalisques to waxworks. It should not be overlooked that Pierre's disparaging comments were not reserved for the odalisques alone but were applied equally to pernicious precursors like Gérard's *Cupid and Psyche.* Even if abjection was more often elicited by female, rather than male, bodies, it is crucial to notice that Pierre singled out for criticism precisely those works that most clearly embodied sensualized classicism. More than once, Ingres's odalisques were described as "erotic subjects," a label clearly meant to reestablish binary oppositions.[54] But the dissatisfaction with Ingres's bodies signaled a loss of confidence in any sort of generative stable term against which binary oppositions could be defined. As the oppositional strategies of both the Ingres and the Canova criticism made abundantly clear, in gendered terms, the missing stable term would have been *masculine.*

If abjection was not identified with the female body per se, neither was it identified solely with the eroticized body. Nadar's horror of the hand in *Bertin* and Petroz's shock at the extreme muscular development of the lictors demonstrate that the formless or deformed body conjured up abjection as well. In the eyes of some critics, then, Ingres's bodies—either too muscled or too soft—violated notions of both the feminine and the masculine. At the core of such criticism, I would argue, was a persistent unease with the female body as well as the rather profound crisis of confidence in representations of the male body. Repeatedly, artists like Ingres and Canova, whose works were the classical canon, failed convincingly to represent the heroic male body.[55] What they depicted was either so exaggeratedly masculine as to be unbelievable or so closely allied with the sensual as to threaten masculinity. When we add to this anxiety the disturbing association with waxworks, and with Curtius's caverne des grands voleurs in particular, Ingres's bodies could not fail to provoke the most intense and visceral horror. They did so in ways that make clear the problems inherent in representing a heroic male body within a neoclassical vocabulary after the Revolution and demonstrate how the sensualized body was apt to stand for everything that threatened order, reason, control—in short, the tenets of Western civilization. Through invocations of the moral force of line or by intense expressions of horror, Ingres's critics attempted to stave off the threat of absorption posed by the all-too-fluid boundaries distinguishing masculinity from femininity, the ideal from the sensual, and life from death. Their responses make it clear that, like abjection itself, Ingres's serpentine line could elicit both fear and reassurance, precisely because of its associations with the sensual, the soft, the formless, and the feminine.[56]

HALF

OCTOPUS,

HALF

TROPICAL

FLOWER:

MODERNIST

CRITICISM

The vehement responses to Ingres's anatomical distortions in 1855 were comparatively rare. Far more common was praise for Ingres's eroticized bodies as the perfect embodiment of ideal beauty with no mention whatsoever of distortion.[1] By contrast, the artist's distortions constantly are invoked in twentieth-century writings as the mark of his achievement. These differences make clear how the abject body, which so thoroughly disgusted certain critics in the nineteenth century, in the twentieth century becomes the abstract body.

Twentieth-century critics actually share the notion that the sensualized body—that is, the formless or deformed body—is horrific. Both posit an ideal that eschews any excessive notion of the sensual or the real. But rather than adopt the nineteenth century's dual unease over the insufficient or oversufficient articulation of Ingres's bodies, critical language in this century stages a creative battle between intellect and feeling. Much like earlier Ingres enthusiasts who invoked the purity of the artist's style in order to disclaim any charges of untowardness, these more recent critics legitimate the representation of a horrific body by invoking the artist's formal invention, next to which the real pales. While in the nineteenth century the sensual was incorporated—with some misgivings—into the classical canon, in the twentieth, deformation was integral to modernism. In fact, it is Ingres's profanation of anatomy (the term is André Lhote's) that at once separates Ingres from the Academy and makes him the first modernist. An analysis of the critical strategies of twentieth-century writers is crucial for theorizing any notion of women's pleasure. For not only does this discourse tame the abject so effectively as to make it imperceptible to anyone unfamiliar with its history, it also, through notions of

transcendence, masks assumptions that pleasure in looking is a male prerogative.

Maurice Denis was probably the first critic to champion Ingres as a modernist and as a model for early twentieth-century painters. In 1902, Denis touted Ingres's "truly French qualities of precision and clarity."[2] But it was not until the 1920s, amidst the efflorescence of classicism following World War I, that the notion of Ingres as the first artist to express a "modern sensibility" was fully elaborated. The principal advocates for this position were the critics André Lhote and Roger Bissière. They took great pains to explain what was modern about Ingres, and they also sought to link him to an emerging canon of art-historical precedents for modernism. Thus, Lhote referred to Ingres as "the first cubist-impressionist." Lhote's "Ingres-Cézanne-Cubism filiation" included stops along the way for Courbet, Manet, Monet and the Impressionists, the Post-Impressionists and Neo-Impressionists, whose art, he claimed, culminated in the "austere violence of the new painters" (that is, the Cubists).[3] For Bissière, Ingres's great achievement was that he was the first of his generation to view a painting as a world unto itself. "Ingres, one of the first perhaps among the moderns and the only one of his generation, had the presentiment that a painting is a finite world having its own laws and life independent of imitation, a plastic construction . . . it mistrusts empiricism. . . . Its doctrine is already based on feeling."[4] As Bissière's last comment suggests, "feeling," as opposed to painstaking transcription, enables the creation of a painting based solely on formal laws and internal representational means. Feeling, for him (as well as for Lhote and Denis), was another name for the sensual, and was often contrasted to the precision and clarity that Denis had termed "national characteristics" of France. This by now familiar binary opposition between sensuality and precision was often constructed from language that signaled the simultaneous attraction and threat of the sensual. At the same time, these terms reveal the close links between sensuality and deformity.

When Bissière says that Ingres's doctrine is based on "sensation," for example, he quickly qualifies this remark by emphasizing that Ingres's work is cold.

For us what one has called Ingres's coldness is precisely his greatest virtue . . . because . . . everyone who strove for spiritual ends, everyone having the classical spirit, absolutely did not want to be slaves to their emotions and was conscious, on the contrary, of being strong enough to be dominated without being diminished. . . . What the detractors of Ingres call coldness we call purity. . . . His sensuality [is] completely cerebral.

. . . it [his art] would never have touched us so deeply if its moral value had been smaller.[5]

Here Bissière evokes the artist's purity, with its reassuring complement of moral values, as the seal of approval for the sensuality in his work. Lhote makes a similar point when he speaks of the combination of intelligence and instinct in Ingres's work. The very specific vocabulary that Lhote employs highlights binary oppositions. Structural terms like "mental architectures" or "constructive line" could not be more different from phrases like "voluptuous waves" or "the bubbling up of the spring" (which he opposes to "the calm of the estuary").[6]

But most revealing for our discussion are Lhote's extensive references to the *Grande Odalisque* (fig. 15; plate 2), for these enable us to see, in a particularly vivid way, the interdependence between modernism and deformation. For Lhote, the *Grande Odalisque* best embodies Ingres's modernist sensibility. He cites as proof the outrage provoked by the painting when it was first shown—a disturbance that Lhote attributes to the work's anatomical deformations. These brazen distortions simultaneously separate Ingres from the Academy and establish him as a modernist: "This nude, who appears so classical to us today that everything in it seems marvelously natural, possesses, in the eyes of professional critics, among other defects, two too many vertebrae, and a breast unreasonably placed under her arm! Here is anatomy profaned, this sacred science, this keystone in the vault of the temple of decadent academicism."[7]

In Lhote's mind, the painter's deformations were motivated by a violent love of nature. He tells us that, confronted with the nude model, Ingres simply lost his head.

> This flesh with such amiable swellings, with such voluptuous undulations, he can no longer dissect it with the tip of his pencil as if it were the end of a scalpel; it is she . . . who will enter into him, victoriously, and transform his scientific conception of the human body into a purely palpable one. From then on the exact number of vertebrae will matter little to him. Anatomical truth no longer exists, if that truth is in opposition to the feeling that the body before his eyes gives him. This adorable curve of the back, so flowing, so supple, so long, he will lengthen still further, in spite of himself, to make even clearer to others the confusion that she inspires in him. He will deform; what his body *has just learned* will enter into contradiction with what his intellect *knows.*[8]

In this passage Lhote advances the somewhat fanciful notion that distortions were directly inspired by contact with living flesh—significantly, with female flesh. The creative process in this case is like intercourse itself. Of course, Lhote is careful to protect the pronounced sensuality in Ingres's work from charges of untowardness, or even of immorality, through references to the artist's "elevated intellect": "One

has discussed his sensuality which, according to certain descriptions, borders on bestiality. This sensuality, undeniable, moreover, which could have pushed a less elevated intellect toward a realism of a bad kind, becomes wonderful in Ingres."[9]

In opposing knowledge and feeling, Lhote demonstrates the necessity for their coexistence and the difficulty of being true to one without being false to the other: "Should he [Ingres] correct these errors? If he again expresses what he knows about things, isn't he going to be untrue to his feelings?" What's more, Lhote sees this as a distinctly modern quandary ("a painful dilemma, unknown by the Primitive and the Renaissance artists, but singularly frequent in the work of certain modern artists"), which forces them to vanquish the sensual rather than to glorify it.[10] As Lhote's description makes glaringly clear, the denouement of the artist's creative process—even with its central drama of its encounter with the sensual—is the triumph of the intellect. Ingres's invented forms, those distorted bodies that seem more real than the models themselves, are for Lhote a necessary assertion of binary thought.

> This naive confusion that makes the hand run off the line, and makes from objects a different figure from their subject, isn't this the most beautiful homage an artist can make to what he studies? Isn't this still "nature", this form that man invents through his contact with it? And this invention, isn't it the unique truth, in short?
>
> If one grants such liberties to the artist. . . . He must become intelligent again after having only responded to feeling; become an organizing will again after having only been a recording instrument . . . in a word, substitute, voluntarily, this time, the plastic signs of his feeling for the signs literally representative of a discriminating analysis.[11]

As an example, Lhote discusses Thetis's famous boneless arm, claiming that in this passage Ingres has captured the figure's "essential form" (fig. 57). In other words, deformation not only serves to represent Thetis's true form—that is, the formless—but to master what Lhote elsewhere terms "pure feeling". "This is not an arm as it is in reality, with its folds, its angles and the confused mass of its veins and muscles. It is an invented form, a warm and sinuous thing, made to be caressed and sensually enveloped." Ingres's work affords an extreme pleasure for the viewer. "The pleasure that the imagination experiences in this game is violent, and it is difficult to resist the desire to cultivate this unknown universe." The notion of violent pleasure invoked here seems to allude to the physiognomical distortions in Ingres's works, but it also suggests that violence inheres in the very process of creating the sensualized body.[12]

In the *Grande Odalisque,* deformation, sensuality, and modernism all come together, played out across the female body. The highpoint of Ingres's achievement in this picture, according to Lhote, is the fact that it contains nothing that is not of the artist's own invention: "There is not one form in this figure that is not invented; it is improbable from one end to the other. . . . There is not one line that coincides with the natural form, which appears completely thick by comparison. Just analyzing the face of the *Odalisque,* I experience a limitless pleasure in ascertaining the mixture of violence and deference of which it is the product." The artist has so improved upon nature that the model looks "thick" by comparison. Ingres has taken the "sacred confusion" of nature and made of it a more perfect fantasy body. And, as Lhote makes clear, it is this capacity for deformation that underpins the Cubists' admiration for Ingres. More important, though, Lhote considers such deformation imperative. "Expressive deformation, based on feeling, has become necessary again, and this is why the new painters have elected as supreme master the greatest of realist contortionists, the painter of the Odalisque with two too many vertebrae." Small wonder then that the extra vertebrae of the *Grande Odalisque* have been canonized. Not only do these early twentieth-century writers, and Lhote in particular, reinvent Ingres as a modernist, they make deformation integral to the modernist canon.[13]

The very fact that Lhote takes pains to separate Ingres's anatomical deformations from bestiality, however, suggests a threat; the abject lingers in the wings. It is left to Maurice Denis to *link* Ingres's work with bestiality. In doing so, Denis repeats Odilon Redon's remark to the effect that distortion is not necessarily gendered (which provides a nice counterweight to Lhote's proclivity to associate deformation with the sensualized female body). Describing the figure of Paolo in *Paolo and Francesca* (fig. 26), Redon had said, "[He] clasps her in his arms with an intrepid and geometrical movement like a crab seizing its prey: But it is Ingres who has made monsters!"[14] By evoking Redon's claim that Ingres made monsters, Denis also recalled the writings of Baudelaire, Sand, and Nadar. The violent language they share with Redon is at odds with the way the abject most often has been expressed by twentieth-century writers, whose metaphors from the natural and animal world are seemingly pleasant. Their tendency to lovingly highlight the sensual components of the female body should give pause, however. By seeming to banish violence and bestiality, these authors threaten to make these critical components of the abject disappear entirely. Inasmuch as the difficult symbiosis of pleasure and repulsion at the heart of abjection is linked to a system of power relations, both pleasure and repulsion need to inform any feminist agenda for representing the female body. With this in mind, it is all the more important to examine how later twentieth-century writers domesticate the abject.

It is in Kenneth Clark's classic text *The Nude: A Study in Ideal Form*, which has done so much to emphasize formal issues over extra-aesthetic ones, that we first find the critical language that not only sensualizes but also tames the abject. In attempting to explain Ingres's distortions by recourse to the artist's psyche, Clark also introduces another strategy for subduing the abject. Although not published until 1956, Clark's text has much in common with early twentieth-century writings about Ingres. In constructing his history of the nude, Clark asserts that since the seventeenth century the female nude has been considered "a more normal and appealing subject [for artists] than the male," and, moreover, that the principal function of representations of the nude is to mitigate physical desire.[15] In reaching these bold conclusions, Clark sets up an opposition between the celestial and the vulgar, reminiscent of Lhote's battle between knowledge and feeling. "Since the earliest times the obsessive, unreasonable nature of physical desire has sought relief in images, and to give these images a form by which Venus may cease to be vulgar and become celestial has been one of the recurring aims of European art" (71). This conception of the two Venuses derives from Plato, who in the *Symposium* has a guest propose that there were two Aphrodites—one celestial, one vulgar (Plato uses the terms "crystalline" and "vegetable"). Clark points out that this dichotomy became axiomatic in medieval and Renaissance philosophy and that even to this day the two types have not disappeared, although the distinction between them has grown very slight.

While Clark never specifies his criteria for determining what constitutes a successful nude, his own disposition for the celestial and the concomitant need to assert ideal form over base matter emerge as central concerns. Nonetheless, Clark encounters difficulties in balancing these oppositional terms. In his discussion of Leonardo's *Leda*, for example, he suggests that a nude could be rendered unattractive if the intellect figured too prominently (120).[16] As the sole analogue to this work from the European tradition, Clark cites Ingres's *Turkish Bath* (fig. 56). But, implies Clark, Ingres's figures escape the fate of *Leda*: "Even at eighty-two Ingres felt the tug of physical desire, which makes his Hindu contortions both more and less disquieting!" (120). Clark makes explicit the idea that the key to Ingres's art is this tug of war between form and sensuality. "He [Ingres] recognized that he must reconcile his insatiable appetite for particularity with an ideal of classical beauty, and his greatness as a delineator of the nude could be described, in modern jargon, as a tension between the two" (154). By casting this battle in aesthetic terms, Clark obscures the deep psychic investment in the need to control representations of the female body. Furthermore, he adopts one of the most prevalent strategies to be found in recent writings about Ingres's works: the displacement of the distortions onto the artist's psyche.

Clark's discussion of the *Grande Odalisque,* while brief, is significant. Describing it as "the most uncompromisingly personal, and for this reason, the least classical" (157) among Ingres's earlier works, Clark implicitly holds it up for comparison with the *Bather of Valpinçon* (fig. 55). Although the *Grande Odalisque* does not emerge the stronger from this comparison, Clark does not condemn its distortions. Yet, Clark's clear preference is for the *Bather of Valpinçon,* his favorite among Ingres's productions: "Of all his works it is the most calmly satisfying and best exemplifies his notion of beauty as something large, simple, and continuous, enclosed and amplified by an unbroken outline" (154). Indeed, without the virtual replication of this seated figure, Clark contends, the *Turkish Bath* risks becoming a demonstration of raw feeling, for, in that painting, Ingres "has at last felt free to release his feelings," and

all that was implied in the hand of Thetis or the sole of the odalisque's foot is now openly attributed to thighs, breasts, and luxurious *déhanchements.* The result is almost suffocating; but in the middle of this whirlpool of carnality is his old symbol of peaceful fulfillment, the back of the *Baigneuse de Valpinçon.* Without her tranquil form, the whole composition might have made us feel slightly seasick. (169–70)

In underlining the need for control in representations of the female nude ("his [Ingres's] notion of beauty as something large, simple, and continuous, enclosed and amplified by an unbroken outline"), Clark makes it clear that there is a crucial distinction between the pleasurable and the obscene, a distinction predicated on gendered binary assumptions.[17]

Clark's discussions of Ingres and the School of Fontainebleau, of which the *Grande Odalisque,* he says, "could, indeed, be claimed as the culminating work," reveal a rather complex series of attitudes. Despite his apparent discomfort with the distorted anatomies in the *Turkish Bath,* Clark obviously finds something compelling about the reference to physical desire. Clark similarly is fascinated by an elusiveness he finds in the "exquisite ladies of Fontainebleau," who escape definition as either celestial or vulgar. "Their very strangeness of proportion," he says, "seems to invite erotic fantasies, for which the substantial bodies of Titian leave less opportunity" (139). In linking deformation to the erotic, such passages help us understand the peculiar admixture of attraction and discomfort voiced by critics in response to Ingres's distortions. They also reveal the inherent instability of the binary oppositions that Clark is at such pains to maintain.

Perhaps the most extreme example of the distinctive mixture of sensuality and formalism, eroticism and abjection, that Clark finds in Ingres's work, and the binary framework that he imposes on it, appears in Clark's brief analysis of *Jupiter*

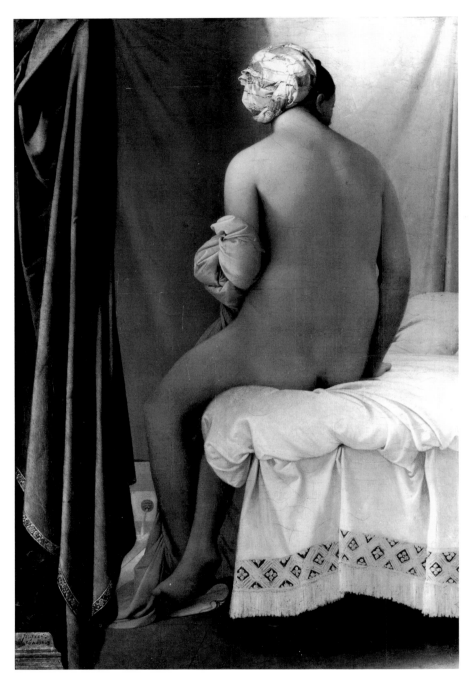

55. Ingres, *Bather of Valpinçon*, 1808. Oil on canvas, 146 × 97.5
cm. Louvre, Paris (R.M.N.).

and Thetis (fig. 57). In this passage, his tendency to polarize the classical and the physical is a perfect match for the overdetermined oppositional strategies of the painting itself.

> The Jupiter is an admirable piece of classical furniture; but the figure of Thetis achieves a crescendo of sensual—we may even say sexual—excitement, starting with the outline of her body . . . following her swanlike neck, and rising up her arm, boneless but disturbingly physical, till it culminates in her extraordinary hand, half octopus, half tropical flower. (153)

Clark's equation of sexual excitement with a complex hybrid comprised of avian, invertebrate, and vegetal forms is a peculiar form of praise. In fact, his references to swan, octopus, and tropical (as in exotic) flower, recall the lexicon of rodent metaphors in Geffroy's description of Ingres's *Baronne de Rothschild.* Just as the overall sensuality of Geffroy's style masked offensive phrases like "a head of hair with bluish glints like the wing of a crow," the climactic description of Thetis's

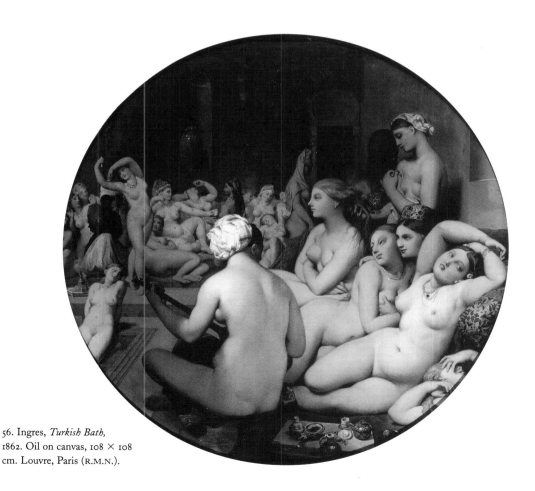

56. Ingres, *Turkish Bath,*
1862. Oil on canvas, 108 × 108
cm. Louvre, Paris (R.M.N.).

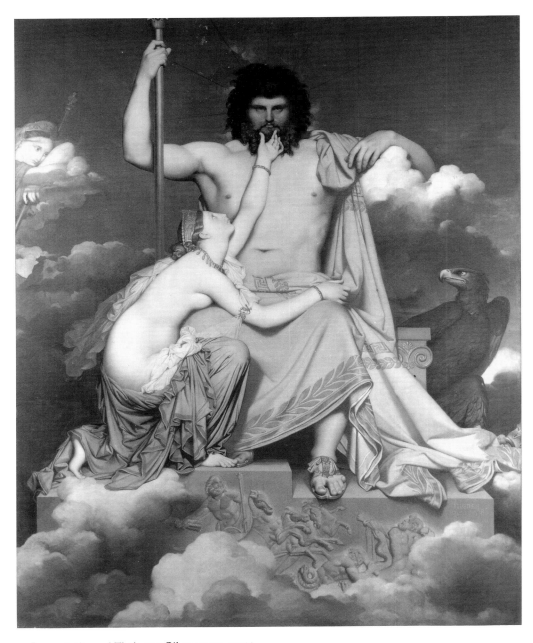

57. Ingres, *Jupiter and Thetis*, 1811. Oil on canvas, 327 ×
260 cm. Musée Granet, Palais de Malte, Aix-en-Provence.
Photograph by Bernard Terlay, Aix.

body, with its accumulation of clause upon clause, might cause one to overlook Clark's recourse to hybridism to describe this singularly protean sea nymph. This constellation of metaphors, unintentional though it may be, serves to naturalize associations between the female body, distortion, sensuality, and bestiality. Precisely because the figure of Thetis so powerfully represents sexual excitement, she must be defined as "the in-between, the ambiguous, the composite"—in short, the abject.

To his credit, Clark realized that Ingres's ability to evoke eroticism so openly in a painting like the *Turkish Bath* would have been unthinkable without his status as "petit éléphant bourgeois"—his seat in the Academy, his frock coat, and his absurdly orthodox opinions. In making a segue to his discussion of Manet's *Olympia,* Clark invokes "that fear of the body which is usually called Victorian" as "a subject worthy of more disinterested examination than it has yet received" (160). He fails, however, to see that such an examination could hardly be disinterested, a fact that goes a long way to explaining the silence on this matter in much of the Ingres literature.

Fear of the body could not be further from Robert Rosenblum's mind. His monograph on Ingres, first published in 1967, details the sensual aspects of Ingres's paintings in a melting prose style not seen since Gautier wrote his fantastic description of the *Grande Odalisque's* toes.[18] Rosenblum's seduction, like Gautier's, is palpable and complete. At the same time, Rosenblum's formal descriptions bring a renewed clarity and authority to the binarism so characteristic of twentieth-century writings on Ingres. Rosenblum says of the *Grande Odalisque,* for instance, that it exhibits "a flesh of voluptuous malleability, yet this pliant stuff is polished to a marmoreal firmness, so that it seems alternately warm-blooded and cold, slack and taut, a fusion of opposites" (107). In another place, he says of the *Odalisque with Slave* (fig. 34),

> her skin . . . elaborates the icy eroticism of the *Grande Odalisque* in its titillating fusion of rounded breasts and belly with contours almost as cold and metallic as those of the columns in the background. And upon this flawless surface of unwrinkled, boneless flesh, the jewels of the necklace and earring become as exquisitely sensual as the pink mouth, nipples, and navel. Yet even this libertine creature is subjected to the disciplines of Ingres's pictorial order. (142)

The very confidence with which Rosenblum asserts a binary grid for viewing Ingres's paintings might be said to permit his sensualized language.

In its day, Rosenblum's was a revisionist text, presenting the full range of Ingres's painted production for the first time to a scholarly community primarily familiar with his drawings. At the same time, Rosenblum, much affected by early

twentieth-century writers like Bissière, also made a strong claim for Ingres as modernist. In addition to clearly articulating the abstract qualities in Ingres, Rosenblum gives several specific examples of precocious modernism, often juxtaposing Ingres's works to early twentieth-century productions that may be indebted to his example. Rosenblum is fully aware that "looked at from a realistic viewpoint, Ingres's anatomy, whether of nineteenth-century ladies or mythological heroines, can be grotesque" (23): the right hand of *Mme Moitessier Seated* (fig. 59) is "as pliable as a starfish" (164), and "the frozen, tusklike perfection" of the arm and back of the *Bathing Woman* of 1807 (fig. 58) "is likewise countered by the sudden appearance of wriggling, wormlike fingers that press into supple flesh" (70). For Rosenblum, as for Lhote, "the sheer genius of Ingres's formal sensibility" (24) makes his distortions acceptable. Both unquestionably construe the deformation and eroticization of the female body as modernist.

Much the same thing happens in writings on Ingres that initially seem very different from those we have discussed. Norman Bryson's *Tradition and Desire* (1984) and Richard Wollheim's *Painting as an Art* (1987), like much recent scholarship, are grounded in psychoanalytic theory.[19] A central theme in both is the artist's desire, for which the distortions in the paintings might be said to constitute evidence. Both devote attention to the phenomenon of repetition in Ingres's work: Wollheim asserts that Ingres enacts a protracted oedipal struggle through the spatial anomalies in his work; Bryson charts the diminution of Ingres's sexual desire and his subsequent transcendence, through the relation of the artist to tradition. Like Clark and Rosenblum, these authors attempt to explain Ingres's distortions through a reconstruction of the artist's psyche.[20] While there may be some validity to this method, most writers who employ it do not attempt to substantiate their interpretations through any sort of detailed analysis of Ingres's personal life. (Wollheim does base his argument to some extent on data about Ingres's life, though his book is hardly a psychobiography.) Still, even if they had drawn extensively on the fascinating biographical study of the artist by Marie-Jeanne Ternois, I am inclined to agree with Wendy Leeks that concentration on the personal denies Ingres's paintings any life outside of their maker's existence.[21] If this tendency to see the paintings as pictograms of the artist's psychic life is so disturbing, it is because it is symptomatic of a larger problem. In failing to acknowledge what is at stake in these images and how they themselves might be complicit in their meanings, these authors confirm a particular subject position and a particular fantasy of modernism, both of which are gendered.[22] This is a discourse which subsumes the universal under the prerogative of the masculine. I know, of course, that we are talking about pictures. But given the fact that these authors see Ingres's paintings as Rorschach tests of the artist's actual or psychic life, the implications seem even more ominous.

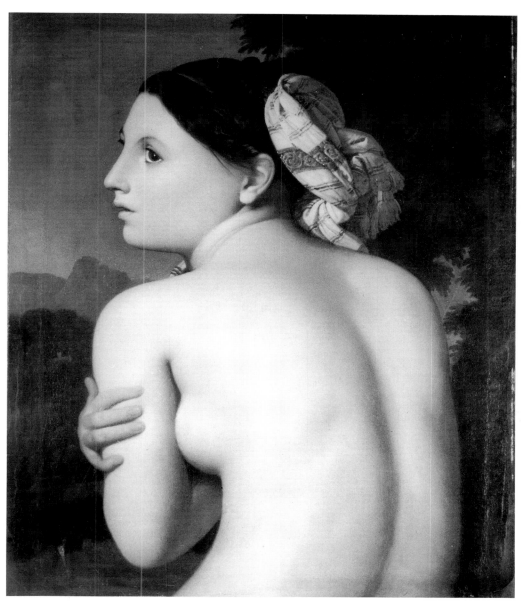

58. Ingres, *Bathing Woman,* 1807. Oil on canvas affixed to
panel, 51 × 42 cm. Musée Bonnat, Bayonne.

These implications are distilled with alarming clarity in Bryson's description of *Mme Moitessier Seated*. In reinscribing Ingres as a protomodernist, this passage is Bryson's pièce de résistance. In many ways, it is also typical of the uncritical ways in which most twentieth-century texts at once elevate the distortion of primarily female bodies and dangerously elide the issues of deformation, female sexuality, and bestiality. Bryson considers *Mme Moitessier Seated* "Ingres' supreme production; the lyric image of Europe in the era of high capitalism." Before it, he admits his own "anxiety of influence." The picture's greatness, for Bryson, stems from Ingres's ability to overcome his obvious debts to his sources: this is particularly evident in the Herculanean painting and the Raphael studio piece *Joanna of Aragon*. Bryson's description of the painting is too long to analyze in its entirety, but for any reader familiar with theories of abjection, what is most noteworthy is Bryson's claim that the summa of Ingres's achievement lies in the elimination of everything that could be said to constitute real flesh or skeletal support.

> The image has been purged and repurged, painted, erased, overpainted and re-erased, reduced through unending distillations which conclude in a form whose centrality is achieved by elimination of everything that is contingent, accidental, or immediately alive. The arms retain all the colour but none of the radiance or vibrancy of real flesh: this is tinted ivory, not skin over bone, and indeed Mme Moitessier is one of the least vertebrate or skeletally supported of Ingres' women: there is no sensation whatever of the stretch of skin over muscle, or of skin as integument; it is pure contour.[23]

This account troubles me precisely because it is so unaware of its underlying assumptions. It preaches what Lhote, Clark, Rosenblum, and others have already said, only louder. And embedded in this eulogy is a formation of thinking that, taken to its logical conclusion, is simply determined to excise women's bodies. The irony of suppressing what is alive in women, of taking away their structural means of support and turning them into pure contour, is rich. As we have seen, this long-lived, if fluctuating, discourse of the abject, which equates Ingres's paintings (and the artist himself) with death, speaks of the nightmares occasioned by formlessness and at the same time neutralizes even these tendencies through the moralizing—and gendered—force of line. The fact that twentieth-century discourse has been so effective in naturalizing equations between women's bodies, modernism, deformation, and animality is intensely disturbing to me, for as a feminist living in the late twentieth-century, I am, of necessity, its heir. The principal question I would like to raise is this: How can a woman spectator possibly locate herself within this benighted discourse in which pleasure is conjoined with the monstrous female body? In other words, "What's a girl to do?"

59. Ingres, *Mme Moitessier Seated*, 1856. Oil on canvas,
120 × 92 cm. National Gallery, London.

By this time, it will come as no surprise that my pleasure in look-
ing at Ingres's *Grande Odalisque* (fig. 15, plate 2) is, at best, equivo-
cal. The contradictory discourses of pleasure and horror that have
surrounded the painting also of necessity have shaped my response
as a viewer. As a feminist art historian who was raised on Rosenblum's
monograph on Ingres, serpentine line and smoothed-over flesh
have come to signify pleasure, a pleasure that is only heightened by
the appeal to the senses in this painting. Touch, smell, sound, taste—
all are deployed in the service of pleasure. But the body of the
Grande Odalisque clearly also is objectified, rendered passive. Its
skeletal support is questionable at best. Here is woman *reduced* to
the sensual and this, much like the equation made between defor-
mity and female sensuality, is intensely disturbing. But to reduce my
response, in the face of these observations, to an ambivalent female
identification, to "passive femininity" or "regressive masculinity," as
Mulvey put it, would be entirely to abandon pleasure in looking.[1]
Rather than dismiss my possibilities for pleasure, I want to argue
that there are aspects of the sensual in this painting that might be
reclaimed or reconstituted. While pleasure in looking will inevita-
bly be inflected by "masculine" identifications, these very identi-
fications provide means of resistance. The fluidity of the *Grande
Odalisque*'s body, for example, might be seen as form that threatens
to defy boundaries, rather than as formlessness. Ingres's distortions
might be said to confound unintentionally the ideal of beauty for
which he strove. But the imagery deployed uncritically by white
male artists like Ingres can take on very different meanings when it
is deployed self-consciously. In this chapter, I want to explore the
ways in which abjection can function as a kind of subversive
agency. The power of the parodic to usurp dominant imagery, to

steal its meaning, and to make use of that very imagery to better expose its under-
lying implications is both central to much recent feminist praxis and indispensable
to any consideration of female pleasure in looking.[2]

At first glance, nothing could be further from Ingres's *Grande Odalisque* than
Cindy Sherman's 1992 photograph *Untitled #250* (fig. 60, plate 8). It questions the
ideal at every turn. The face has so many wrinkles, it must be one hundred years
old. While smooth and seemingly young, the body is plastic. Chunky fragments
take the place of Ingres's fluid contour line. The torso might pass. The rounded
breasts are all right, but the belly sticks out. In fact, you can see it hanging over the
groin. And the groin is scary—cropped short (there are no legs or buttocks) and
deliberately tilted out toward the viewer so as better to reveal a huge, hairy vagina.
The parted red vaginal lips are the size of a prize tomato, and, as if that weren't
bad enough, they churn out a string of meaty sausages. The arms strike a bathing-
beauty pose, but they are literally dislocated from the torso and far too skinny. And
then, they frame that horrific face.[3] The unruly platinum-blonde hair recedes no-
ticeably. It is also dry and obviously fake, a fact underlined by the bed of dark wigs
upon which the figure reclines. There is nothing demure about Sherman's oda-
lisque. She displays herself baldly, and she directly confronts the viewer. Bright eyes
(they are brown, though they should be blue) are rimmed by dark circles and set
below arched yellow brows that haven't been plucked for an eternity; her nose is
sharp and pointy, and her lips are set in a catastrophic attempt at a smile. She has

60. Cindy Sherman, *Untitled #250*, 1992. Color photograph,
127 × 190.5 cm. Courtesy of Metro Pictures, New York.

too much make-up, but nothing could hide her constellations of wrinkles. How could such a loathsome image possibly be related to Ingres's?

Far from being the *Grande Odalisque*'s opposite, however, Sherman's photograph actually continues Ingres's legacy of deforming the female body. If Sherman can be said to take on Ingres's mantle, however, it is only to cast it off. For, in her image, distortion functions as critique. Sherman mercilessly pokes fun at ideal beauty. She deliberately confuses the real and the ideal, much as Ingres's distortions were perceived to have done. But she does so to attack the equation between deformity and female sexuality. By willfully pushing deformity to grotesque extremes, she adopts abjection as a subversive strategy. Sherman's image not only resists being recuperated by the ideal, as Ingres's deformations do not, but it resists the entire discourse of control underlying such deformations. In so doing, *Untitled #250* offers a rebuttal to canonical art history. It is part of a strong tradition of feminist work, both visual and theoretical, that suggests ways in which the disgusting actually can be empowering for women. These works acknowledge the troublesome relationship between female spectatorship and pleasure and then confront head-on the association of female sexuality and the monstrous body. Sherman's purposeful recourse to the disgusting thus participates in a larger feminist strategy. The French philosopher Luce Irigaray, the historian of science Donna Haraway, and the artist Kiki Smith all use abjection as an empowering concept for women. Why and how can disgusting images like Sherman's be useful or positive for women?

In addressing this question, I am responding to two decades of feminist criticism that has addressed the representation of the female body. Central to my inquiry, and to the broader debate, are questions about defining pleasure from the point of view of women. If Ingres's work, with its emphasis on the sensual, would seem to invite such queries, the critical writings we have examined make clear that there are substantial problems in any such project. Critics have developed a discourse of the monstrous female body in order to avoid discussing the anxieties occasioned by sexual difference, and, beyond this, they generally have circumvented altogether the fundamental question of who is looking. The contradictions encountered by theorists make the exploration of the social and psychological construction of female spectatorship a necessary, if daunting, task, as the writings of Berger, Mulvey, de Lauretis, and Doane make clear.[4] But feminist interventions have transformed the fundamental methodologies of art history and have empowered women as makers and viewers of their own pleasure.[5]

All this does little to extricate us from the troublesome relationship between female spectatorship and pleasure, particularly the conjunction of sexuality and distortion. In viewing a painting like the *Grande Odalisque,* women inevitably respond differently from men simply because the painting represents a woman's body. Pub-

lished responses by women to Ingres's paintings are rare, however. And, to compli-
cate matters further, a woman may have the same response as a man. Writing
under the pseudonym Claude Vignon, Noémie Cadiot was the only woman critic
to review Ingres's work in the Exposition Universelle, and there is nothing about
her response to distinguish it from the appreciative responses of most male critics.[6]
Nor is there any evidence that George Sand's horrified comparison of the *Grande
Odalisque* to a bloodsucker can be attributed to her identity as a woman.[7] As Lisa
Tickner has so aptly pointed out, any study of women's experience "will have to
come to terms with the question of what it is for its subject 'to be a woman some-
times.'"[8] In other words, being female is only one aspect of a woman's experience—
at some times, it will be the definitive aspect of her response as a viewer; at other
times, it may not enter into her response at all.

But how does a woman, even if only responding as a woman sometimes, locate
herself within a discourse in which pleasure is conjoined with the monstrous female
body? If responses to the female body can be taken as a statement about some-
thing else—as expressions of attitudes toward women in society, for example—
how might women take control of these images? Before considering how recent
critical and theoretical work has employed abjection, I want briefly to review the
concept and consider how it appears in the critical response to Ingres. I have found
helpful in Kristeva's formulation of abjection the notion that blurring boundaries—
between inside and outside, human and nonhuman, life and death—simultane-
ously elicits disgust and pleasure. Inasmuch as these apparently contradictory re-
sponses can be taken as a psychic formation, they can help explain the range of
responses critics in the nineteenth century experienced in looking at Ingres's paint-
ings of bodies, particularly those that viscerally express physical repugnance. De-
tractors generally reserved their most intense disgust for those very works which
enthusiasts touted as embodiments of supreme beauty—the odalisques. More re-
cently, twentieth-century critical writings about Ingres have transformed the dis-
course of horror that consistently haunts the discourse of the ideal into less
terrifying, but still abject, metaphors of amphibian and aquatic life.

Faced with a discourse that equates female bodies with the deformed, the mon-
strous, and even with death, a number of artists and critics have begun to consider
abjection itself as a critical strategy. What happens, these critics ask, when one ex-
ploits the confusion of boundaries, when the grotesque is consciously intensified
for political ends?

Despite feminist gains of the 1970s and the early 1980s, these new strategies re-
flect an ever-increasing awareness of both the problems besetting any notion of
female subjectivity and a continuing sense of disempowerment. Specifically, they
are a response to representations that are so violent as to sanction the excision of

the female body ("Mme Moitessier is one of the least vertebrate or skeletally supported of Ingres' women: there is no sensation whatever of the stretch of skin over muscle, or of skin as integument; it is pure contour") and to acts of violence toward women.[9] Central to this critical work is the notion that the abject has the power to evoke powerful physical responses that are simultaneously shocking and pleasurable. Its function as critique is thus inseparable from its power to shock and disgust. In employing the discourse of the monstrous for subversive ends, these theoreticians and artists also engage larger feminist concerns, including sexual difference and female subjectivity. This is as true of Irigaray's symbolic use of the terms *the two lips* or *mucous* as it is of Haraway's concept of the *cyborg*. As my analysis will show, the images created by Smith and Sherman seem to me especially successful precisely because of their ability to confront directly the question of pleasure in looking. But informing the content of all these interventions is the question of how women can lay claim to their bodies, in both symbolic and real terms.

Luce Irigary is most famous for "This Sex Which Is Not One," her witty ode to female genitalia.[10] As a response to the ways in which "female sexuality has always been conceptualized according to masculine parameters" (24), she constructs a language of female eroticism that resists Western logos, with its "predominance of the visual" and "discrimination and individualization of form" (25). While man "in order to touch himself, needs an instrument: his hand, a woman's body, language," woman "touches herself in and of herself without any need for mediation." What's more, "woman 'touches herself' all the time, and moreover no one can forbid her to do so, for her genitals are formed of two lips in continuous contact . . . she is already two—but not divisible into one(s)—that caress each other" (24). Irigaray's unexpected, and slightly naughty, image of the two lips is intended as an alternative to notions of "lack," "penis envy," and "atrophy" that have so often been employed to devalue female genitalia. In its simultaneous assertion and questioning of sexual difference, this essay is part of a larger project whose goal is to find ways of representing women that, at the very least, resist stereotypes. One of Irigaray's strategies involves making a positive link between the female body (often specifically its bodily liquids) and the fluid and opposing it to the male body, which is associated with solids. In this way, Irigaray essays a corrective to the worrisome formlessness so often ascribed to Ingres's sensualized bodies.[11] In addition, she provocatively treads a fine line between essentialist definitions that equate women with their bodies and social constructions of gender.

Irigaray's challenge to the more horrific associations of the abject is most dramatically embodied by the link she makes between the female body and *le muqueux* (the mucous or mucosity). In describing the female body as mucous, Irigaray notes

its association with "chaos, abyss, or dregs" and its status as "raw material, a cast-off from what has already been born."[12] As a membrane, the mucous also occupies the boundary between inside and outside. While its ability to evoke the abject is one measure of its power as an image, *mucous,* as Irigaray employs the word, also blurs a series of binary oppositions—including those between the corporeal and the transcendent, subject and object, male and female, and solid and fluid. For Irigaray, the female body can symbolize as adequately as the male, and it can be used to overturn the binary oppositions at the heart of Western thought.

Irigaray's formulation of a new world that is embodied by mucous may strain the limits of even the most dystopian fantasies. But the tension between the literal and the symbolic has always been one of her most favored strategies. The absurdity of her symbols is willful, her evocation of mucous as unlikely as her use of two lips to represent woman. Both serve to destabilize the very stereotypes that have engendered them—woman as monstrous body and woman as reduced to her body. Irony notwithstanding, Irigaray's enterprise is deadly serious, for if, as Irigaray suggests, woman threatens not only the "horror of the abyss" but also "loss of identity, death" for the male subject, then women's urge to assert themselves as equal subjects must assume a horribly threatening form.[13] It is Irigaray's distinctive association of shock and irony that gives her most successful images—particularly the two lips—their power. Unlike the two lips, however, which, at least in part, are a retort to Lacan's concept of the phallus, mucous, as a symbol, relies on sexual ambiguity.[14]

The historian of science Donna Haraway in her "Manifesto for Cyborgs" emphasizes another aspect of the abject—the hybrid.[15] Like Irigaray's symbols, Haraway's image of the cyborg—a fusion of machine and human organism—draws its power from its very monstrosity and uses irony as both a rhetorical strategy and a political method. Haraway offers her vision of the cyborg as a critique of the notion of evolution embodied by science and technology. Instead of "the final imposition of a grid of control on the planet . . . a Star War apocalypse waged in the name of defense . . . the final appropriation of women's bodies in a masculinist orgy of war," the cyborg world, as Haraway intends it, might be a world "in which people are not afraid of their joint kinship with animals and machines, not afraid of permanently partial identities and contradictory standpoints" (72). Integral to her theory of a "feminist science" is the hope that "we can learn from our fusions with animals and machines how not to be Man, the embodiment of Western logos" (92–93). Like Irigaray, Haraway wants to break down the binary oppositions structuring the Western self. Neither wholly organism nor wholly machine, the cyborg, on a symbolic level, does just that. For Haraway its hybrid status also func-

tions on another level; as both a creature of social reality and a creature of fiction, the cyborg refers to "the two joined centers structuring any possibility of historical transformation"—material reality and imagination. In arguing for "pleasure in the confusion of boundaries and for *responsibility* in their construction," Haraway makes an impassioned plea for a more interactive vision than the polarity and hierarchical domination underlying Western science and politics (66–67).

Like Haraway's cyborg, Cindy Sherman's *Untitled #251* (fig. 61) conflates the real and the imaginary, constructing a creature that elicits the simultaneous fascination and revulsion of the abject. Sherman's extraterrestrial also is a hybrid that joins the human and the nonhuman, but it goes far beyond Haraway's cyborg in exploring sexual ambiguity. By making a figure that is biologically female *and* male, Sherman resists oppositional thought on another level: she confounds the visual signs at the heart of sexual difference. If Haraway's cyborg parodies the methods of modern science and technology, Sherman's image functions, on at least one level, as a critique of Surrealist double-entendres.

Untitled #251 is eerily reminiscent of Magritte's disturbing painting called *Rape* (fig. 62).[16] Visibly headless, both bodies sport on their torsos breasts that double as eyes and a slit or vagina where we might expect a mouth to be. Instead of the deadpan illusionism of Magritte's figure, however, Sherman shows fragments of a hospital mannequin barely visible behind a breastplate of extraterrestrial armor. And, instead of the phallic neck of Magritte's painting, we get the phallus itself. Sherman's sci-fi creature, with its double-entendre of body parts and its double complement of male and female sex organs, denaturalizes the more realistic strategies of Surrealist artists. Magritte's image, by virtue of its title alone, is meant to suggest sexual violence; Sherman's image brings these fantasies of sex and violence up short. Her hybrid is at once male and female, at once earthling and extraterrestrial, simultaneously revealing its genitals and wearing a protective shield. It is neither particularly erotic nor particularly violent; in fact, it is difficult to imagine these sexual parts ever finding each other or another being. Sherman's creature conjures up and pokes fun at the illusionism and violence so prevalent in both Surrealist imagery and horror films.

Sherman's trajectory from constructions of the ideal to the abject in and of itself constitutes an interesting response to Ingres's deformations and their relation to the ideal. Her *Film Stills* and first *Untitled* works set up an exploration of the surface of sexual identity: the viewer is challenged to examine how a woman looks—what she wears, how she makes herself up, how she's presented, how she's placed in the image, and what she evokes (which movie star, which moment in a narrative)—all the while confronting how meaning is produced. Sherman started with herself as a model for exploring constructions of woman and femininity. Even in her recent

61. Cindy Sherman, *Untitled #251,* 1992. Color photograph, 114.3 ×
172.7 cm. Courtesy of Metro Pictures, New York.

62. René Magritte, *Rape,* 1934. Oil on canvas, 72.4 × 53.3 cm.
The Menil Collection, Houston.

work, where she technically has disappeared, she continues to examine the determination of difference. Now, however, instead of focusing on the exteriors of bodies and the masquerade of femininity, her work has become more of a dialogue—between inside and outside, masculinity and femininity, as well as other forms of difference.[17]

Since 1985 Sherman has made the blurring of boundaries central to her work. Her fusion of natural and artificial, alive and dead, human and animal, more often than not relies on grotesque details for maximum repulsion—slimy teeth, sullied flesh, sunken eyes, an oversized tongue. Sherman's intensification of the grotesque is calculated to create a visceral disgust in some viewers reminiscent of Nadar's response to Bertin's left hand. Much like the horror films that inform her imagery, Sherman's work brings about a confrontation with the abject, including the corpse, bodily excretions, and what the film theorist Barbara Creed calls "the monstrous-feminine."[18] The point of Sherman's work, however, unlike that of horror films, is neither to clarify the boundaries between the human and nonhuman nor to reassert the fragile sense of identity the abject threatens. In horror films, the monster's demise at the end functions in part to reassure viewers; in Sherman's work the disgust and anxiety provoked by the abject do not diminish.[19]

Much as Ingres's bodies could evoke all the horrors of the Reign of Terror for some viewers, Sherman's photographs have the effect of conjuring up real violence. Her abject imagery produces the same uneasy associations among sensuality, violence, and even death that Curtius's waxworks and Ingres's paintings elicited in the minds of outraged viewers.[20] Sherman's images of food, which seemingly depict what has been ingested and come up again (in one case, perhaps, along with internal organs), recall the violence of bulimia. Although decidedly more repulsive, this series is a logical outgrowth of earlier work chronicling a range of unsavory signs whose function, at least in part, is to negate ideals of beauty—marks of aging, pimples on the buttocks, the look of something that is not quite human. The aged harpie in *Untitled #250* (fig. 60, plate 8) may take the pose of countless immortal Venuses, but her face, evoking as it does aging and decay, emphasizes mortality.

For Ingres's most shocked viewers, distorted anatomies contradicted the ideal and were perceived as grotesque. But inasmuch as these deformations can also be interpreted as visible signs of the difference attributed to female sexuality, they simultaneously function as demonstrations of the anomalous nature of female sexuality and the need for its control. If, like abjection itself, these "bodily stigmata" elicit both horror and fascination, they also often have been interpreted as evidence of Ingres's desire.[21] Is it not possible then to interpret these bodily distortions as signs of female desire, as signs of the very power that women's sexuality embodies, a power so threatening as to demand such representation?

To my mind, Sherman's departures from the ideal function in precisely this way. Indexes of the aberrant, they represent the power and horror of sexual difference. Sherman's work thus builds on the unease about the sensual that is the leitmotif of the writings about Ingres. By constantly interpellating the freakish in sexually explicit images, Sherman keeps her audience face to face with the abject. What I find so compelling about this recurrent confrontation is that it consistently combats the naturalization of the abject. It does so by implicating the viewer in determining what constitutes aberrant sexualities, what is real and what is fantasy. By forcing the viewer to confront how the psychic construction of the abject translates into real life, Sherman exposes the construction of female sexuality as both ideal and monstrous. Her images use the abject both as a sign of difference and as a sign of power.

In Ingres's painting a few well-chosen spinal supplements have been interpreted as enhancing the sensuality of a nude. By contrast, the relentless monstrosity of Sherman's recent photos not only resists being recuperated by the ideal, it defies the entire discourse of control underlying such deformations. Beyond keeping the viewer face to face with a blatant materiality that withers the ideal, she uses the horrific to take control of the process of representation itself.

The ability of Sherman's imagery to continue to shock and to repulse is the measure of its power, and it is also a measure of its capacity to empower. Central to my experience of these works as empowering is the power in looking itself. I refer here to the challenge these works pose to the historical association of looking with men (as opposed to the association of women with touch), as well as the association of looking with male pleasure.[22] Of course, the brazen quality of Sherman's recent work and its unremitting grotesqueness scarcely offer the pleasure traditionally associated with viewing the female body. Nevertheless, by redeploying the monstrous, by keeping alive the very notion of the abject as threat, Sherman's imagery provides the pleasure of reimaging and, hence, reimagining that pleasure and, by extension, the power it betokens.

Like Sherman, Kiki Smith explores the blurring of social boundaries regarding sexuality in her recent work. But Smith's starting point was quite different. Instead of focusing on body surfaces, Smith investigated the body's internal order, especially the nervous and digestive systems. Her early work, in particular, consisted of maps of body interiors, internal organs (a womb, a heart) in isolation or artfully grouped together, or parts of the skeleton. Since then, all of Smith's work has been directed toward "both inside and outside, or things that are interactive between the inside and outside, like the fluids."[23] But she is very clear about the frustration she experiences with binary thought:

Our society suffers from a schizophrenia of dichotomy. Somebody made it up, this dualism, this dichotomy; it's hierarchical. It separates people from their environment—culture from nature, men from women, body from mind, body from spirit. All the things that are closer to the earth—like the earth itself, females and the body—are lower on the hierarchical scale and, therefore, everybody suffers in our society because they don't know where they are.[24]

In blurring the distinctions between inside and outside, life and death, her work resists the very dichotomies that the abject functions to inscribe.

Smith's pieces are deceptively simple. *Skirt* is just that: a skirt (fig. 63). But the fact that it hangs from the ceiling as if it were on a body, with only a pair of feet on the floor below it, transforms it from a banal object to a surreal one. In fact, *Skirt* functions very much like skin; it is inseparable from the body it contains, even if in this case that body is strikingly absent. Another work, *Womb,* also confounds interior and exterior, as well as hardness and softness (fig. 64). It is definitely not a womb. Yet its bronze form gives solidity to a rarely seen internal organ and renders visible a shape we generally think of as merely the body's interior. Its form—a cross between animal head and found object (like a hand grenade)—makes this object, for all its deadpan presentation, intensely disturbing.[25] *Womb* makes touchable a body part that is untouchable: literally, because of its location in the body, and figuratively, because of its often mystified reproductive role. The fact that there is nothing inside—the piece can be opened—thwarts expectations about containment and situates *Womb* squarely within the context of recent debates about abortion.[26]

Smith also highlights the permeability of boundaries, by showing a body in the act either of giving birth, of defecating, or simply of emitting fluid (see figs. 65, 66). While Smith's emphasis on bodily excretions is unquestionably the most abject part of her art, her attention to the biological confronts the viewer rather uncomfortably with those aspects of life we tend to keep at a distance. This is as true for our squeamishness about internal organs as it is for our polite denial of the processes of daily life, like going to the bathroom. By representing body parts and bodily functions that are considered taboo, or at the very least private, Smith points to the fact that many aspects of our lives that are taken for granted are also, paradoxically, unspeakable.

A number of Smith's concerns uncannily respond to issues which, while relevant for artists in general, are integral to both Ingres's production and the discourse it spawned. Smith's notion of skin, for instance, functions in a way that is very similar to the way the serpentine line functioned for Ingres. Smith's assertion about wanting to make sculpture that is "something like an envelope . . . that is kind of

63. Kiki Smith, *Skirt,* 1990. Cloth, glass, 134.6 × 33 cm. Private collection. Courtesy of Thomas Ammann Gallery, Zurich.

weightless, that has no substance to it, that is just this veneer" recalls the tension in Ingres's works between two and three dimensions. Smith's papier-mâché bodies, which she refers to as "hard/soft combinations," also bring to mind the opposition between Ingres's controlling line and the soft sensual bodies it inscribes. While the Ingres literature has consistently valued his use of line, frequently highlighting the need for it to master the sensual, Smith's ordering system only highlights the physical resistance to such control. "A lot of times I make things that are spilling off, or falling down. I've noticed it's a propensity, it's something I gravitate toward. . . . I've made lots of sculptures of guts falling out, or things with nosebleeds, or shitting, or vomiting—things falling out."[27]

Given the tendency of nineteenth-century critics to make deprecating comparisons of Ingres's odalisques to waxworks, it is fascinating to note that when Smith chose to address similar issues—linear contours, permeable form, amorphous bodies, tactile sexuality—she chose wax as her principal material. In a recent interview, Smith referred to the death mask of her grandmother that hung in the hallway when she was a child. She also described how she and her sister Beatrice made a death mask of their father when he died and how, in turn, when Beatrice died, Smith made a death mask of her, "because we had done it together."[28] Of interest here is the way in which wax, with its capacity both to replicate the living and to

64. Kiki Smith, *Womb,* 1986. Bronze, 45.7 × 30.4 × 20.3 cm. Collection Jane L. Smith. Courtesy of Joe Fawbush Gallery, New York. Photograph by Nicholas Whitman.

65. (*Foreground*) Kiki Smith, *Untitled*, 1989. Gampi paper, life
size. Collection of Michael and Eileen Cohen. Courtesy of Pace
Wildenstein, New York. Photograph by George Rehsteiner.

record death, embodies the relationship between sensuality and death that troubled critics of Ingres's paintings—so much, in fact, that they likened those paintings to Curtius's waxworks. As the critic Roberta Smith noted in a review of Smith's show containing largely wax sculptures, "Her [Kiki Smith's] women look normal, almost like real people, which makes their situations all the more horrific."[29]

Given the generic quality of Smith's figures, the power of her wax casts to simulate life—or death, for that matter—is unexpected. Like Ingres's paintings, Smith's sculptures are simultaneously abstract and horrific. But wax is only one of the vehicles Smith employs to horrific effect. In a variety of ways, she also compromises the abstract through bodily distortions. For instance, one figure crouching on a shelf has deep scratches, which appear as red streaks in the yellowish flesh of her back (*Untitled*, 1992). Unlike the extra vertebrae of the *Grande Odalisque*, these cannot be read as positive enhancements of the ideal body. Rather, they suggest blood and violence, an impression only accentuated by the placement of the figure's hands under her buttocks and rounded back. And for a viewer mindful of vertebrae, one of Smith's most affecting pieces is probably *Blood Pool*, a figure frozen in fetal position, like some ancient Pompeiian victim, with her spinal column sprouting from her back like a row of teeth (fig. 67).[30] In contrast to the sensu-

66. Kiki Smith, *The Tale,* 1992. Wax, pigment, and papier mâché, 58.4 × 58.4 × 406.4 cm. Private collection, New York. Courtesy of Joe Fawbush Gallery, New York.

alized *Grande Odalisque,* the spiky backbone in *Blood Pool*—at once threatening and confrontational—cannot be perceived as part of an ideal body. Furthermore, in the context of contemporary awareness of violence toward women, Smith's works seem to present the female body as a site of physical and perhaps psychic abuse.[31]

Another of Smith's recent works, *Untitled,* 1992, is a stark white figure crouching on her hind legs, with disproportionately long arms extending forward on the floor (fig. 68). Formally, this sculpture comes closest to Ingres's mode of sensualizing anatomical distortion. The addition of white pigment gives the work the heightened abstraction of the unmodeled flesh of Ingres's bodies, while the curved back and extreme elongation of the arms, so often seen in his female nudes, recall nothing so much as the protean form of Thetis. In the context of Smith's other works, however, this untitled work also suggests what is uncontainable about the body—the spiky spine outside the flesh, the ooze of excrement, the arms whose life's blood might just flow out of them. The boundary between inside and outside that is emphasized in *Untitled,* much like that in the figure kneeling on all fours who trails a long tail of excrement (fig. 66), is fluid and, as such, signals a self-conscious resistance to boundaries that is antithetical to the controlling discourse of formlessness enacted in Ingres's female bodies. For Smith, the movement between inside and outside is analogous to human growth: "The parameters of where you exist are ambiguous sometimes, and you're constantly being made new all the time. You're a flexible thing; you're not this inert definition. You're something that's constantly changing, and that fluidity is not to be lost. It gives people a sense of the possibility for change in their lives, to let go of things that don't work for them."[32]

Her positive attitude toward fluidity and her insistence on blurring boundaries are also meant as a corrective to patriarchal formations of thought. Smith speaks of reclaiming, rather than redeeming, the female body: "Our bodies are basically stolen from us, and it's about trying to reclaim one's own turf, or one's own vehicle of being here, to own it and use it to look at how we are here."[33] Some of the things Smith wants to reclaim historically have been associated with women: "Things that have been prescribed to women are disregarded, devalued. . . . There is a cultural inheritance about being raised a girl child. Basically it's a sense of being disregarded. You can take the things held as deficits against you and embrace them and be caring to them." Among these are things that relate to Smith's "domain as a girl child."[34] This is apparent in the laciness of the paper skirts she makes, in the importance of dolls in her work, and in her appreciation of the kind of intensive labor often associated with needlework.

Much as she exposed aspects of the body that went unseen, Smith now insists on exploiting the elements of the social construction of one's gender that are often

67. Kiki Smith, *Blood Pool*, 1992. Wax and pigment, 106.6 × 60.9
× 40.6 cm. Courtesy of Joe Fawbush Gallery, New York.

68. Kiki Smith, *Untitled*, 1992. Wax and pigment, 139.7 × 71 × 60.9 cm.
Private collection. Courtesy of Thomas Ammann Gallery, Zurich.

hidden. "Then you have to exploit those parts, be as out front with those parts as possible. You demand that you get to exist as who you are," Smith says.[35] Her desires to be herself and to expand the generic definitions of gender underline two of the most pressing questions in current feminist debates about representing women: How is one to create positive images of women without reproducing the structures of meaning in which woman is represented for men? Simultaneously, how is one to represent a person who happens to be a woman without having her be interpreted as a specific woman?[36]

Both Sherman and Smith, like Irigaray and Haraway and others, ask, Where is woman? How is she represented and defined? Their critical orientation presents a marked contrast to the unself-conscious manipulation of bodies in Ingres's work and the dominant discourse surrounding them. Through its insistence on a proper, contained body, this discourse consistently has repressed, distanced, or naturalized the disturbing aspects of Ingres's sensualized bodies. Instead, the artists and theorists I have been discussing use abjection to unmask constructions of the ideal and its troubled relationship to female sexuality. Consciously using the physical disgust the abject provokes, their imagery attempts to harness that power for different ends. Abjection as a subversive strategy scarcely assures the disempowerment of representational strategies—both symbolic and real—that lie at the heart of its critique. But the dual repulsion and attraction characterizing the abject can provide the force for images that resist disempowering constructions of female sexuality. As I have argued, in that resistance lies the power to shock and to give pleasure. To a limited extent, these newly abject images already have transformed the possibilities of representing women's bodies. An increasing number of artists and writers, particularly women, have made this the necessary link between anger and power in their work.[37] Using to their advantage the ways abjection can be used to embody unconscious fears and aversions, they push the symbolic associations structuring both abjection and violence against women to the point where their own anger and power can no longer be avoided.

Back down. Back off. Turning back. Back up. Backlog. Back and forth. Back and fill. Backslide. Backlash. Backward. Backwater. Backwoods. Backside. Backhanded. Backbite. Backslap. Backstroke. Backsaw. Backfire. Backtalk. Looking back. Backbone. Backstop.

INTRODUCTION:
RETRACING THE
SERPENTINE LINE

Epigraphs: ". . . un dos où court dans la chair souple une délicieuse ligne serpentine" (Théophile Gautier, *Les Beaux-Arts en Europe* 1 [Paris: Michel Levy Frères, 1855], 2:157). "Et qu'on ne s'y trompe point: sous ces lignes si calmes, il y a bien de l'ardeur contenue par la volonté de ne pas dévier de la voie tracée *à priori*" (Charles-Louis Duval, *Exposition universelle de 1855: L'Ecole française* [Paris: Imprimerie Centrale de Napoléon Chaix et Cie, 1856], 6).

1. *The Works of William Hogarth,* ed. John Nichols et al. (Philadelphia: George Barrie and Son, 1900), 7: 73. For the history of serpentine line, including the introduction of the term in the Renaissance, see David Summers, "Maniera and Movement: The Figura Serpentinata," *Art Quarterly* 35, no. 3 (1972): 269–301; and idem, "Contrapposto: Style and Meaning in Renaissance Art," *Art Bulletin* 59 no. 3 (1977), 336–61. On the importance of Hogarth and serpentine line for Diderot, whose salons were widely known at the end of the eighteenth century, see Else Marie Bukdahl, *Diderot Critique d'Art* (Copenhagen: Rosenkilde et Bagger, 1982), 2: 94–103. For an excellent discussion of the gendered properties of line later in the century, see Jennifer L. Shaw, "The Figure of Venus: Rhetoric of the Ideal and the Salon of 1863," *Art History* 14, no. 4 (December 1991): 540–70.

2. Quote from French edition: "Il cherche à prouver par de nombreux exemples, que la ligne serpentine est la véritable ligne de la beauté et que ce sont les formes ondoyantes qui plaisent le plus à l'oeil." Hogarth, *Analyse de la beauté,* trans. Hendrik Jansen, vol. 1 (Paris: Hendrik Jansen and Levrault, Schoell, 1805), 19. Unless noted otherwise, all translations are by the author. On grace and the ornamental, see *Works of William Hogarth* 7: 33ff. As David Summers and others have pointed out, concepts of grace and the ornamental had important roots in rhetorical strategies as well (Summers, "Contrapposto," 349ff). Quote on windy lines is from *Works of William Hogarth* 6: vii.

3. Interestingly, the allusion to extra vertebrae, attributed to the critic Auguste-Hilarion, comte de Kératry, by Ingres's student Eugène-Emmanuel Pineu-Amaury-Duval, does not appear in Kératry's review of the *Grande Odalisque,* published when the work was first exhibited in 1819. See Kératry, *Annuaire de l'Ecole Française de Peinture ou Lettres sur le Salon de 1819* (Paris: Maradan, 1820); and Amaury-Duval, *L'Atelier d'Ingres,* 2nd ed. (Paris: Crès, 1924), 282. For further discussion, see below, Chap. 4.

4. John Berger, *Ways of Seeing* (London: Penguin, 1972), 46.

5. The journal article was written in 1973 and published in 1975. It is reprinted in Laura Mulvey, *Visual and Other Pleasures* (Bloomington: Indiana University Press, 1989), 14–26. Quotes are from pages 15–16.

6. Quotes are from "Afterthoughts on 'Visual Pleasure and Narrative Cinema' inspired by King Vidor's *Duel in the Sun* (1946)," in Mulvey, *Visual and Other Pleasures,* 30. See Teresa de Lauretis, *Alice Doesn't: Feminism, Semiotics, Cinema* (Bloomington: Indiana University Press, 1984); Mary Ann Doane, *The Desire to Desire: The Woman's Film of the 1940s* (Bloomington: Indiana University Press, 1986). See also *Feminism and Film Theory,* ed. Constance Penley (New York: Routledge, 1988).

7. De Lauretis, *Alice Doesn't,* 156, 143, 157. Jane Gaines and bell hooks, among others, have suggested that the story also needs to be rewritten so that it takes into account the ways in which gender is complicated by race and sexual preference. See Gaines, "White Privilege and Looking Relations: Race and Gender in Feminist Film Theory," *Screen* 29, no. 1 (Fall 1988), 12–27; hooks, *Black Looks: Race and Representation* (Boston: South End Press, 1992), 115–31.

8. The one exception is Wendy Leeks. See "Ingres Other-Wise," *Oxford Art Journal* 9, no. 1 (1986), 29–37; and, especially, her unpublished dissertation, "The 'Family Romance' and Repeated Themes in the Work of J.-A.-D. Ingres," Ph.D. diss., University of Leeds, 1990.

9. One of Ingres's most famous aphorisms is "Le dessin est la probité de l'art" (Drawing is the probity of art). See *Ingres raconté par lui-même et par ses amis,* ed. Pierre Courthion (Geneva: Vesenaz, 1947), 56.

10. The phrase *sujets érotiques* is used by the critic Guyot de Fère in opposition to Ingres's *sujets religieux.* See Guyot de Fère, "Beaux-arts: Exposition." *Journal des arts, des sciences et des lettres* (June–July 1855): 67.

11. For analyses of the binary relation of sexuality and for an excellent discussion of binary oppositions, see Judith Butler, *Gender Trouble* (New York: Routledge, 1990), 18ff. For the relationship between sex and gender, see ibid., 6–8; and Thomas Laqueur, *Making Sex: Body and Gender from the Greeks to Freud* (Cambridge, Mass.: Harvard University Press, 1990), 11–13.

12. The definition of essentialism is from Diana Fuss, *Essentially Speaking: Feminism, Nature and Difference* (New York: Routledge, 1989), xi. My discussion of essentialism and constructionism is indebted to Fuss. On the dangers of abolishing difference, see ibid., esp. 18ff.; and Luce Irigaray, *This Sex Which Is Not One,* trans. Catherine Porter (Ithaca, N.Y.:

Cornell University Press, 1985), especially her notion of hom(m)o-sexuality, or sameness, 172.

1. PROFILING HOMOEROTICISM: ACHILLES RECEIVING THE AMBASSADORS OF AGAMEMNON

A slightly different version of this chapter was published under the same title in *Art Bulletin* (June 1993): 259–74.

1. William Hogarth, *The Works of William Hogarth,* ed. John Nichols et al. (Philadelphia: George Barrie and Son, 1900), 7:73.

2. Thomas Crow, citing models of rhetorical decorum, refers to the ability of the heroic body to move from a warriorlike to a relaxed state. See Crow, "Revolutionary Activism and the Cult of Male Beauty in the Studio of David," in *Fictions of the French Revolution,* ed. Bernadette Fort (Evanston, Ill.: Northwestern University Press, 1991), 67–69.

3. It enabled him to spend five years at the French Academy in Rome. Due to lack of governmental funds, his sojourn began only in 1806.

4. "Le Sujet est le moment où les Grecs envoient des Ambassadeurs à Achille retiré dans sa tente, où Ils le trouvent avec Patrocle s'amusant à chanter Sur Sa lyre les exploits des heros. Homere, iliade livre 9e" (Philippe Grunchec, *Le Grand Prix de peinture: Le concours des Prix de Rome de 1797 à 1863* [Paris: Ecole nationale supérieure des beaux-arts, 1983], 132).

5. Like other works of the time, Le Brun's painting, which shows Alexander making a protective gesture toward his companion, Ephestion, implies homoeroticism. Ingres made a drawing of this subject early in his career (formerly Henri Lapauze collection, Paris), repr. in Alvar Gonzales-Palacios, "La Grammatica neoclassica," *Antichità viva* 4 (1973):41.

6. On the valorization of negotium by the men of the Revolution, see Dorinda Outram, *The Body in the French Revolution* (New Haven: Yale University Press, 1989), 69–72, 81.

7. For important recent discussions of the *Sabines,* see Ewa Lajer-Burcharth, "David's *Sabine Women:* Body, Gender and Republican Culture under the Directory," *Art History* 14, no. 3 (September 1991): 397–430; and Alex Potts, "Beautiful Bodies and Dying Heroes: Images of Ideal Manhood in the French Revolution," *History Workshop Journal* 30 (Autumn 1990): 3. Both articles are reprinted and revised in *David contre*

David, ed. Régis Michel (Paris: La Documentation française, 1993), 2 vols. See 1:471–91 and 2:647–69, respectively.

8. The critic Pierre Chaussard, for example, distinguishes between the beauty of Romulus, the superior hero, and that of the more virile Tatius. See Chaussard, *Sur le tableau des Sabines par David* (Paris: Charles Pougens, 1800), 7–8, cited in Potts, "Beautiful Bodies," 3.

9. Régis Michel, "Bara: Du martyr à l'éphèbe" in Marie-Pierre Foissy-Aufrère et al., *La Mort de Bara: De l'événement au mythe, autour du tableau de Jacques-Louis David* (Avignon: Musée Calvet, 1989), 73; and Crow, "Revolutionary Activism," 63ff. For an overview of this imagery, see Abigail Solomon-Godeau, "Male Trouble: A Crisis in Representation," *Art History* 16 (June 1993): 286–312.

10. Broc's painting is reproduced in Frederick J. Cummings, Pierre Rosenberg, and Robert Rosenblum, eds., *French Painting, 1774–1830: The Age of Revolution* (Detroit: Detroit Institute of Art; New York: Metropolitan Museum of Art, 1975), 180. It was first exhibited in 1801, the year Ingres won the Rome prize. On Winckelmann's homoerotic ideal, see Dennis M. Sweet, "The Personal, the Political, and the Aesthetic: Johann Joachim Winckelmann's German Enlightenment Life," in *The Pursuit of Sodomy: Male Homosexuality in Renaissance and Enlightenment Europe,* ed. Kent Gerard and Gert Hekma (New York and London: Harrington Park Press, 1989), 147–62; Sweet, "An Introduction to Classicist Aesthetics in Eighteenth-Century Germany: Winckelmann's Writings on Art," Ph.D diss., Stanford University, 1978; Potts, "Beautiful Bodies," 1–21; and Potts, *Flesh and the Ideal: Winckelmann and the Origins of Art History* (New Haven and London: Yale University Press, 1994).

11. For recent discussions, see Yvonne Korshak, "*Paris and Helen* by Jacques Louis David: Choice and Judgment on the Eve of the French Revolution," *Art Bulletin* 69, no. 1 (March 1987): 102–16, and Francis H. Dowley and Yvonne Korshak, "Discussion: An Exchange on Jacques Louis David's *Paris and Helen,*" *Art Bulletin* 70, no. 3 (September 1988): 504–20.

12. John J. Winkler describes Aphrodite as a "feminine" goddess, weak and unsuited for war (Winkler, *The Constraints of Desire: The Anthropology of Sex and Gender in Ancient Greece* [New York and London: Routledge, 1990], 169ff).

13. Quote from *L'Iliade d'Homère,* trans. Mme Dacier (Paris: G. Martin, H.-L. Guérin, A. Bou-

det, L. F. Delatour, 1756), 1:248, n. 273. David would appear to allude to this passage by including the prominent incense burner against the right wall in *Paris and Helen.*

14. Quote from *Les Oeuvres d'Homère,* trans. Mme Dacier (Leide: J. de Wetstein and Son, 1771), 3:21–22, n. 55. Dacier's interpretation differs dramatically from the way the passage is usually read today. When singing, Achilles is not so much being "noble and warlike" as not doing deeds. As such, he most resembles a poet, who is somehow neither male nor female (conversation with the classicist Meredith Hoppin, April 14, 1992).

15. A similar argument is made in Eve Kosofsky Sedgwick, *Between Men: English Literature and Homosocial Desire* (New York: Columbia University Press, 1985); and in Judith Butler, *Gender Trouble* (New York: Routledge, 1990). For an interesting reading of a related female spectator figure in several versions of Ingres's *Antiochus and Stratonice,* see Wendy Leeks, "The 'Family Romance' and Repeated Themes in the Work of J.-A.-D. Ingres," Ph.D. diss., University of Leeds, 1990, 73ff. If meant to represent Briseis, the female figure here violates the classical unity of time, for she should be still in Agamemnon's camp when the emissaries arrive at Achilles' tent. The figure of Phoenix does this as well, inasmuch as he suggests a later moment in the narrative, when Achilles has refused to return to the battle: "Le vieux Phoenix, guerrier vénérable, prend enfin la parole, en poussant des soupirs accompagnés de larmes; car il tremblait pour le sort de la flotte des grecs" (Paul-Jérémie Bitaubé, *Oeuvres completes* 2, 4th ed. [Paris: Dentu, 1804], 60).

16. I put the term *homosexuality* in quotes in the text because its use here is anachronistic. The word itself was not coined until 1891 in French (Claude Courouve, *Bibliographie des homosexualités* [Paris: Claude Courouve, s.d.]) and 1892 in English (David M. Halperin, *One Hundred Years of Homosexuality and Other Essays on Greek Love* [New York and London: Routledge, 1990], 15). It is usually argued that the concept of homosexuality as we know it came into being around this time. Writings about homosexual behavior and identity in eighteenth-century France are rare: see Maurice Lever, *Les Bûchers de Sodome* (Paris: Fayard, 1985); Michel Rey, "Police and Sodomy in Eighteenth-Century Paris: From Sin to Disorder," in Gerard and Hekma, *Pursuit of Sodomy,* 147–62); and Courouve, *Les Gens de la Manchette*

(Paris: Claude Courouve, 1978). I would like to thank Arlette Farge for calling my attention to Lever's and Courouve's books.

17. Quote from Halperin, *One Hundred Years of Homosexuality,* 87. For ancient interpretations, see Bernard Sergent, *Homosexuality in Greek Myth,* trans. Arthur Goldhammer (Boston: Beacon Press, 1986), 250ff; and Kenneth J. Dover, *Greek Homosexuality* (Cambridge, Mass.: Harvard University Press, 1978), 53. For contemporary interpretations, see John Boswell, *Same-Sex Unions in Premodern Europe* (New York: Villard Books, 1994), chap. 3; and Halperin, *One Hundred Years of Homosexuality,* 179, n. 63.

18. On the complexities of this issue and Plato's unusual conviction that Achilles was the eromenos in the relationship, see Dover, *Greek Homosexuality,* 53, 197; Sergent, *Homosexuality in Greek Myth,* 251; Halperin, *One Hundred Years of Homosexuality,* 86; and W. H. Clarke, "Achilles and Patroclus in Love," *Hermes* 106 (1978): 388. I would like to thank Mary Stieber for urging me to clarify this point.

19. I would like to thank Elizabeth McGowan for the observation about the shapes of lyre and torso. Consideration of the sculptural types arose from discussion with Richard Brilliant, July 1992. On the *Apollo Lykeios,* see G. E. Rizzo, *Prassitele* (Milan and Rome: Treves, Treccani, Tumminelli, 1932), 79–85; Charles Picard, *Manuel d'archéologie grecque* 4, pt. 1 (Paris: A. and J. Picard, 1954), figs. 140, 141, 145; and Margarete Bieber, *The Sculpture of the Hellenistic Age,* revised ed. (New York: Columbia University Press, 1961), 18 and fig. 17. On Skopas's *Pothos,* see Andrew Stewart, *Greek Sculpture: An Exploration* (New Haven: Yale University Press, 1990), 184, 284–85, and fig. 546.

20. "C'est dans l'état d'une société à demi-civilisée, que les passions et le sentiment se déploient avec plus d'énergie, et il n'y a pas eu de peuple plus sensible que les grecs" (Bitaubé, *Oeuvres complètes,* 1:29). See the list made by Armand Cambon of Ingres's books in the Musée Ingres, Montauban, France. Bitaubé, born in Germany to an old French family that had emigrated to Prussia after the Edict of Nantes was revoked, was a pastor in his native country before moving to France, where he translated the *Iliad* and the *Odyssey.* A member of the Institut de France and the Academy of Berlin (see Paul Mazon, *Madame Dacier et les traductions d'Homère en France* [Oxford: The Clarendon Press, 1936], 18), Bitaubé undoubtedly was familiar with the

work of Friedrich August Wolf, the dominant Greek scholar in North Germany, whom Goethe is said to have hidden behind a curtain to hear teach at Halle. Bitaubé's views about homosexuality in the ancient world may have been influenced by those of Wolf, who considered it standard in Greek society. See Friedrich August Wolf, *Prologomena to Homer* (1795), trans. A. Grafton, G. W. Most, and J. E. G. Zetzel (Princeton: Princeton University Press, 1985), 3.

21. Citing M. Roberts's *Histoire de l'Amérique,* Bitaubé writes: "Le mépris des femmes est le marque caractéristique des sauvages dans toutes les parties du globe. L'homme qui fait consister tout son mérite dans sa force et dans son courage, regarde sa femme comme une créature inférieure, et la traite avec dédain." For the latter quote: "Nous n'avons qu'un ami, il est tant de maîtresses!" (Bitaubé, *Oeuvres complètes* 3: 134). Bitaubé is typical of many classical scholars who have failed to recognize the alternation of homosexual and heterosexual preferences in the same individual.

22. Bone mingling, as it is alluded to here (ll. 83–92) can be read in a carnal sense (conversation with Elizabeth McGowan, September 1989). Homer reiterates reference to the joint burial of Achilles' and Patroclus's bones in Book 24 of the *Odyssey* (ll. 71–77).

23. For a discussion of late eighteenth-century deathbed scenes, see Robert Rosenblum, *Transformations in Late Eighteenth-Century Art* (Princeton: Princeton University Press, 1967), 28–35. For paintings of Briseis mourning the dead Patroclus, see, for example, the entries for the Rome prize competition of 1815, repr. in Grunchec, *Le Grand Prix de peinture,* 159. Halperin cites many of the textual examples that I have noted in Bitaubé's translation (Halperin, *One Hundred Years of Homosexuality,* 75–87).

24. For the *Pasquino* group, see Francis Haskell and Nicholas Penny, *Taste and the Antique* (New Haven: Yale University Press, 1981), 291–96. E. J. Johnson first suggested to me the parallel between Ingres's Ajax and the sculptural figure. For the *Faun,* see Haskell and Penny, *Taste and the Antique,* 209, fig. 108.

25. On this subject, see Foissy-Aufrère, "Bara: Ou la Belle Mort," in Foissy-Aufrère et al., *La Mort de Bara,* 21; both Nicole Loraux, "Mourir devant Troie, tomber pour Athènes: De la gloire du héros à l'idée de la cité," 27–43, and Jean-Pierre Vernant, "La Belle Mort et le cadavre ou-

trage," 41–79, in *La Mort: Les Morts dans les sociétés anciennes,* ed. Gherardo Gnioli and Jean-Pierre Vernant (Paris: Maison des sciences de l'homme, 1982); and Emily Vermeule, *Aspects of Death in Early Greek Art and Poetry* (Berkeley: University of California Press, 1979), esp. 83–117.

26. For Potts's argument, see Potts, "Beautiful Bodies," esp. 6. My attempt to address the issue of the feminized bodies was encouraged by John Goodman's "Notes Toward a History of the Gender Politics of Style in Prerevolutionary France" (Paper delivered at the Institute of Fine Arts, New York University, Oct. 1, 1993). On same-sex behavior, and particularly the analogies between teacher-student and father-son relationships, see Goodman's discussion of David and Drovais in ibid.; and Thomas E. Crow, *Emulation: Making Artists for the Revolution* (New Haven: Yale University Press, forthcoming).

27. For laws on homosexual behavior, see Lever, *Bûchers de Sodome,* 386; and Courouve, *Bibliographie des homosexualités,* 13. For political pornography, see Lynn Hunt, "Pornography and the French Revolution," in *The Invention of Pornography: Obscenity and the Origins of Modernity, 1500–1800,* ed. Lynn Hunt (New York: Zone Books, 1993), 308; Jeffrey Merrick, "Sexual Politics and Public Order in Late Eighteenth-Century France," *Journal of the History of Sexuality* 1 (1990), 68–84; and Antoine de Baecque, "Pamphlets: Libel and Political Mythology," in *Revolution in Print: The Press in France, 1775–1800,* ed. Robert Darnton and Daniel Roche (Berkeley: University of California Press, 1989), 165–75.

28. See also Flaxman's *The Embassy to Achilles,* one of his illustrations for the *Iliad,* reproduced in *Flaxman's Illustrations to Homer,* ed. Robert Essick and Jenijoy LaBelle (New York: Dover, 1977); and Asmus Carstens's watercolor, *The Heroes in Achilles' Tent* (1794, Nationalgalerie, Berlin, repr. in Alfred Kamphausen, *Asmus Jakob Carstens* [Neumunster in Holstein: K. Wachholtz, 1941], plate 18).

29. Winkler, *The Constraints of Desire,* 164–65. Marilyn Arthur (Katz) notes that the eighteenth-century view of Homer as barbaric does not distinguish between Homer and the classical view of what anthropologists call "a divided world," a world, that is, in which there is a principal opposition between masculine and feminine. Arthur

contends that in Homer's time this dichotomization is less rigid and that the opposition between public and private is nonexistent. See Arthur, "The Divided World of *Iliad* VI," in *Reflections of Women in Antiquity,* ed. Helene Foley (New York: Gordon and Breach Science Publishers, 1981), 19.

30. On the Civil Code and on feminists' views, see Claire Goldberg Moses, *French Feminism in the Nineteenth Century* (Albany: SUNY Press, 1984), 18ff. On women as silent witnesses, see Joan Landes, *Women and the Public Sphere in the Age of the French Revolution* (Ithaca: Cornell University Press, 1988), 152–68.

31. As Halperin put it: "Perhaps the impulse to explore and to fix more precisely the social meaning of friendship reflects a common desire, on the part of the interconnected cultures of the eastern Mediterranean around the turn of the first millennium, to claim and to colonize a larger share of public discourse, of cultural space, for the play of male subjectivity" (Halperin, *One Hundred Years of Homosexuality,* 85). He also cites D. Hammond and A. Jablow, "Gilgamesh and the Sundance Kid: The Myth of Male Friendship," in *The Making of Masculinities: The New Men's Studies,* ed. Harry Brod (Boston: Allen and Unwin, 1987): "With hindsight, the narratives of friendship seem to be political propaganda for abrogating familial ties in favor of male solidarity" (246). The same homosocial relations characterize the Rome prize competition and the academic system itself.

32. Anna Blume made this observation in conversation, August 1990.

33. Quote from Winkler, *Constraints of Desire,* 177. Landes, among others, has noted that organizations for women were liquidated in the wake of the Revolution and that the universalizing ideals of classicism and public values were consciously set in opposition to a feminine binary encompassing the particular and the private, Landes, *Women and the Public Sphere,* 12. The ways in which classicism was constructed have quite different ramifications for masculine roles. Although the classical world was associated with men's sexual freedom (Sweet, "Personal, Political, and Aesthetic," 153), there were limits: inasmuch as classicism was seen as antiaristocratic, it is perhaps not surprising that during this period sodomy was considered an aristocratic vice (Rey, "Police and Sodomy," 134–35).

1. See below, Chaps. 4 and 6.

2. A similar strategy informs Michelangelo's figures *Day* and *Night,* to which Ingres's pendant also owes a debt.

3. Quatremère de Quincy and the *secrétaire de la legation de France à Rome,* Artaud, found "l'ardeur contenue d'Apulée" in Canova's reclining group and "l'union celeste de l'Amour et de l'âme immortelle" in the standing version (cited in René Schneider, "L'art de Canova et la France impériale", *Revue des études napoléoniennes* 1 [1912]: 37). According to Leopoldo Cicognara, Murat commissioned the standing version, symbolizing innocence, as a pendant to the reclining version, symbolizing *volupté* (Cicognara, *Storia della scultura dal suo risorgimento in Italia fino al secolo di Canova,* vol. 7 [Prato: I Fratelli Giachetti, 1824], 259).

4. Mario Praz, "Canova, or the Erotic Frigidaire," *Art News* 56 (November 1957): 24–27+.

5. "Que ce tableau peut paraître un peu voluptueux à cette cour, d'en faire un autre de tout autre sujet, religieux ou autre" (cited in Hans Naef, "*La Dormeuse de Naples:* Un dessin inédit d'Ingres," *Revue de l'art,* no. 1–2 [1968]: 102). On Ingres's attempts to recover the *Sleeper of Naples,* see Nouvelles acquisitions françaises 22817, fol. 241, salle des manuscrits, Bibliothèque Nationale, Paris; and Hans Naef, "Un Chef-d'oeuvre retrouvé: *Le portrait de la reine Caroline Murat* par Ingres," *Revue de l'art,* no. 88 (1990): 11–20.

6. "Des obligéants, comme il y en a tant par le monde, ont accredité à ce qu'il paraît que j'ai eu l'intention de retracer les traits de Mme Murat dans cette peinture. Çela est absolument faux, mon modèle est à Rome, c'est une petite fille de 10 ans qui m'en a servi, et d'ailleurs ceux qui ont connu Mme Murat peuvent me juger" (letter to the comte de Narbonne-Pelet, French ambassador to Naples, cited in Naef, "Deux dessins d'Ingres, Monseigneur Cortois de Pressigny et le chevalier de Fontenay," *Revue de l'art,* no. 6 [1957]: 248).

7. Gérard Hubert, *La Sculpture dans l'Italie Napoléonienne* (Paris: Editeur E. de Boccard, 1964), 152.

8. Virtually all of the literature on Paolina Borghese includes discussion of her amorous adventures with men other than her two husbands, General Victor-Emmanuel Leclerc, who died in 1802, and Prince Camillo Borghese, whom she married in 1804.

9. "La *Vénus victorieuse* vint jouir d'un triomphe nouveau au palais Borghese, où elle fut, pendant un certain temps, exposée et livrée aux jugements du public. Le cortège des amateurs, tant de Rome que de l'étranger, ne cessoit point de se presser autour d'elle. Le jour ne suffisant pas à leur admiration, ils obtinrent de pouvoir la considérer de nuit, à la lumière des flambeaux, qui, comme l'on sait, accuse et fait découvrir les plus légères nuances du travail, et en accuse aussi les moindres négligences. On fut enfin obligé d'établir une enceinte, au moyen d'une barrière contre la foule, qui ne cessoit pas de se presser à l'entour" (Quatremère de Quincy, *Canova et ses ouvrages* [Paris: Adrien Le Clere et Cie, 1834], 149). Quatremère is undoubtedly referring to the moment when the statue was transferred from Paolina Borghese's residence in Torino, where it was displayed in her private apartment, to the Galleria Borghese in 1814.

10. Very little has been written on these subjects and this chapter makes no claims to be an exhaustive study of them. It should be seen as a preliminary step toward a more extended investigation of the taste for a sensualized neoclassicism during the Napoleonic period.

11. For socializing between Récamier and the Bonaparte sisters, see Edouard Herriot, *Madame Récamier et ses amis* (Paris: Plon, 1905), 1:60. Eight surviving letters, written by Caroline Murat to Mme Récamier from 1824 to 1838, in the Archives Nationales (31 AP 28 d. 598) indicate the longevity of their friendship. See also Jeanne-Françoise Récamier, *Souvenirs et correspondance tirés des papiers de Madame Récamier* (Paris: Michel Lévy Frères, 1859), 1: 275–76; 279–81; 2: 143–46; 177–78. Mme Récamier also visited the queen during her reign in Naples and subsequently during her exile in Trieste in May 1825.

One of the two busts inspired by Mme Récamier was later recast as *Beatrice* (Ennio Francia, "Madame Récamier a Roma e l'amicizia con Canova," *Strenna dei romanisti* 50 [1989]: 195–96.

12. Angelo Borzelli, *Le Relazioni del Canova con Napoli al tempo di Ferdinando I e di Gioacchino Murat* (Napoli: Emilio Prass, 1901), 21–28.

13. Mazois excavated Pompei under a contract from the queen and published his findings in *Les Ruines de Pompei* (Paris: Firmin Didot, 1824), 2 vols. (See Hans Naef, *Die Bildniszeichnungen* [Bern: Benteli Verlag, 1977], 1: 344ff.)

14. For their chronologies, see Francia, *Delfina de Custine, Luisa Stolberg, Giuliette Récamier a*

Canova: Lettere inedite (Roma: Edizioni di Storia e Letteratura, 1972), 127–28; and Naef, "Un Chef-d'oeuvre retrouvé," 12. On the recently rediscovered portrait of the queen of Naples, see below, Chap. 2. Ingres made several drawings for "un petit tableau de la noble famille." See Daniel Ternois, *Les Dessins d'Ingres au Musée de Montauban: Les portraits* (Paris: Les Presses artistiques, 1959), vol. 3, nos. 139–48; Naef, *Die Bildniszeichnungen* 4: 210–21; and Henry Lapauze, *Le Roman d'amour de M. Ingres* (Paris: P. Lafitte et Cie., 1910), 268, cited in Naef, "Un Chef-d'oeuvre retrouvé," 12.

15. For 1808 works, see François Boyer, "Autour de Canova et de Napoléon," *Revue des études italiennes* (July–September 1937): 215; and Italo Faldi, *Galleria Borghese: Le Sculture dal secolo XVI al XIX* (Roma: Istituto Poligrafico dello Stato, 1954), 46. A drawing by Pelagio Palagi illustrates the visit of Murat to the exhibition on the morning of November 14, 1809 (repr. in Elena di Majo et al., *Bertel Thorvaldsen* [Roma: De Luca Edizioni d'Arte, 1989], 8). For the disparity between the list of works to be sent to Paris and the works actually sent, see Procès-verbaux de la classe des Beaux-Arts An 14; 2 E2, p. 238 (Archives de l'Institut: Institut Nationale), which includes the *Sleeper,* described as "Une femme couchée"; and the séance du samedi 16.7bre, 1809: 5 E4 dr 1809) (Archives de l'Institut de France), which does not include it. Both documents are reprinted in Marcel Bonnaire, *Procès-Verbaux de l'Académie des Beaux-Arts* (Paris: Librairie Armand Colin, 1943), 2: 195, 268–69.

16. This hypothetical scenario does not preclude other ways of reading the pendant. It would be interesting to chart, for example, the possible connections of this pendant to the paintings in the gallery of Francis I at Fontainebleau, a Napoleonic residence during the years in question. I have in mind the relationship between Primaticcio's so-called earthly Venus and the *Grande Odalisque* and similar oppositions between front and back views in a number of these mannerist works.

17. On Mme Récamier, see Francia, *Delfina de Custine,* 122. On Paolina Borghese's statue, see Quatremère de Quincy, cited in n. 9; on Caroline Murat, see Margery Weiner, *The Parvenu Princesses* (London: John Murray, 1964), 211. For an analysis of the supposed inappropriateness of women in the public sphere, see Sarah Maza, "The Diamond Necklace Affair Revisited (1785–1786): The Case of the Missing Queen," and

Lynn Hunt, "The Many Bodies of Marie Antoinette: Political Pornography and the Problem of the Feminine in the French Revolution," both in *Eroticism and the Body Politic,* ed. Lynn Hunt (Baltimore: Johns Hopkins University Press, 1991), 63–89 and 108–30. See also Landes, *Women and the Public Sphere,* 93ff.

18. On Mme Récamier's preference for Gérard's portrait, see Anita Brookner, *Jacques-Louis David* (New York: Harper and Row, 1980), 145.

19. See Gérard, *Portrait de Caroline Murat avec ses enfants Achille et Laetitia,* 1803, repr. in Comtesse Rasponi, *Souvenirs d'enfance d'une fille de Joachim Murat, La Princesse Louise Murat Comtesse Rasponi, 1805–1815* (Paris: Perrin et Cie., 1929), facing 20; and Vigée-Lebrun, *Portrait de Caroline Murat avec sa fille Laetitia,* repr. in Hubert Cole, *The Betrayers Joachim and Caroline Murat* (London: Eyre Methuen, 1972), plate 10. For an analysis of portraits of women emphasizing their maternal role, see Carol Duncan, "Happy Mothers and Other New Ideas in Eighteenth-Century French Art," reprinted in *Feminism and Art History,* ed. Norma Broude and Mary D. Garrard (New York: Harper and Row, 1982), 200–219.

20. Cavaignac quote ("Madame Murat surtout avait la manie de régner") in Mme Cavaignac, *Mémoires d'une inconnue, 1780–1816* (Paris: Plon, 1894), 231. Niepperg cited in Cole, *The Betrayers,* 240.

21. "Les droits éventuels et successoraux de la reine Caroline" and "la cession était faite surtout en sa faveur," cited in Albert Vandal, "Le Roi et la reine de Naples (1801–1812)," *Revue des deux mondes* (February 1, 1910): 488. For the queen's roles, see ibid. (Feb. 15, 1910): 767, 771–72.

22. La Feuillade d'Aubusson, "Murat et Caroline en 1809," *Feuilles d'histoire* (1910). A copy of this article, in longhand, is in the Archives Nationales, Paris: 31 AP 47: 1–13. A letter demonstrates that Napoleon took to heart La Feuillade d'Aubusson's communications: "S'il [Murat] a des droits à mes bontés pour ses services militaires que je sais apprécier, il n'a rien fait pour être Roi; il le doit à son union avec ma soeur; il doit donc avoir en elle confiance et ménagements" (letter from the Emperor to Maréchal Berthier, cited in Vandal, "Le Roi et la Reine de Naples" [February 22, 1910]: 49).

23. "C'est la tête de Cromwell sur le corps d'une jolie femme," cited in Comtesse Rasponi, *Souvenirs d'enfance,* 83.

24. Naef, "Un Chef-d'oeuvre retrouvé," 11–20.

25. The portrait *Bonaparte as First Consul* is much larger (225.7 × 144.2 cm) than *Queen Caroline Murat* (92 × 60 cm).

26. The costume in *Queen Caroline Murat* is curious. Hélène Toussaint has suggested that it may have been reworked after Murat's death to suggest mourning (conversation, November 1990). Ingres indicated that there was extensive repainting involved and that the portrait was not without problems (see Lapauze, *Le Roman d'amour*, 267). However, a conservation report dating from September 23, 1988 (Private collection) describes only one pentimento—in the placement of the clock—adding that layers of discolored varnish are evident on the queen's dress.

27. See Cole, *The Betrayers*, 202ff, for regency. Given both Ingres's increasing reliance on the napoléonides for patronage and certain events in his private life—his father's death in March 1814, the stillbirth of his first, and, as it turned out, his only child, in August—there was a distinctly personal component to this wish for continuity.

28. See Lapauze, *Le Roman d'amour*, 267.

29. Quoted passages are from René Schneider, "L'Art anacréontique ou alexandrin sous l'Empire," *Revue des études napoléoniennes* [1916] 2:258. "Le goût de la mythologie gracieuse, tendre et voluptueuse, et par conséquent de la forme jolie, jolie souvent jusqu'à la manière. L'inspiration en vient de la Grèce d'Orient, soit de celle d'Anacréon de Téos et de Sapho de Lesbos, qui vivaient au VIe siècle, soit des époques hellénistique et greco-romaine, où domine l'esprit alexandrin. C'est de cette dernière source que l'Empire est le plus avide. Entre le mort d'Alexandre et Hadrien l'hellénisme, fatigué d'epopée, puis habitué à la sujétion romaine, s'était laissé aller à la douceur de vivre dans les sites privilégiés d'Asie Mineure, d'Egypte ou de Campanie, et avait bercé son imagination de jolies fables où Eros joue le meilleur rôle, d'abstractions ingéniéuses, et de pastorales où la rusticité n'est qu'un ragoût de blasés. La France, en pleine épopée impériale, fait comme lui, et d'après lui." On anacreontism, see also Schneider, "L'art de Canova," 36–57.

30. "Ora meritatamente si ammira la vivacità, la grazia, colla quale è dipinta la donna nuda che dorme, di grandezza naturale" (Visconti, cited in Elena di Majo et al., *Bertel Thorvaldsen*, 22, n. 12).

31. "Je ne crains pas d'affirmer qu'on lui reconnaîtra toujours deux mérites éminens, celui de donner la vie à ses figures, et celui de la grâce, dont on peut dire aussi quelquefois en sculp-

ture qu'elle est plus belle que la beauté" (Quatremère de Quincy, "Sur M. Canova, et les quatre ouvrages qu'on voit de lui à l'exposition publique de 1808," *Le Moniteur universel* [December 28, 1808]: 1429–30).

32. "Conviene pur confessarlo, che mentre il perfetto ci riempie d'altissima ammirazione, siam trascinati ad amare e preferire il grazioso." From "Della Grazia," fifth argument in *Del Bello*, cited in Leopoldo Cicognara, *Lettere ad Antonio Canova*, ed. Gianni Venturi (Urbino: Argaglia Editore, 1973), xvi. Begun in 1802, *Del Bello* was first published in Florence in 1808.

33. Quotations from Quatremère de Quincy, "Sur M. Canova," 1429: "De donner de la vie à ses figures"; "un morceau tout de sentiment"; "Qui nous dira si ce n'est pas à cette grâce qui enchante dans tous ses ouvrages, cette mollesse de pose, cette amabilité de physionomie, ces mouvements gracieux, ces formes moelleuses et ce travail flatteur du marbre qui le distingue et qu'on admire dans son groupe de l'Amour et Psyché?"

34. "Ma pare che il Canova paventasse la terribile gara dell'arte col greco scultore; onde abbellì invece la sua nuova dea di tutte quelle grazie che spirano un non so che di terreno, ma che muovono più facilmente il cuore fatto anch'esso d'argilla" (Foscolo, cited in Francesca Romana Fratini, "Opere di scultura e plastica di Antonio Canova, di Isabella Teotichi Albrizzi," *Studi canoviani* [Quaderni sul neoclassico] [Rome: Bulzoni, 1973], 45, n. 5.) The *Venus Italica*, which Napoleon commissioned to replace the *Medici Venus* in the Pitti Palace, arrived in Florence on April 29, 1812, approximately ten years after the ancient work was taken to Paris as the "bride" for the *Apollo Belvedere* (Hugh Honour, "Canova's Statues of Venus," *Burlington Magazine* 114 [October 1972]: 658, 665–66).

35. "Naturellement, c'est chez les femmes surtout qui sévit la contagion. Canova, Chinard, Prudhon, sont les favoris de Mmes de Groslier, Récamier et Regnault de St-Jean-d'Angély. Gérard exerce sur elles une égale séduction. . . . Mais la plus éprise de cet art est la femme même du maître: Joséphine. Elle a fait de la Malmaison un sanctuaire d'alexandrinisme, où collaborent son goût inné de la grâce abandonnée, le sentimentalisme mythologique de la fin du XVIIIe s., et l'hellénisme campanien" (Schneider, "L'Art anacréontique," 259).

36. The choice of language is revealing here: the feminine as other is often linked to notions of

plague or disease as well as to seduction. Plague and disease metaphors have been applied more recently to those afflicted with AIDS. See Simon Watney, *Policing Desire: Pornography, AIDS, and the Media* (London: Methuen, 1987), 7–57, and Cindy Patton, *Sex and Germs: The Politics of AIDS* (London: South End Press, 1985).

37. "Quand les militaires reviennent d'une campagne, ils aiment retrouver chez eux cet alibi de mythologie gracieuse et amoureuse. La Maison de l'Empereur commande à Callamard la statue d'*Hyacinthe blessé* (1811). Murat est tout heureux d'installer dans son château de Villiers deux groupes de Canova, l'*Amour et Psyché* (1802)" (Schneider, "L'Art anacréontique," 258).

38. For the approach emphasizing feminine taste, see Eleanor Tufts, *Our Hidden Heritage* (London: Paddington Press, 1974); Karen Petersen and J. J. Wilson, *Women Artists: Recognition and Reappraisal From the Early Middle Ages to the Twentieth Century* (New York: Harper and Row, 1976); Ann Sutherland Harris and Linda Nochlin, *Women Artists, 1550–1850* (Los Angeles: Los Angeles County Museum of Art, 1976). For a critique, see Lisa Tickner, "Feminism, Art History, and Sexual Difference," *Genders* (November 3, 1988): 93–128.

39. On the napoléonides and patronage, see especially Paul Marmottan, *Les Arts en Toscane sous Napoléon: La Princesse Elisa* (Paris: H. Champion, 1901) and *Murat à l'Elysée* (Paris: P. Chéronnet, 1912); *The Taste of Napoleon,* Nelson Gallery of Art and Mary Atkins Museum of Fine Art, 1969; William Buchanan, *Memoirs of Painting with a chronological history of the Importation of Pictures by the Great Masters into England* (London: R. Ackermann, 1824), v. 2, 269–294 and François Piétri, *Lucien Bonaparte* (Paris: Plon, 1939). On Josephine's collection in particular see *Catalogue des tableaux de sa majesté l'impératrice Joséphine* (Paris: l'Imprimerie de Didot Jeune, 1811); M. de Lescure, *Le Château de la Malmaison* (Paris: Plon, 1867); and Serge Grandjean, *Inventaire après décès de l'impératrice Joséphine à Malmaison* (Paris: Réunion des musées nationaux, 1964). Auguste Garnerey's watercolor view of the music room (1812; château de Malmaison), containing many of the Empress's paintings, is reproduced in ibid.

40. "Sous le couvert de Napoléon" (Grandjean, *Inventaire,* 37).

41. For the Murats' purchases, see Marmottan, *Murat à l'Elysée,* 23–34. For the Ingres's

paintings, see Patricia Condon, with Marjorie B. Cohn and Agnes Mongan, *In Pursuit of Perfection: The Art of J.-A.-D. Ingres* (Louisville, Ky.: J. B. Speed Art Museum, 1983), 70; and Leeks, "*Family Romance,*" 222–24.

42. Ingres uses the phrase "innocent love" in his ninth notebook, cited in Condon et al., *Pursuit of Perfection,* from which I draw the larger quotation, 70.

43. Schneider, "L'Art anacréontique," 258.

44. "Paolo n'est pas un homme, c'est un baiser" (About cited in Marie-Claude Chaudonneret, "Ingres: Paolo et Francesca," Galérie d'Essai, Ville de Bayonne, Musée Bayonne [dossier], no pagination).

45. Indeed, the Hellenizing classicism described by Schneider *is* Asian; while the classical pedigree in no way diminishes the ideological imperialism at the heart of the *Grande Odalisque* and other orientalist works, it does soften the timeworn distinction between the *Sleeper of Naples* as classical nude and the *Grande Odalisque* as orientalist nude.

46. The phrase is used by David d'Angers in discussing Canova (Henry Jouin, *David d'Angers: Sa Vie, Son Oeuvre, Ses Ecrits Et Ses Contemporains* [Paris: E. Plon et Cie, 1878], 1: 76–77).

47. No women wrote Salon criticism on Ingres under their own names during this period. Under the pseudonym Claude Vignon, Noémie Cadiot discussed Ingres, but her criticism in no way distinguishes itself from that of her male colleagues. See Vignon, *Exposition universelle de 1855: Beaux-Arts* (Paris: Librairie d'Auguste Fontaine, 1855): 186–92.

48. Isabella Teotichi Albrizzi, *Opere di Scultura e di Plastica di Antonio Canova* (Florence: Molini, Landi, 1809). All references to this volume and the subsequent edition (Pisa: Niccolo Capurrò, 1821–1824), 4 vols., appear in parentheses within the body of the text.

49. Fratini, "Opere di scultura," 62.

50. "Egli è vero che le grandi passioni alterano, e quasi dissi, sfigurano i delicati e difficili lineamenti della bellezza; quindi giusto è che la rappresentazione loro sia vietata nell'Arte; ma un mansueto desiderio di piacere, di gioire, d'amare, d'essere amata, forse-che per lo contrario non la rende maggiore, e più cara? È non è forse un tal sentimento, che c'invita a preferire un volto meno avvenente, ma più animato, ad un altro, che nulla al nostro spirito, al nostro cuore, alla nostra immaginazione dica, o richieda? Sembra che Ca-

nova, dando peso egli stesso a questa obbiezione, abbia voluto riscaldare col fuoco divino, che per le vene le scorre, il volto della bellissima sua Venere."

51. "Io dunque ad altro non aspiro, che a risvegliare, s'è possibile, in qualche parte almeno, in voi, ed in quelli che per avventura leggeranno queste mie descrizioni, quei medisimi sentimenti, che le produzioni sublimi del più gran Genio dell'età nostra, in fatto di Belle Arti, hanno destato nel animo mio."

52. "In ogni modo, non avendo l'orgoglio (che d'ogni singolarità l'amor proprio si crea fonte d'orgorglio) di credere unico il mio modo di pensare, voglio lusingarmi di non dispiacere nè a Voi, per quella tanta analogia di cuore e di spirito che ci lega, nè a quelli che per avventura penseranno come io penso su questo proposito. . . . E riguardo all'amor proprio, certo essendo dell'indulgenza degli uomini in generale per un sesso, verso di cui si compiacciono piuttosto di esercitare la generosità che la giustizia, sotto l'egida possente e sicura dell'altrui amor proprio, io mi lusingo di mettere il mio pienamente a ricovero."

53. "La figura di Teseo è bella di bellezza ideale. Grande energia di muscoli, robustezza di membra, eroica nobiltà in tutta la persona e nei tratti del volto specialmente. Ogni uomo che l'ammira vorrebbe rassomigliargli; ed ogni donna si sente in petto il cuore di Arianna."

54. "Adone, quajsi per dirle addio, mentre già muove il passo per andarsene, l'abbraccia poco al di sotto delle reni, e la guarda. Ma che? quel suo braccio non stringe, quel suo sguardo non guarda. Essa respira il più caldo affetto; egli il freddo, ed in tale circostanza ingrato, sentimento della riconoscenza. Questo delizioso gruppo sarà certamente ammirato dai due sessi; ma piacerà meno alle donne. Nè pure in marmo soffrono elleno d'ispirare un sentimento più debole di quello che provano! Se una donna avesse concepito l'idea di questo bel gruppo, egli è certo che Adone avrebbe il sentimento di Venere, e Venere quello di Adone."

55. "Viene trovato generalmente che qui la Madre d'Amore, malgrado la seducente mollezza de' suoi be' muscoli, le forme sovrumane del volto, e l'affetto, che si spande dal cuore, e che cotanto un volto abbellisce, piace meno d'Adone. Accaderebbe ciò forse appunto perchè Venere priega? O quale lezione per il mio sesso! Donne gentili, quai diverreste voi, se Venere stessa perde delle sue attrattive, pregando?"

56. "Or, mi tocca,—e vorrei che non m'avanzasse più foglio,—ma mi tocca pur troppo, e tremando—nè io son facile a tremare—parlarvi della Venere del Canova. Che dirò? che non dirò? . . . Io dunque ho visitata, e rivisitata, e amoreggiata, e baciata, e—ma che nessuno il risappia,—ho anche una volta accarezzata, questa Venere nuova. Non importa che io, per dirvene un mio parere, torni a vederla; si perchè incancherito come son io, non posso uscire sotto il diluvio di tant 'acqua per cui l'Arno ier l'altro sera uscì a passeggiare per Firenze: si perch'io ho tutto nella mente nel cuore il bel simulacro di quella Diva" (letter of October 15, 1812, cited in Fratini, "Opere di scultura," 45, n. 5).

57. "Una bocca vergine sulla quale avrei sospirato appena, ma non avrei osata di baciarla" (letter to Signora Cornelia Martinetti, August 1812, cited in Fratini, "Opere di scultura," 45, n. 5).

58. "Al calcagno, alle caviglie, sotto le piante, sulle dita, tutto è raddolcito dalla più morbida pastosità, e tutto sembra informato da uno spirito celeste. . . . Figlia di Giunone e di CANOVA, sensibile simulacro d'un essere non visibile quanto non sei bella! pure bella come sei, lunghi dal sedurmi i sensi colle attrattive del piacere, mi trasporti l'anima nel soggiorno delle intelligenze perfette" (*L'Ebe di Antonio Canova ordinata e posseduta dal Conte Giuseppe Albrizzi e descritta da Vittorio Barzoni* [Venice: Carlo Palese, 1803], 11.). Essentially a pamphlet, this is one of many modest panegyrics, either in prose or in verse, dedicated to a specific work by Canova. It was probably financed by Count Giuseppe Albrizzi, who owned the statue.

59. ("I didn't know how . . . ") "Non sapeva staccarmene: nondimeno era divota e meravigliosa adorazione, non altro." ("When I saw . . . ") "Ma quando vidi questa divinità del Canova, me le sono subito seduto vicino, con una certa rispettosa domestichezza, e trovandomi un'altra volta soletto presso di lei, ho sospirato con mille desiderii, e con mille rimembranze nell'anima." ("If the Venus . . . ") "Insomma, se la Venere de' Medici è bellissima dea, questa che io guardo e riguardo è bellissima donna; l'una mi faceva sperare il Paradiso fuori di questo mondo, e questa me lusinga del Paradiso anche in questa valle di lagrime. Quanto al lavoro, segnatamente nell'atteggiamento voluttuoso del collo; nell'amorosa verecondia del volto e degli occhi, e nella mossa amabile della testa; ma benchè la volutta, la verecondia e l'amore sieno doti celesti, per cui la mi-

sera e triste natura nostra partecipa talor del divino, son pur sempre doti che ricordano l'umanità." Passages are cited in Fratini, "Opere di scultura," 45–46. The part of Foscolo's description in which Venus combines voluptuousness and modesty under the rubric of love can be aligned with Albrizzi's conjunction of "la seducente mollezza de' suoi be' muscoli, le forme sovraumane del volto, e l'affetto, che si spande dal cuore, e che cotanto un volto abbellisce" of "la Madre d'Amore," cited below. The need to domesticate sensuality by means of a moralizing dimension is apparent in such descriptions.

60. Canova enhanced the confusion between representation and life for the viewer by applying tints to the marble.

61. "On la dirait vivante. Le sculpteur de Vénus semble avoir emprunté pour son ciseau quelque chose de la douceur des pinceaux du Titien, son compatriote. La grâce avec laquelle les épaules et le cou sont attachés, les lignes du torse, les extrémités précieusement finies, forment une série de perfections que les élèves ne sauraient trop étudier, et dont on trouverait difficilement un modèle autre part que dans un autre ouvrage de Canova" (M. H. De Latouche, *Oeuvre de Canova: Recueil de gravures d'après ses statues et ses basreliefs* [Paris: Audot, 1824], no pagination).

62. "Eppur essa non apriva bocca; e appena si lasciò dir da me sommessamente alcune paroline, e mi rispose in modo che nessuno c'intese. Ah, s'io potessi pigliarmi confidenza! . . . e giurerei di non baciarla che sulla fronte; ma mi si raffrederebbero le labbra, perche là è una Musa scolpita da Canova" (Foscolo, cited in Fratini, "Opere di scultura," 45, n. 5).

63. "Donne vezzose, che avete l'animo naturalmente ad amare inclinato, guardatelo si questo giovane pericoloso, ma passate oltre, e troppo in esso non arrestate lo sguardo. Giujnone e Diana erano Dee, erano immortali. Temete gl'ineguali imenei."

64. "Era Paride bello come un bel Dio: lo disse Omero, e pare che il solo Canova l'udisse, o l'intendesse. Quanta soavità, quanta grazia, quanta semplicità, quanta armonica proporzione di membra! O Paride bellissimo! A te fra tutte le creazioni di Canova, a te ognuno offrirebbe quel pomo, che a Venere tu serbi: se non che una sola era la perfetta bellezza, che a te s'affaccia; ma qui, fra tante meraviglie del tuo Scultore, chi mai può essere abbastanza ardito per scegliere?"

65. ". . . e mossela nella vezzosa e seducente attitudine di chi se n'esce allora allora [sic] del

bagno; quando le freschissime membra acqua stillanti offrono agli occhi quella vaghezza, e destano quella inesprimibile voluttà. . . . Che dirò poi del dolce riso, che sulle labbra le spunta; del collo, del petto, che bellissimo sorge con castigato piccioletta mole; del dorso, che con dolcissima curva verso gli omeri s'innalza, e dolcissimamente discende sino al cader delle reni? L'occhio avido di celeste piacere si pasce di tante bellezze senza saziarsi, intantochè non più freddo, nè inanimato gli comparisce il marmo rammorbidito." Albrizzi's description of the *Venus Italica* may well have been influenced by Foscolo's, cited in part above and in full in Fratini, "Opere di scultura," 45–46, n. 5.

66. "Ueber den Bildhauer Antonio Canova," *Römische Studien* I (Zurich: Gessner, 1806). It was amply summarized in *Memorie Enciclopediche di Napoli* in the same year. I have relied on the English version, "Canova and His Works," published in *Dublin University Magazine* 23 (April 1844): 469–78; and 24 (August/September 1844): 162–74, 289–300. All references to Fernow's study will appear in parentheses in the text.

67. ("He has too much talent . . .") Car il a trop de talent pour n'avoir pas des envieux." ("Nonetheless, Monsieur Canova . . .") "Quoi qu'il en soit, Monsieur Canova a voulu répondre à cette objection, comme il appartient à l'homme de mérite de répliquer à la critique, c'est-à-dire, par les ouvrages qui la désarment. . . . Il s'est exercé depuis une dizaine d'années à de grands sujets, qui éxigent le style le plus vigoureux, la plus grande force de dessin, et toute la hardiesse du ciseau le plus savant. . . . On pourra juger par là, quels que soient ses succès, que du moins il n'a craint de se mesurer avec aucun genre de nature de style et de sujets: et ce noble effort d'une ambition désintéressée, qui s'impose les plus pénibles tâches pour le seul honneur de lutter dans toutes les carrières ouvertes au génie de l'art, suffit pour donner une haute idée et de la noblesse du caractère de l'artiste, et du ressort qui donne l'impulsion à son talent, et des résultats qu'on peut en attendre" (Quatremère de Quincy, "Sur Canova," 1430).

68. "Dès 1802, lorsque Canova, cherchant à toucher l'Ecole française au coeur, c'est-à-dire à l'Institut, voulut offrir à celui-ci le plâtre du Pugilateur Crégas, tout bosselé de muscles, pour prouver aux Français qu'il n'était pas apte qu'à la grâce, c'est à Murat, prince de l'énergie, qu'il songea pour le présenter en séance à la section des

Beaux-Arts" (anonymous critic in *Le Moniteur Universel,* cited in René Schneider, "L'Art de Canova," 47). The choice of Murat illustrates how stereotypes are used both to legitimize and to mask contradictions. This man, who so obviously embodied the stereotypical male attributes of courage and military prowess, was actually responsible for putting Canova's anacreontic works on the map. (See Boyer, "Autour de Canova," 206–07.) On the other hand, Murat also was notoriously foppish in his appearance and at the time generally perceived to wield no political power.

69. "Or, voici un artiste féminin, féminin en dépit du colossal, de l'Hercule et Lycas et du Pugilateur, féminin jusqu'à la pointe du ciseau. La femme règne dans son oeuvre, qu'elle a d'ailleurs spontanément adoptée: Joséphine, Marie-Louise, Elisa, Pauline, Caroline, Mme Récamier, Mme de Staël-Corinne, Mme de Groslier, Mme Vigée-Lebrun, la comtesse Albany, toutes, s'y reconnaissent et s'y aiment. Cheveux, oreilles, extrémités, y sont soignés dans le détail avec coquetterie. Sur les formes rondes, savonneuses, l'oeil et la main glissent, sans rencontrer aucun des ressauts de la vie, muscles, plis, ou veines. L'adolescence et l'éphèbie le séduisent autant que la femme, l'androgynie attire cette plastique emasculée: la Nymphe endormie est une réminiscence à peine déguisée du type de l'Hermaphrodite. Il aime l'albâtre, moins mâle que le marbre" (Schneider, "L'Art de Canova," 55). See also David d'Angers' response to Canova's works, originally published in 1844, and cited in Jouin, *David d'Angers,* 76–77.

70. "L'expression de la force et du caractère énergique": this is a phrase Quatremère de Quincy used in his defense of Canova ("Sur Canova," 1430). For *Hercules and the Pgymies,* see Cahier I, fol. 118v., Musée Ingres, Montauban, France. For the Château of Dampierrre, see Carol Ockman, "The Restoration of the Château of Dampierre: Ingres, the Duc de Luynes and an Unrealized Vision of History" (Ph.D. diss., Yale University, 1982). When *Jupiter and Thetis* was submitted as an *envoi* in 1811, the judges at the Institut de France considered the god's torso to be "d'une largeur exagérée dans sa partie supérieure, et étroit à l'attache des hanches" (Archives de l'Académie des Beaux-Arts: Procès verbaux de la Classe des Beaux-Arts, 5 E5 Dec. 28, 1811). For the exaggerated musculature in the *Saint Symphorian,* see below, Chapter 4.

3. TWO LARGE EYEBROWS À L'ORIENTALE: THE BARONNE DE ROTHSCHILD

Earlier versions of this chapter appeared in *Art History* 14, no. 4 (December 1991): 521–39, and, in abridged form, in *Jewish Quarterly* 39 (Autumn 1992): 12–15.

1. "Le premier aspect de ce portrait cause un peu de surprise. L'oeil a besoin de se faire au luxe de tons rouges qui le frappe d'abord; mais, une fois entré dans cette gamme de couleurs, il ne peut se lasser d'en admirer la précision et la richesse. Le spectateur, captivé par ce coloris inattendu, se reporte par la mémoire aux précédens portraits de l'auteur, dans lesquels la perfection du dessin, l'extrême vérité des attitudes, l'étude des détails poussée à sa dernière limite, avaient suffi, même en l'absence de couleur, à créer des oeuvres si remarquables, et retrouvant ici ces qualités agrandies et complétées, il n'hésite pas à placer cet ouvrage au premier rang.

"Les épaules éblouissantes s'enlèvent richement sur le velours foncé des coussins. Et les étoffes! A coup sûr, elles sont de fabrique vénitienne, et n'eussent point déshonoré les épaules d'un doge" (L. de Geffroy, "Beaux-Arts.—L'Anadyomène.—Le portrait de Madame de Rothschild, par M. Ingres," *Revue des Deux Mondes* (August 1, 1848), 447–48. The green background corresponds to the interior of the Hôtel Fouché, purchased by the Rothschilds in 1824.

2. "Le choix d'une pose est d'ordinaire, chez lui, le fruit d'observations assidues, faites le plus souvent à la dérobée, et ce n'est pas une des moindres causes de la grande ressemblance qu'il sait donner à ses portraits. Pourquoi juge-t-on le plus souvent, sans connaître les originaux, que ces portraits doivent être ressemblans? C'est qu'on y trouve un tel réalisme, une telle vérité de détails techniques, qu'on sait que rien n'est là sans motif, rien n'a été livré au hasard, que c'est la vie prise sur le fait;" And "Les bras et les épaules sont d'un beau dessin et modelés presque sans aucune ombre; l'oeil tourne autour." Geffroy reports that in response to a complaint from the baroness, Ingres replied: "Madame, répond-il flegmatiquement, c'est pour moi que je peins et non pour vous. Plutôt que d'y rien changer, je garderai le portrait." The critic adds: " . . . il eût fait comme il disait. M. Ingres, du reste, avait raison;" Responding to the charge that there were few fine portraitists at the time of Diderot, Geffroy asserts: "L'école française, depuis David, s'est rele-

vée de cette infériorité, et, de nos jours, M. Ingres et ses principaux élèves contribuent à maintenir à la hauteur où l'ont placé les grands maîtres un genre, qui, suivant l'expression, doit être particulièrement honoré chez un peuple républicain, où il convient d'attacher les regards des citoyens sur les defenseurs de leurs droits et de leurs libertés" (Geffroy, "Beaux-Arts," 448–49).

3. "Le modèle, assis sur un divan, se présente de face, dans l'attitude d'une causette attentive, les genoux croisées, la main gauche soutenant légèrement le menton, le bras droit jeté en travers avec abandon et tenant un éventail fermé. La tête est coiffée d'un *petit-bord* de velours noir, attaché en arrière et orné de deux plumes blanches qui retombent à droite et à gauche, encadrant une chevelure à reflets bleuâtres comme l'aile du corbeau. . . . Deux grands sourcils à l'orientale se dessinent sur ce front, d'une pâte brillante; dans les yeux, à l'avenant, pétillent la vie et l'esprit. . . . Rien de plus doux et de plus intelligent à la fois que ce regard, qui est à coup sûr celui d'une femme spirituelle. . . . Rien de plus vivant que cette tête" (Geffroy, "Beaux-Arts," 447).

4. The attitudes of ancient statues, loosely transposed, inform Ingres's late portraits (see Edgar Munhall, *Ingres and the Comtesse d'Haussonville* [New York: Frick Collection, 1985], chap. 4), but the likely models for the *Baronne James de Rothschild*—a variant of the Pudicity pose (see plate 102, fig. 612 in Bieber, *Ancient Copies* [New York: New York University Press, 1977]) or a crouching Aphrodite (see p. 339 in Salomon Reinach, *Répertoire de la statuaire grecque et romaine*, vol. 1 [Paris: Ernest Leroux, 1906])—do not have the crossed legs found in the painting and, even more clearly, in the drawings (see especially the amusing study for the corsage and bare crossed legs, Musée Bonnat, Bayonne, no. 1019). In fact, I know of no other society portraits of respectable women showing them with legs crossed. Crossed legs do appear in portraits of women with less respectable occupations, for example a photograph of the dancer Rose Deschamps (repr. in F. Loliée, *La Fête Impériale* [Paris: Jules Tallandier, 1926], opposite 112). I would like to thank Cornelius Vermeule for his thoughts on ancient poses.

5. My principal source for information about Baron James and his family is Anka Muhlstein, *Baron James: The Rise of the French Rothschilds* (New York: Vendome, 1983).

6. "Si son chemin de fer marche bien, ce sera la Compagnie du Nord. Si son chemin de fer marche moyennement bien, ce sera la Compagnie Rothschild. Si son chemin de fer va mal, ce sera le chemin de fer Rothschild. Si son chemin de fer va très mal, ce sera le chemin de fer du juif Rothschild" (cited in Béatrice Philippe, *Etre Juif dans la société française, du moyen age à nos jours* [Paris: Editions Montalba, 1979], 61).

7. "Le roi des juifs," "la nouvelle royauté du coffre-fort," "le grand prêtre du dieu Argent, qu'on adorait au 19e siècle." Quotes and paraphrases are from the anti-Semitic literature from 1846 through 1869 in the Rothschild Archives at the Archives Nationales (132 AQ 21–22).

8. For the anti-Semitic responses from these disparate camps, see Philippe, *Etre Juif*, 156ff.; Leon Poliakov, *The History of Anti-Semitism*, vol. 3 (New York: Vanguard, 1975), 356ff.; Jacob Katz, *From Prejudice to Destruction: Anti-Semitism, 1700–1933* (Cambridge, Mass.: Harvard University Press, 1980), 123ff. For caricatures of Jews at the time of the Dreyfus Affair, see *The Dreyfus Affair*, ed. Norman Kleeblatt (Berkeley and Los Angeles: University of California Press, 1987).

9. Victor Hugo described the Bible as "l'oeuvre romantique par excellence" (cited in Luce Klein, *Portrait de la juive dans la littérature française* [Paris: Editions Nizet, 1971], 37). On the antibiblical stance of Enlightenment thought, see idem, 30 ff, and Charles C. Lehrmann, *The Jewish Element in French Literature* (Rutherford, N.J.: Fairleigh Dickinson University Press, 1971), 109–31. On the revival of biblical imagery and its conflation with exoticism, see Klein, *Portrait*, 37–49, and Lehrmann, *Jewish Element*, 142–56.

10. "La Reine, son auguste épouse, si digne d'une mission qu'elle a toujours rempli avec un dévouement religieux" (J. B. Mesnard, *Dix Jours de Règne de Rothschild Ier . . .* (Paris: Ballay Aîné, 1846), 36 (Archives Nationales 132 AQ 22).

11. "Assez jolie et très polie" (Maréchal de Castellane, *Journal* [Paris: Plon, 1896]), 2: 201; "véritable grande dame, et remplie de distinction dans ses manières" (Eugène de Mirecourt, *Les Contemporains* [Paris: Gustave Havard, 1856], 30); Lady Granville is cited in Cyril Ray, *The Story of Château Lafite-Rothschild* (London: Peter Davies, 1968), 52. There is the particular problem here, one often encountered with women's lives, that there is almost no biographical material. Portions of the baroness's correspondence survive (Rothschild Archives, London) as do her account books beginning in 1870 (private collection, France) and an account book for her household from 1822 (private collection, Paris).

12. Philippe, *Etre Juif,* 138. While only Am-schel among the brothers (the others were Sa-lomon, Nathan, Karl, and James) chose to be Orthodox, the Baron and Baroness James raised their children according to Jewish practices (see Michael Marrus, *The Politics of Assimilation* [Oxford: Clarendon Press, 1971], 66). When it came to marriage arrangements for his children, the baron preferred alliances with families "whose Judaism was authentic and Orthodox" to those "with members of the Jewish financial aristocracy." Alliances within the family were even better: four out of five of James and Betty's children married cousins, as did sixteen of the eighteen Rothschilds of their generation (Muhlstein, *Baron James,* 199, 76).

13. "Il y a dans les mots 'une belle juive' une signification sexuelle très particulière et fort different de celle qu'on trouvera par exemple dans ceux de 'belle Roumaine,' 'belle Grecque' ou 'belle Américaine.' C'est qu'ils ont comme un fumet de viol et de massacres. La belle Juive, c'est celle que les Cosaques du tsar traînent par les cheveux dans les rues de son village en flammes." (From Sartre, *Refléxions sur la question juive* [Paris: Paul Morihien, 1946], 48–49; this book was published in English as *Anti-Semite and Jew,* trans. George J. Becker [New York: Schocken, 1965]. The translated passage in this text is taken from Becker.) See also chap. 15, "Sexual Antisemitism: 'Horribly Sensual,'" in *Ideology and Experience: Anti-Semitism in France at the Time of the Dreyfus Affair,* by Stephen Wilson (Rutherford, N. J.: Fairleigh Dickinson University Press, 1982).

14. For pictorial stereotypes, see Bernhard Blumenkranz, *Le Juif mediéval au miroir de l'art chrétien* (Paris: Etudes augustiniennes, 1966). For literary representations see Klein, *Portrait,* and Lehrmann, *Jewish Element.* My discussion of the physiologies is drawn from Richard Sieburth, "Same Difference: The French *Physiologies,* 1840–1842," *Notebooks in Cultural Analysis* 1, no. 1 (1985), 163–200. Benjamin is cited in ibid., 174–75.

15. See Philippe, *Etre Juif,* 157.

16. "C'était blanc comme neige, des yeux de velours, des cils comme des queues de rats, des cheveux luisants, touffus, qui donnaient envie de les manier, une créature vraiment parfaite" (*La Comédie humaine* [Paris: M. Bouteron, 1936] 8: 511). My discussion of images of Jewish women in literature owes much to Klein, *Portrait,* 101–80.

17. "Ses traits offraient dans sa plus grande pureté le caractère de la beauté juive: ces lignes ovales si larges et si virginales qui ont, je ne sais quoi d'idéal, et respirent les délices de l'Orient, l'azur inaltérable de son ciel, les splendeurs de sa terre et les fabuleuses richesses de sa vie. Elle avait des beaux yeux voilés par de longues paupières, frangés de cils épais et recourbés. Une innocence biblique éclatait sur son front. Son teint avait la blancheur matte des robes du lévite. Elle restait habituellement silencieuse et recueillie; mais ses gestes, ses mouvements témoignaient d'une grâce cachée, de même que ses paroles attestaient l'exprit doux et caressant de la femme" (*La Comédie humaine* 10: 422).

18. "Coralie offrait le type sublime de la figure juive, ce long visage ovale d'un ton d'ivoire blond, une bouche rouge comme une grenade, un menton fin comme le bord d'une coupe. Sous les paupières brulées par une prunelle de jaïs, sous des cils recourbés, on devinait un regard languissant, où scintillaient à propos les ardeurs du désert. Ces yeux ombrés par un cercle olivâtre étaient surmontés de sourcils arqués. . . . Ces beautés d'une poésie vraiment orientale, étaient encore mises en relief par le costume espagnol convenu de nos théâtres" (*La Comédie humaine* 4: 727).

19. Gautier quotes follow: "Ce sont des longs visages d'un ton d'ivoire blondissant, des bouches rouges comme des grenades en fleur, des yeux aux paupières arquées, entourées d'un léger cercle bleu avec un cristallin diamante; des prunelles de jaïs, un regard languissant trempé de soleil, où brillent toutes les ardeurs de l'Orient" (Gautier, *Les Portraits Contemporains,* 5th ed. [Paris: Charpentier, 1886], 396). "Probablement, si l'on pénétrait dans ces maisons pourries . . . on y trouverait, ainsi que dans les anciennes juiveries, des Rebecca et des Rachel d'une beauté orientalement radieuse, roides d'or et de pierreries comme des idoles hindoues, assises sur les plus précieux tapis de Smyrne, au milieu de vaisselles d'or et de richesses inappréciables entassées par de l'avarice paternelle; car la pauvreté du Juif n'est que extérieure" (Gautier, *Le Voyage en Italie* [Paris: Hachette, 1860], 313ff., cited in Klein, *Portrait,* 108).

20. "Que m'importe, juive adorée
Un sein d'ébène, un front vermeil!
Tu n'es pointe blanche, ni cuivrée
Mais il semble qu'on t'a dorée
Avec un rayon de soleil."
(Hugo, "La Sultane Favorite," *Les Orientales* [Paris: Hachette, 1884], 73)

21. Quote from Steve Neale, "The Same Old Story: Stereotypes and Difference," *Screen Education* 32/33 (Autumn/Winter 1979–80): 33. On the topos of sexual fantasy in Orientalist imagery, see

Linda Nochlin, "The Imaginary Orient," *Art in America* (May 1983): 124ff. For conjunction of Turkish, Greek, Spanish, and Jewish women, see Klein, *Portrait,* 50.

22. Quote from Homi K. Bhabha, "The Other Question . . . Homi K. Bhabha Reconsiders the Stereotype and Colonial Discourse," *Screen* 24, no. 6 (1983): 18. My discussion of repetition is indebted to Bhabha's argument, 18–36. Both Bhabha and Sieburth compare colonialist discourse and the *physiologies,* respectively, to the simultaneous recognition and disavowal of difference at the heart of Freud's concept of the fetish. For Bhabha "the stereotype . . . as the primary point of subjectification in colonial discourse, for both coloniser and colonised, is the scene of a similar [primal] fantasy and defence—the desire for an originality which is again threatened by differences of race, colour and culture" (*Other Question,* 27). For Sieburth the physiologies "might be said to transform the social world into an utterly predictable, utterly interpretable system of signs or marks which suppresses all problematic social alterity through a standardized code of signification whose attraction lies not in *what* it signifies but rather in the absolute *systematicity* of its signs" ("Same Difference," 180).

23. "Le rôle où la beauté de mademoiselle Falcon ressort le plus avantageusement et semble, pour ainsi dire, dans son milieu naturel, c'est le rôle de *la Juive* . . . elle ressemble tout à fait a une des compagnes de la fille de Jephtà, si ce n'est à la fille de Jephta elle-même, et c'est ce qui nous a fait revenir en mémoire le nom et le tableau de Lehmann" (Gautier, *Portraits Contemporains,* 397–98). On the painting, see Marie-Madeleine Aubrun, *Henri Lehmann, 1814–1882* (Paris: Musée Carnavalet, 1983), 140.

For discussions of Jewish patriarchs in paintings produced during the July Monarchy, see Grunchec, *Le Grand Prix de peinture,* 390, 396, 397, 407. Discussing the biblical personages of Vigny and Hugo, Luce Klein argues that the male figures are in each case surrogates for the poet, while their female counterparts are projections of that "I". "Les figures masculines nous paraîtront tendre, en le sublimant, à s'identifier au "moi" du poète. Ce "moi" du héros est vu de l'intérieur, tandis que les figures féminines sont généralement vues du dehors, comme les projections du Moi, pour lequel, elles sont tout à la fois l'Autre, (complémentaire du Moi) et l'image ou les images de la Femme rêvée par le poète" (Klein, *Portrait,* 37–38).

24. "Cette toile annonçait un sentiment profond et particulier de la poésie biblique; ces jeunes filles avec leurs grands yeux noircis de k'hol, leur nez aquilin, leurs lèvres rouges, leur teint d'ambre jaune, leurs cheveux d'un noir bleuâtre ou d'un or rutilant, leur ovale allongé, leur taille souple et ronde comme les palmiers d'Engaddi, leurs bras puissants terminés par des mains fines, réalisant l'idéal de la beauté hébraïque; elles rappelaient ces descriptions de Sir-Hasirim, dans lesquelles le roi-poète, pour dépeindre sa bien-aimée, ouvre l'écrin des métaphores orientales, entasse les montagnes d'aromates et fait boire le lyrisme à la coupe du haschich. Leurs vêtements splendides étaient colorés par des tons de rubis, de saphirs et d'émeraudes, tranchant sur ce blanc jaune du lin qui ressemble à de l'or en fusion. M. Lehmann a continué de fouiller cette riche veine" (*L'Artiste* 55 [1856]: 117, cited in Aubrun, *Henri Lehmann,* 140).

25. "La créature, aux formes lourdes et communes, qui est là, étendue, n'est point la svelte, la chaste amante d'Ivanhoë. Nous assistons au rapt de quelqu'une des ces malheureuses qui rôdent autour des camps" (Guillot), "le corps de la belle Juive, merveilleux de souplesse et d'abandon, est d'une extrême finesse de couleur" (Mantz), both cited in Lee Johnson, *The Paintings of Eugene Delacroix* (Oxford: Clarendon Press, 1986) 3: 111.

26. Repro. in Johnson, *Paintings of Delacroix,* no. 365, plate 180.

27. Writing about Nathan de Rothschild, Mirecourt describes "son affreux baragouin de juif allemand, dont il n'a jamais pu se débarrasser non plus que son frère James" (Mirecourt, *Les Contemporains,* 22).

28. "Petit" and "laid" (de Castellane, *Journal* 2: 201). "Une monstrueuse figure, la plus plate, la plus basse, et la plus épouvantable face batracienne, des yeux éraillées, des paupières en coquille, une bouche en tirelire et comme baveuse, une sorte de satrape de l'or: c'est Rothschild" (Jules and Edmond de Goncourt, *Journal* [Paris: R. Laffont, 1989], entry of January 21, 1863, 923; cited and translated in Muhlstein, *Baron James,* 48–49).

29. One putative image of the baron does rely completely on nineteenth-century stereotypes: the fleeing figure in Horace Vernet's *Capture of the Smala of Abd-el-Kader at Taquin, May 16, 1843* (1845; Versailles). See Virginia Cowles, *The Rothschilds: A Family of Fortune* (London: Weidenfeld and Nicolson, 1973), 97–98.

30. "M. Ingres possède depuis long-temps toutes les qualités qui font le grand portraitiste. S'il continue, comme il vient de le faire pour le portrait de Mme Rothschild, à y joindre la séduction du coloris, ses portraits resteront parmi les plus précieux monuments de notre époque" (Geffroy, "Beaux-Arts," 449).

31. (On the color change) "C'est toute une histoire que celle de cette robe: elle était bleue dans l'origine, ayant été choisie au goût du modèle; mais, le tableau terminé, l'artiste, mécontent de son effet, sans mot dire et sans prendre conseil de personne, se décide subitement à la changer" (Geffroy, "Beaux-Arts," 448). Given that the portrait was finished during the revolution of 1848, it is interesting to speculate about the meaning of the change in that context. While Ingres was holed up in his studio with *Vénus Anadyomène* and the *Baronne de Rothschild,* he discussed the revolution in a letter to his friend Gilibert: "Quels projets peut-on, d'ailleurs, faire dans ces moments d'angoisse où l'on vit au jour, au bord du précipice dont la pente est si rapide sur le gouffre où l'on est seulement appuyé à la république que tout le monde veut, mais que tant d'anges infernaux feraient rouge quand nous la voudrions, comme Astrée, belle, vierge, noble et pure?" (letter of May 1848, Archives du-Tarn-et-Garonne; also reprinted in Boyer d'Agen, *Ingres: D'Après une correspondance inédite* [Paris: H. Daragon, 1909], 391).

(On how the new color heats up the general tone) "Le rouge clair qu'il a adopté a chauffé le ton général du tableau, et s'allie bien mieux au velours grenat et au vert sombre de la tenture damassée qui fait le fond. . . . Les traces de l'opération n'ont pu être complètement effacées. Le dessous azuré n'a point tout-à-fait disparu aux endroits qui étaient recouverts par la gaze et les dentelles du corsage. Il en résulte pour celles-ci une teinte bleuâtre, et, dans certains passages de l'étoffe, des reflets violets qui étaient peut-être dans l'intention de l'artiste, et qui donne plus de richesse à la soie" (Geffroy, "Beaux-Arts," 449). The surface of the painting would appear to corroborate the change in color. (The fiery school) "la fougueuse école de Vénise," ibid., 449. "Rebeccas and Rachels" is from Gautier, cited in n. 19.

32. This fusion does not seem to occur in images of Jewish men where the positive biblical stereotype and the negative stereotype of the usurer are often polarized.

33. *Mme Rivière,* exhibited at Ingres's first Salon, was criticized by Pierre Jean Baptiste Publicola Chaussard, who wrote, "Cette pose, cet ajustement ne conviennent pas à une dame que nous savons être un modèle de grâce et de décence" (Chaussard, *Le Pausanias français: Salon de 1806* [Paris: F. Buisson, 1806], 181). Ingres's early works often are more harshly criticized than those produced late in his career, when he was the reigning master of classicism.

4. THIS FLATULENT HAND: NINETEENTH-CENTURY CRITICISM

1. "L'auteur de l'*Odalisque* a fait maintes fois des figures pleines de vent, rondes, enflées, qui, pour employer une comparaison vulgaire, ont le tort de rappeler ces jouets d'enfants, monstres ou animaux de baudruche, ballons légers qu'un air captif remplit de tous côtés, sans prendre souci de la forme. Si l'on avait la patience d'examiner sous ce rapport l'*Odalisque,* on aurait le regret de conclure, non seulement que la silhouette de l'ensemble est d'un goût douteux, mais encore que le dessin intérieur est vague, absent ou faux." Paul Mantz, "Salon de 1855," *Revue française* 2 (1855): 227.

2. "L'Artiste-fossoyeur" and "[Ingres's odalisques] sentent toutes le cadavre." "Formes effilées semblent plutôt sortir d'un évidoir que d'un pinceau." All quotes are from Charles Laborieu, "L'Art ancien: Les Peintures des Beaux-Arts" (hereafter cited as "Les Peintures des Beaux-Arts"), no. 10 (Oct. 5, 1855): 5–7.

3. Julia Kristeva, *Powers of Horror: An Essay on Abjection,* trans. Leon S. Roudiez (New York: Columbia University Press, 1982), 4. On abjection, see also *Abjection, Melancholia and Love,* ed. John Fletcher and Andrew Benjamin (London and New York: Routledge, 1990).

4. For the critics who accused Ingres of taking art back to its infancy, see Gustave Jal, *L'Ombre de Diderot et le Bossu du Marais* (Paris: Coréard, 1819), 149; C. P. Landon, "Salon de 1819," *Annales du musée* 1 (Paris, 1819): 29; "T," "Salon," *Le Moniteur universel* (December 9, 1819): 1553; [Anon.], *Arléquin de rétour au muséum ou Revue des tableaux en vaudevilles* (Paris: Imprimerie Brasseur Ainé, 1819), 33; and Kératry, *Annuaire de l'Ecole Française de Peinture* 108. On Ingres's color, see Jal, *L'Ombre,* 149–50; Landon, "Salon de 1819," 28; Kératry, *Annuaire,* 108; and [Anon.], *Lettres à*

David sur le salon de 1819 par quelques élèves (Paris: Pillet Aîné, 1819), 72. On the primitifs, see George Levitine, *The Dawn of Bohemianism: The Barbu Rebellion and Primitivism in Neoclassical France* (University Park, Pa.: Pennsylvania State University Press, 1978).

5. Jal, *L'Ombre*, 149; [Anon.], *Lettres à David*, 72; [Anon.], *Observateur au salon: Critique des tableaux en vaudeville* (Paris: Imprimerie de Renaudière, 1819), 11; P. A., "Notice sur l'exposition des tableaux en 1819," *Revue Encyclopédie* 5 (January 1820), 55–56; Kératry, *Annuaire*, 108; "T," "Salon," 1553; Landon, "Salon de 1819," 29; [Anon.], *Arléquin au rétour au muséum*, 33. Michel Tourneux, *Salons et expositions d'art à Paris, 1801–1870* Paris: Schémit, 1919), 41–46, led me to thirteen reviews. For a more comprehensive list, see *A Bibliography of Salon Criticism from the Ancien Régime to the Restoration, 1699 to 1827*, ed. Neil McWilliam (Cambridge and New York: Cambridge University Press, 1991), 212–19, published after I completed my research. Despite important patronage from the napoléonides, Ingres's work was not yet widely known in 1819, and certainly not in France.

6. An exception is the review in *Journal des dames* which only discusses works by women artists (Charles Richomme, "Exposition universelle des beaux-arts," *Journal des dames* 2 [September 1855]: 20). The only other important exhibition in France to show the *Grande Odalisque* was held to benefit artists at the Bazar de la Bonne Nouvelle in 1846. See the comments of Charles Baudelaire in Baudelaire, "Salon de 1846," *Curiosités esthétiques: L'art romantique* (Paris: Classiques Garnier, 1990), 153; George Sand's letter to Delacroix of January 21–22, 1846, in Sand, *Correspondance 7* (Paris: Garnier, 1970), 245–46; and F. de Lagenevais, "Peintres et sculpteurs modernes: I. M. Ingres," *Revue des Deux Mondes* 3 (1846): 514–41. For the Exposition Universelle, I have relied on Christopher Parsons and Martha Ward, *A Bibliography of Salon Criticism in Second Empire Paris* (Cambridge and New York: Cambridge University Press, 1986).

7. For archaism, see Georges Niel, "Exposition universelle des Beaux-Arts: M. Ingres," *La Presse théâtrale*, no. 24 (June 17, 1855): 5; Pierre Petroz, "Exposition universelle des beaux-arts," *La Presse* (May 30, 1855); Horsin Déon, *Rapport sur l'Exposition Universelle* (Paris: Alexandre Johanneau, 1855): 30; Etienne-Jean Delécluze, *Les Beaux-Arts dans les deux mondes en 1855* (Paris:

Charpentier, 1855): 202. For paleness, see Paul Mantz, "Salon de 1855," *Revue française*, 2 (1855): 223–24.

8. For similar responses as indexes of the difficulties of representing the female nude, see Jennifer L. Shaw, "The Figure of Venus: Rhetoric of the Ideal and the Salon of 1863," *Art History* 14, no. 4 (December 1991), 540–70. See also T. J. Clark, *The Painting of Modern Life: Paris in the Art of Manet and His Followers* (New York, Knopf, 1985), 79–146.

9. "Quelle pureté de lignes! Peut-on assez louer cette pose gracieuse, ces voluptueux contours et cette transparence merveilleuse de la chair dans la demi-teinte" (Ernest Gebauer, *Les Beaux-Arts à l'Exposition Universelle de 1855* [Paris: Librairie Napoléonienne, 1855], 5–7).

10. "Gracieux, élégant dans ses sujets érotiques"; "de figures charmantes aux formes délicates, suaves et pures." The passage continues: "Les pieds et les mains de la grande odalisque sont d'une remarquable finesse, la tête est à la fois, noble et belle; l'autre odalisque est pleine d'abandon dans sa pose; la Vénus a un charme, une grâce, des formes admirables" (Guyot de Fere, "Beaux-arts: Exposition," *Journal des arts, des sciences et des lettres* [June–July 1855]: 67).

11. "Un adorateur fanatique et exclusif de la ligne et du contour." "Nous avons bien assez à faire d'admirer comme il convient tous ces corps de femmes les attitudes si gracieuses, les contours si moelleux, la ligne si pure et si correcte, et surtout tellement douce et fondue" (Pesquidoux, "Beaux-Arts: Etudes critiques," *L'Appel*, no. 40 [August 19, 1855]: 118; and idem, "Beaux-Arts: M. Ingres," *L'Appel*, no. 42 [September 2, 1855], not paginated. This kind of language is not restricted to Ingres's nudes. See, for example, Niel, "Exposition universelle," 5, on *Mme Duvauçay* (1807).

12. Gautier's lengthy remarks originally appeared in installments in *Le Moniteur universel* from March through December 1855 (for complete citations, see Parsons and Ward, *Bibliography of Salon Criticism*, 29–30) and were subsequently published in Gautier, *Les Beaux-Arts en Europe*. Duval's extensive, but narrower, articles appeared in *Le Globe industriel et artistique* from August through December 1855 (for complete citations, see Parsons and Ward, *Bibliography of Salon Criticism*, 28–29) and were collected in Duval, *Exposition universelle de 1855*. All references to these two works are from the collected versions.

13. "Et pourtant, si jamais créature divinement belle s'étala dans sa chaste nudité aux regards des hommes indignes de la contempler, c'est à coup sûr l'*Odalisque couchée;* rien de plus parfait n'est sorti du pinceau. Soulevée à demi sur son coude noyé dans les coussins, l'odalisque, tournant la tête vers le spectateur par une flexion pleine de grâce, montre des épaules d'une blancheur dorée, *un dos où court dans la chair souple une délicieuse ligne serpentine* [my italics], des reins et des pieds d'une suavité de forme idéale, des pieds dont la plante n'a jamais foulé que les tapis de Smyrne et les marches d'albâtre oriental des piscines du harem; des pieds dont les doigts, vus par-dessous, se recourbent mollement, frais et blancs comme des boutons de caméllia, et semblent modelés sur quelque ivoire de Phidias retrouvé par miracle; l'autre bras languissament abandonné, flotte le long du contour des hanches, retenant de la main un éventail de plumes qui s'échappe, en s'écartant assez du corps pour laisser voir un sein vierge d'une coupe exquise, sein de Venus grecque, sculptée par Cléomène pour le temple de Chypre et transportée dans le sérail du padischa (Gautier, *Les Beaux-Arts en Europe* 1: 157–58).

14. Although I cannot develop this discussion here, the ways in which the orientalist aspects of a number of Ingres's images intensify the pleasure or horror of the critical responses should surely be considered in light of colonialist expansion during the Restoration and the July Monarchy.

15. Kristeva speaks of "a jouissance in which the subject is swallowed up but in which the Other, in return, keeps the subject from foundering by making it repugnant" (Kristeva, *Powers of Horror,* 9). Line and its moral dimension obviate the need to make the Other repugnant, as do sexual and cultural difference.

16. "Ses *Odalisques,* qu'il faut éviter de discuter sous le point de vue de la couleur, sont conçues dans *ce goût élévé de la ligne serpentine* [my italics], qui n'admet aucun contour abrupte, aucune opposition heurtée dans la silhouette des corps, aucun mouvement risqué ou disgracieux. On s'explique aisément qu'un esprit aussi scrupuleusement appliqué à l'étude incessante du beau extérieur puisse faire bon marché des fantaisies de la palette. . . . Grâce à son laborieux exemple et à celui de ses glorieux rivaux contemporains, on comprendra encore en France qu'il importe avant tout de savoir bien dessiner et que les destinées de l'art y sont étroitement attachées" (Duval, *Exposition Universelle,* 12).

17. In Kristeva's terms: "We may call it a border; abjection is above all ambiguity. Because, while releasing a hold, it does not radically cut off the subject from what treatens [*sic*] it—on the contrary, abjection acknowledges it to be in perpetual danger (*Powers of Horror,* 9).

18. Fernow, "Canova and His Works" (September 1844): 295.

19. Fernow, "Canova and His Works" (August 1844): 166.

20. The original text of the French author cited reads: "Combien de statues modernes privéés d'os et de nerfs ne se soutiennent debout que parce qu'elles sont de pierre!" (Fernow, "Canova and His Works" [August 1844]: 168).

21. "Oeuvres graves et sévères," "et d'autres qui séduisent et charment" (Guyot de Fere, "Beaux-arts" [April 1855], 44). "Pur, correcte, un peu froid," "impossible de rien trouver de plus séduisant et de plus moelleux" (Debellocq, "Course à travers le Palais des Beaux-Arts," *L'Amateur* 13 [July 1855]: 23). "A voulu prouver que la grâce n'était pas son domaine éxclusif," "la démonstration est complète" (Gustave Planche, "Exposition des Beaux-Arts: L'Ecole Française," *Revue des Deux Mondes* 11 [September 15, 1855]: 1143).

22. "Comme toujours, des développements de musculatures absurdes et inutiles muscles absurdes" (Nadar, "Salon de 1855," *Le Figaro,* no. 73 [September 16, 1855]: 5). "Une exhibition forcenée de musculature dans les deux licteurs" (Du Pays, "Exposition universelle des beaux-arts," *L'Illustration* 25 [June 30, 1855]: 419). "L'exagération musculaire du licteur" (Paul Chéron, "Exposition universelle," *Le Théâtre,* no. 1245 [August 25, 1855]: 2).

23. "L'oeil est tout d'abord choqué par le prodigieux développement musculaire des licteurs. Leurs formes emphatiques dissimulent mal de singulières erreurs de construction. . . . Celui de droite ne porte pas sur ses jambes; l'omoplate de l'autre est hors des proportions humaines. Tous deux étalent une multiplicité de veines, de fibres, de détails de tout genre qui vont jusqu'à la difformité" (Petroz, "Exposition universelle des beaux-arts," *La Presse* [May 30, 1855]: not paginated).

24. "Jamais soldat et brutal [*sic*] n'a eu cette peau violette, vernie, passée à l'éponge ou à l'estompe, cette musculature brillante qui ressemble à tout ce qu'on voudra, sauf à une chair vivace et animé par le sang" (Ponroy, "Exposition universelle des beaux-arts . . . ," *Le Globe industriel et artistique* [July 1, 1855]: 144).

25. "Le public ne vit d'abord dans ce tableau qu'un enchevêtrement de jambes inégales et bossuées de muscles nerveux . . . un jeune saint semblable à une jeune sainte" (Thierry, "Exposition Universelle de 1855," *Revue des Beaux-Arts* 6 [1855]: 203).

26. "M. Ingres comprend et indique avec une ravissante chasteté le sentiment voluptueux, qui est en quelque sorte le souffle de la matière, ce n'est pas l'expression de la volupté" (Comte de Viel-Castel "Exposition universelle: Beaux-Arts," *L'Athénaeum français* 4 [October 6, 1855]: 861).

27. "Du style, une indéfinissable grandeur, un sentiment de calme et de noblesse." "M. Ingres peut se tromper quelquefois, mais il n'est jamais vulgaire" (quotes from [Anon.], "Exposition universelle de 1855: Beaux-Arts," *Le Coiffeur parisien* 11 [September 8, 1855]: 18–20).

28. "Correct, avide de la pureté, et de l'harmonieuse souplesse des lignes." "Quelle grâce et quelle souplesse . . . que de moelleux." "Une sorte d'effacement et de mollesse . . . qui nuit à l'énergie de l'idée, et rend plus difficile qu'on ne pense la juste appréciation des ses oeuvres" (quotes from Paul Nibelle, "Exposition universelle.—Beaux-Arts.—Peinture," *La Lumière* [September 15, 1855]: 147).

29. "Son anatomie est irréprochable; mais sa peau est d'ivoire violace; il n'y a dessous ni veines, ni artères, ni réseaux nerveux. Ses odalisques sont pures de lignes, mais elles sont plates et inertes comme des figures de vases étrusques" (G. Pierre, "Salon de 1855," *Le Portefeuille* [June 3, 1855]: 27).

30. "Montreurs de figures de cire" (Pierre, "Salon de 1855," 27).

31. "Remarquons aussi qu'emporté par cette préoccupation presque maladive du style, le peintre supprime souvent le modelé ou l'amoindrit jusqu'à l'invisible, espérant ainsi donner plus de valeur au contour, si bien que les figures ont l'air d'une forme très-correcte, gonflés d'une matière molle et non vivante, etrangère à l'organisme humain" (Baudelaire, "Beaux-Arts: Ingres," *Le Portefeuille*, no. 13 [August 12, 1855]: 130).

32. "Cette femme moelleusement étendue charme l'oeil au premier abord. . . . ce n'est qu'à la longue, après un examen réitéré que l'on s'aperçoit des fautes de dessin incompréhensible chez M. Ingres. . . . cette femme qui, couchée, paraît d'abord si gracieuse et si belle de forme, ne pourrait se tenir debout tant elle est disporportionnée" (Niel, "Exposition Universelle des Beaux-Arts," 5).

33. "Aussi la structure des académies de M. Ingres conserve-t-elle quelque chose d'anormal et d'inexplicable. . . . Tout le monde a vu la petite *Odalisque* [*l'Odalisque à l'esclave*]. . . . Le torse, jeune et délicat, est charmant dans sa partie supérieure; la ligne est d'abord séduisante et onduleuse; mais elle se brise tout à coup, elle se contourne et s'achève comme il plaît à Dieu. Le corps de *l'Angélique* est disgracieux au possible et presque tuméfié" (Mantz, "Salon de 1855" [*Roger et Angelique*], 222).

34. "Voyez cette droite surtout . . . regardez ce fantastique paquet de peaux . . . sous laquelle au lieu d'os et de muscles, il ne peut y avoir que des intestins, cette main qui a des flattuosités et dont j'entends les borborygmes! J'en ai rêvé, de votre horrible main!" (Nadar, "Salon de 1855," *Le Figaro* no. 77 [Sept. 16, 1855]: 4).

35. "Quand je pense que j'ai admiré dans l'enfance de mon sentiment des arts, la première odalique [*sic*] aux contours verts et au dos de sangsue blanche . . . je remercie le soleil du bon Dieu de m'avoir ouvert les yeux . . . car il faut être paralytique pour tomber dans de telles erreurs" (Sand, *Correspondance,* 246).

36. Kristeva, *Powers of Horror,* 2.

37. Kristeva quote from *Powers of Horror,* 4. For the corpse, see also Elizabeth Grosz, *Sexual Subversions: Three French Feminists* (Winchester, Mass.: Unwin Hyman, 1989), 75.

38. "Quoi d'étonnant que nous pensions à la mort, puisque nous sommes en face de M. Ingres, l'ennemi de la vie, de M. Ingres, l'artiste-fossoyeur!" (Laborieu, "Les Peintures des Beaux-Arts," 5). "L'avenir . . . ne pardonnera à M. Ingres . . . cette persistante frayeur de tout ce qui est la vie, le mouvement et la passion"; "il . . . étudiera— avec la curiosité de l'esprit, jamais avec la sympathie du coeur—le singulier génie de ce maître" but "s'éloignera d'une oeuvre que semblent couvrir de leur ombre attristée les grandes ailes de la mort" (Mantz, "Salon de 1855," 229). "Un peintre d'un froid à faire éclore des ours blancs" (Nadar, "Salon de 1855," no. 73 [August 19, 1855]: 2). Other critics who mention death in discussing Ingres's works include Edouard Thierry, for whom "M. Ingres est un Italien du seizième siècle . . . il parle une langue morte" ("Exposition universelle de 1855," *Revue des Beaux-Arts* 6 [1855]: 286); and Boiteau d'Ambly, who dubs Ingres's exhibition space "la salle des morts" and asserts that "la foule a froid autour de ces oeuvres" (*La Propriété littéraire et artistique* 2

[August 1, 1855]: 468). A number of these critiques point to a regretful absence of the real: Ingres's art is "loin des clapotements de la vie réélle" (Boiteau d'Ambly, 469). "Poète de la forme, éprise de la beauté plastique, il repugne à l'expression de la passion, de la souffrance, des mouvements vifs et violents de l'âme" (Nibelle, "Exposition universelle," 147).

39. These include Bertrand-Rival's pathology museum of the Revolutionary period, Fontana's Specola museum, known throughout Europe in the late eighteenth century, and the Musée Dupuytren, which opened in the Ecole de Médecine in 1835. For knowledge of these collections, I am indebted to Jann Matlock's "Censoring the Realist Gaze," in *Realism, Gender, and Sexuality,* ed. Margaret Cohen and Christopher Prendergast (Minneapolis: University of Minnesota Press, 1995).

40. See Charles de Forster, *Quinze ans à Paris (1832–1848): Paris et les parisiens* (Paris: Didot, 1848–49), 1: 24, cited in Matlock, "Censoring the Realist Gaze."

41. "Nous ne toucherons pas non plus à ces odalisques qui rappellent les femmes de cire de l'ancien salon Curtius et qui sentent toutes le cadavre" (Laborieu, "Les Peintures des Beaux-Arts," 5–7).

42. Unless otherwise specified, my discussion of Curtius and Tussaud is indebted to Pauline Chapman's books *Madame Tussaud's Chamber of Horrors* (London: Constable, 1984) and *The French Revolution as Seen by Madame Tussaud, Witness Extraordinary* (London: Quiller, 1989).

43. See Louis-Sebastier Mercier, an acerbic observer of Parisian culture and mores, cited in Chapman, *Madame Tussaud's Chamber,* 7.

44. *L'Espion du boulevard du Temple* (1782), cited in Jean Adhémar, "Les Musées de Cire en France, Curtius, le 'Banquet Royal,' les Têtes Coupées," *Gazette des Beaux-Arts* 92 (Dec. 1978): 206. See also Chapman, *French Revolution,* 11.

45. The relationship between horror and hearsay seems significant here. Many viewers would not actually have seen the caverne but would have heard about it or perhaps seen reproductions of its inmates. More research needs to be done on the visual images of Curtius's exhibitions that might have circulated during and subsequent to the Revolutionary period. The most recent scholarly account is David Bindman, *The Shadow of the Guillotine and the French Revolution* (London: British Museum Publications, 1989), 212ff.

46. According to Chapman, David, whose bust joined the salon de cire in 1792, based his portrait of Marat on sketches made by Grosholtz by order of the National Assembly. She also suggests that Grosholtz read Marat's translation of Newton's *Optics* and Marat's own *Découvertes sur la lumière,* to which some of the spectacular lighting in the salon de cire, the caverne, and ultimately in her Chamber of Horrors in London was indebted (*The French Revolution,* 167, 145). Because of the lack of evidence, there is some question about whether or not Curtius or Tussaud modeled directly from heads decapitated during the Revolutionary period. See Bindman, *Shadow of the Guillotine,* 75: Marie-Hélène Huet, *Monstrous Imagination* (Cambridge, Mass.: Harvard University Press, 1993): 192; and Adhémar, "Les Musées de Cire en France," 208.

47. "Une figure de cire qui n'est perverse que par l'intention" (Pierre, "Salon de 1855," 28).

48. Huet, *Monstrous Imagination,* 205.

49. "Je ne sais, en vérité dans quelle nature inouïe l'école de Gérard et de Girodet a vu la réalité; dans quel insipide cauchemar elle a entrevu l'idéal; mais j'avoue n'avoir jamais rencontré dans les plus scandaleuses orgies du romantisme des aberrations plus notoires, plus topiques, plus palpitantes que dans cette image incolore qui est censée nous représenter l'Amour et Psyché" (Pierre, "Salon de 1855," 28).

50. "Cette femme qui, couchée, paraît d'abord si gracieuse et si belle de forme, ne pourrait se tenir debout tant elle est disproportionnée" (Niel, "Exposition universelle," 5).

51. Ernst Jentsch, "Zur Psychologie des Unheimlichen," *Psychiatrisch-Neurologische Wochenschrift* (1906), 22, 198. Cited in her own translation, by Naomi Schorr, in Schorr, *Reading in Detail* (New York and London: Methuen, 1987), 138.

52. For the formulation of two modes of horror, I am indebted to Lynda Bundtzen.

53. "L'amant qui s'allonge et se désosse avec une langueur passionnée" (Petroz, "Exposition Universelle" [May 30, 1855]).

54. The phrase appears in Guyot de Fere ("Beaux-Arts: Exposition," 67) and also occurs in the writings of a number of other critics cited above.

55. For many nineteenth-century critics, the lone image in Ingres's oeuvre to successfully embody maleness was the portrait of M. Bertin, hardly an advertisement for the vitality of traditional history painting, but for many an

image whose "modernity" would have been preferable to the peasants of 1848.

56. See Barbara Creed, "Horror and the Monstrous-Feminine: An Imaginary Abjection," *Screen* 27:1 (1986): 45.

5. HALF OCTOPUS, HALF TROPICAL FLOWER: MODERNIST CRITICISM

1. Only About (*Voyage à travers l'exposition des beaux-arts*, 122, 127) and Gautier (*Les Beaux-Arts en Europe*, 1: 147) viewed Ingres's liberties with the human body as evidence of artistic merit.

2. "Qualités vraiment françaises de précision et de clarté" (Denis, *Théories, 1890–1910* [Paris: L. Rouart et J. Watelin, 1920], 92, originally published in *L'Occident*, July–September 1902). On the role of nationalism in writings between 1914 and 1925, see Kenneth E. Silver, *Esprit de Corps: The Art of the Parisian Avant-Garde and the First World War, 1914–1925* (Princeton: Princeton University Press, 1989), 236ff.; 377.

3. "Le premier cubiste-impressioniste," "la filiation Ingres-Cézanne-Cubisme," "austères violences des peintres nouveaux." Quotes are from André Lhote, *La Peinture, Le Coeur et L'Esprit* (Paris: Editions Denoël et Steele, 1933), 74, 85. These essays were originally published between 1919 and 1922.

4. "De même Ingres, un des premiers peut-être parmi les modernes et le seul de sa génération, eut le pressentiment que le tableau est un monde fini ayant ses lois et sa vie propres indépendantes de l'imitation, une construction plastique . . . il se méfie de l'empirisme. . . . Sa doctrine il la base déjà sur la sensation" (Roger Bissière, "Notes sur Ingres," *L'Esprit Nouveau* 4 [January 1921]: 392).

5. "Pour nous, ce qu'on a nommé la froideur d'Ingres est précisément sa plus grande vertu . . . car . . . tous ceux qui s'efforcèrent vers des fins spirituelles, à tous ceux qui ayant l'esprit classique, ne voulurent point être les esclaves de leurs émotions et eurent conscience au contraire qu'elles étaient assez fortes pour être dominées sans être diminuées. Ce que les détracteurs d'Ingres nomment froideur nous l'appelons pureté. . . . Sa sensualité . . . toute cérébrale. . . .

Qu'il [son art] ne nous eût jamais touché si profondément si la valeur morale eût été moins grande" (Bissière, "Notes sur Ingres," 397).

6. References are from Lhote, *La Peinture*. The combination of intelligence and instinct is discussed on p. 50. See also "architectures mentales" (69), "la ligne constructive" (73), "ondes voluptueuses" (71), "le bouillonnement de la source" and "le calme de l'estuaire" (74–75). The new significance given to architecture and metaphors of construction in the visual arts during these years is discussed in Silver, *Exprit de Corps*, 205 ff.

7. For outrage: "Il me suffira de noter que l'avènement d'Ingres marque celui de la sensibilité moderne . . . Pour saisir la différence radicale qui existe entre l'attitude d'Ingres et celle de ses devanciers, il faut se rappeler le bruit que suscite à son apparition sa fameuse *Grande Odalisque*" (Lhote, *La Peinture*, 64). For "this nude": "Ce nu, qui nous paraît aujourd'hui si classique, et tout nous semble merveilleusement naturel, possède, aux yeux des censeurs professionels, entre autres tares, deux vertèbres de trop, et un sein déraisonnablement placé sous le bras! Voici profanée l'anatomie, cette science sacrée, cette clef de voûte du temple de l'Académisme décadent" (ibid., 64–65).

8. Love of nature: "Devant la nature, il ne pouvait plus conserver cette froideur toute scientifique qui n'est une vertu que chez l'opérateur qui taille dans la chair vive. . . . Ingres, empli d'un trouble sacré, va perdre la tête" (ibid., 65–66). "This flesh": "Cette chair aux renflements si aimables, aux ondulations si voluptueuses, il ne peut plus la disséquer du bout du crayon comme avec l'extrémité d'un scalpel; c'est elle . . . qui va entrer en lui, victorieusement, et transforme sa conception scientifique du corps humain en une conception purement sensible. Dès lors peu lui importera le nombre exact des vertèbres. Il n'y a plus de vérité anatomique, si cette vérité est en opposition avec la sensation que lui donne le corps qu'il a devant les yeux. Cette courbe adorable du dos, si déliée, si souple, si longue, il l'allongera encore, malgré lui, pour mieux rendre apparent à autrui la trouble qu'elle lui inspire. Il déformera; il entrera en contradiction avec ce que son esprit *sait* pour exprimer, ce que son coeur *vient d'apprendre*" (ibid., 66).

9. See "esprit élevé" and "On a parlé de sa sensualité qui, d'après certaines descriptions, confinerait à la bestialité. Cette sensualité, indéniable d'ailleurs, et qui eût pu pousser un esprit moins élevé vers un réalisme de mauvais aloi, devient admirable chez Ingres" (ibid., 65). Lhote was arguably the first critic since Baudelaire to posit desire

as the motor for Ingres's creative process, an idea that informs much recent writing about the artist.

10. "Doit-il [Ingres] corriger ces erreurs? S'il exprime à nouveau ce qu'il sait des choses, ne va-t-il pas mentir à son sentiment?" and "dilemme douloureux, inconnu des Primitifs et des Renaissants, mais singulièrement fréquent chez certains artistes modernes." Quotes are from ibid., 68.

11. "Ce trouble naïf qui fait dérailler la main, et tracer des objets une figure différente de leur textualité, n'est-ce pas le plus bel hommage qu'un artiste puisse rendre à ce qu'il étudie? N'est-ce pas encore "la nature", cette forme que l'homme invente à son contact? Et cette invention, n'est-elle pas l'unique vérité, en somme?

Si l'on accorde de telles libertés à l'artiste. . . . Il lui faudra redevenir intelligent après n'avoir été que sensible; redevenir une volonté organisatrice après n'avoir été qu'un instrument enregistreur . . . en un mot substituer, volontairement, cette fois, les signes plastiques de son émotion aux signes littéralement représentatifs de l'analyse discriminative" (ibid., 69).

12. ("Pure feeling") "L'effusion pure" and ("This is not an arm . . .") "Ce n'est pas un bras tel qu'il est en réalité, avec ses plis, ses angles et le fouillis de ses veines et de ses muscles, c'est une forme inventée, une chose chaude et sinueuse, faite pour caresser et envelopper sensuellement" (ibid., 71, 69). ("The pleasure . . .") "Le plaisir que goûte l'imagination à ce jeu est violent, et il est difficile de résister au désir de cultiver cet univers inconnu" (ibid., 70).

13.("There is not one form . . .") "Il n'est pas une forme, dans cette figure, qui ne soit inventée; elle est invraisemblable d'un bout à l'autre. . . . Pas une ligne ne coïncide avec la forme naturelle, qui apparaît à la comparaison tout empâtée. Rien qu'à analyser le visage de l'*Odalisque*, j'éprouve un plaisir sans limites à constater le mélange de violence et de déférence dont il est le produit" (ibid., 72–73). "La déformation expressive, sensible, redevint nécessaire, et c'est pourquoi les peintres nouveaux élirent comme maître suprême le plus grand des déformateurs réalistes, le peintre de l'Odalisque aux deux vertébres de trop" (ibid., 89). There is an interesting, if unexpected, parallel here between the neoclassical imperative to idealize the body and the modernist one to deform it.

14. " . . . le Paolo de la *Francesca,* qui l'enlace d'un mouvement hardi et géometrique de crabe saisissant sa proie: Mais c'est Ingres qui a fait des monstres!" (Denis, *Théories,* 101).

15. Kenneth Clark, *The Nude: A Study in Ideal Form* (New York: Pantheon, 1956), 72. All further references will appear as parenthetical page numbers within the text.

16. "It is hard to believe that Leonardo's *Leda* can ever have been an attractive work. The exploitation by the intellect of a theme usually governed by the emotions must always be disturbing to a normal sensibility."

17. See Lynda Nead, *The Female Nude: Art, Obscenity and Sexuality* (London and New York: Routledge, 1992), 13. Her entire discussion of Clark is useful, 5–6 and 12–22.

18. In this context, it is interesting that Rosenblum also revives the use of the term *serpentine*. Speaking of *Mlle. Rivière,* he writes, "In its serpentine route, the boa echoes, in less extravagant terms, the mother's fabulous shawl. . . . The index fingers . . . provide a minor undulation in the overall theme of slow sinuousity" (Rosenblum, *Jean-Auguste-Dominique Ingres* [New York: Harry N. Abrams, 1968], 66). Further references will appear in parentheses within the text.

19. Norman Bryson, *Tradition and Desire: From David to Delacroix* (New York: Cambridge University Press, 1984); Richard Wollheim, *Painting as an Art* [The A. W. Mellon Lectures in the Fine Arts, 1984] (Princeton: Princeton University Press, 1987). See also Leeks, "Ingres Other-Wise," 29–37, and "Family Romance."

20. For Clark, Ingres's art is, at least in part, an expression of his physical desire (see *The Nude,* 120, 159). For Rosenblum, "such strange distortions . . . result from complex and varied interactions of both formal and psychological impulses of which Ingres himself may have been unconscious" (*Ingres,* 23).

21. See Marie-Jeanne Ternois, "Ingres et Montauban," thesis, l'Ecole du Louvre, 1956. Leeks, "Ingres Other-Wise," 29–37.

22. In their uncritical suggestion of a shared parentage for Ingres and Picasso, Bryson and Wollheim both might be said to reinscribe Ingres as a modernist. The very ways in which their books are organized confirm the art-historical canon of white male geniuses. The subtitle of Bryson's book *Tradition and Desire* is *From David to Delacroix;* the majority of Wollheim's chapters are organized around a trio of male geniuses.

23. Description of *Mme Moitessier* in Bryson, *Tradition and Desire,* 173. "Ingres' supreme production" is from ibid., 170. The term *anxiety of*

influence is from Harold Bloom, *The Anxiety of Influence* (New York and London: Oxford University Press, 1973). Bryson begins, "It is with some trepidation that I approach the last work by Ingres to take its place in the present discussion (the critic, too, has his portion of anxiety)."

6. BACKBONE

1. Mulvey, *Visual and Other Pleasures,* 30.

2. I am indebted to Tamar Garb for the formulation of the last portion of this paragraph.

3. The relation between the arms and torso is not unlike the disjunction seen in the figure (modeled after Ingres's second wife) on the extreme right of the *Turkish Bath* (fig. 56).

4. Berger, *Ways of Seeing,* 46–47; Mulvey, *Visual and Other Pleasures,* esp. 14–38; De Lauretis, *Alice Doesn't,* esp. 134–49; and Doane, *Desire to Desire,* esp. 1–13.

5. After more than a century of "masculine" art criticism, feminist responses to Ingres's works by both art historians and artists began to appear. In the early 1970s, Carol Duncan, speaking to the horrific aspects of the *Grande Odalisque* in the tradition of Baudelaire, Sand, and Nadar, likened the odalisque's body to Chicken Kiev. She has been kind enough to give me the recipe: "You take the body of a chicken, debone it, pump it up with butter (Ingres uses something like latex, so it's bloodless), and you get an inflated body, with feet that have never walked. It is served up like a dish. It can't stand. It can't fuck. The choice of an adolescent body expresses a real terror of sexuality, fear of hair, et cetera" (Conversation with Carol Duncan, summer 1992). Duncan's *bon mot* was published in 1983 in Adrian D. Rifkin, "Ingres and the Academic Dictionary," *Art History* 6, no. 2 (June 1983): 167. Rifkin suggested that the essence of the *Grande Odalisque* "lies in this fault of drawing—the extra vertebra—for she is, above all, a woman who will never need to stand up—least of all at a kitchen sink, or on her own two feet. Carol Duncan has compared her to Chicken Kiev, limp portions of dead flesh blown up with butter." Duncan's and Rifkin's critique is the obverse of the glorificatory stance toward deformation found in most twentieth-century writings on Ingres and is part of the feminist project of debunking sexism in modernist art history. Duncan has made a similar argument about the figure of Angelica in Ingres's *Roger and Angelica,* in the essay "The Aesthetics of Power in Modern Art," in *Feminist Art Criticism: An Anthology,* ed. Arlene Raven et al. (New York: HarperCollins, 1991), 60. Duncan's recourse to horror also anticipated the transgressive possibilities of abjection, which might include a kind of pleasure in likening a masterwork of neoclassical idealization to a dead bird turned juicy high-cholesterol treat. Wendy Leeks first raised the question of viewer complicity in discussing Ingres's bather paintings (Leeks, "Ingres Other-Wise," 1986) and has since extended her psychoanalytic reading of desire and spectatorship in her unpublished dissertation. Her work has grappled extensively with the question of female audiences for Ingres's work (Leeks, *The "Family Romance,"* 1990). Among the artists who have made us aware of the gendered assumptions in looking at Ingres's work, Dottie Attie has conducted the most sustained examination. Others include Eileen Cowin, Manual (Suzanne Bloom/ Ed Hill), and John O'Reilly. A number of Ingres-inspired works were brought together in a show entitled "Odalisque" at the Jayne H. Baum Gallery in the winter of 1990.

6. Claude Vignon (Noémie Cadiot), *Exposition Universelle de 1855: Beaux-Arts* (Paris: Librairie d'Auguste Fontaine, 1855): 186–192.

7. It is impossible to separate out the influence of that factor from her lack of sympathy for neoclassicism at this time. I am thinking of the romantic realist leanings evident in her pastoral novels of around this date. Like Lady Montagu's response to a visit to a Turkish bath, Sand's reaction derives from her different allegiance (Leeks, "Ingres Other-Wise," 1986).

8. The rest of the sentence reads: "(and in relation to racial, religious, occupational, class, or other identities); that is, not to be thoroughly saturated, and therefore explicable, in terms of her sex" (Tickner, "Feminism, Art History, and Sexual Difference," 100–101).

9. Iris Young has linked the belief that a certain group possesses an ugly or fearful body to unconscious fears and aversions that help to account for the violence that victimizes such a group. See Iris Marion Young, *Justice and the Politics of Difference* (Princeton, N.J.: Princeton University Press, 1990), 148–49.

10. Luce Irigaray, *This Sex Which Is Not One,* trans. Catherine Porter (Ithaca, N.Y.: Cornell University Press, 1985), 23–33. Page references to this essay appear in parentheses in the body of the text.

11. For antiliteralist readings of Irigaray's controversial image of the two lips, see Margaret Whitford, "Irigaray's Body Symbolic," *Hypatia* 6, no. 3 (Fall 1991): 99ff; Naomi Schorr, "This Essentialism Which Is Not One: Coming to Grips with Irigaray," *Differences* (Summer 1989): 38–58; Jane Gallop, *Thinking Through the Body* (New York: Columbia University Press, 1990); and most recently, Judith Butler, *Bodies That Matter* (New York: Routledge, 1993), 36–49. See also Butler's important critique, 49–55.

12. Luce Irigaray, *Sexes et parentés* (Paris: Minuit, 1987): 195, as cited and translated in Whitford, "Irigaray's Body Symbolic," 102. The following discussion is indebted to this article, esp. 101–06.

13. Quotes from Luce Irigaray, *Amante marine de Friedrich Nietzsche* (Paris: Minuit, 1980): 97, as cited and translated in Whitford, "Irigaray's Body Symbolic," 105.

14. Maggie Berg also interprets the two lips as "an ironic alternative to Lacan's phallus," cited in Whitford, "Irigaray's Body Symbolic," 100.

15. Donna Haraway, "A Manifesto for Cyborgs: Science, Technology, and Socialist Feminism in the 1980s," *Socialist Review* 80 (1985): 72. This essay has since been reprinted in Haraway, *Simians, Cyborgs, and Women: The Reinventions of Culture* (New York: Routledge, 1991), 149–81. Parenthetical references in the body of the text are to the journal article.

16. For an interesting discussion of this painting, see Susan Gubar, "Representing Pornography: Feminism, Criticism, and Depictions of Female Violation," *Critical Inquiry* (Summer 1987): 712–41.

17. The presence of Sherman as a guarantee of the work's authenticity is a topic worthy of consideration in its own right. Not only do some critics express an overweaning anxiety about Sherman's "disappearance," they feel that the work is somehow diminished without her bodily presence. This anxiety is integrally related to the ways in which Sherman's work calls into question the very notion of stable identity. Recent images, included in the *Untitled* series *#255, #257, #258, #263,* and *#264,* inevitably engage distinctions between normative and aberrant sexualities.

18. Creed, "Horror and the Monstrous Feminine," 44–70.

19. The exception is the historical-portrait series which, for some, provided a welcome relief from "the difficult work." For an interesting discussion of this series, see Rosalind Krauss, *Cindy Sherman, 1975–1993* (New York: Rizzoli, 1993), 173–74.

20. For a recent comparison between Sherman's photographs and waxworks, see the short essay by Norman Bryson in Krauss, *Cindy Sherman,* 216–23.

21. On bodily deformations as signs of difference, see Sander L. Gilman, "Black Bodies, White Bodies: Toward an Iconography of Female Sexuality in Late Nineteenth-Century Art, Medicine, and Literature"; Henry Louis Gates, Jr., ed. *"Race," Writing and Difference* (Chicago: Chicago University Press, 1985): 232–56; and Etienne Balibar, from whom I borrow the term "bodily stigmata," in "Is There a 'Neo-Racism'?" in *Race, Nation and Class: Ambiguous Identities,* ed. Etienne Balibar and Immanuel Wallerstein (London and New York: Verso, 1991): 17–28.

22. See Carl Nordenfalk, "The Sense of Touch in Art," in *The Verbal and the Visual: Essays in Honor of William Sebastian Heckscher,* ed. Karl-Ludwig Selig and Elizabeth Sears (New York: Italica Press, 1990), 109–20. See also Mulvey, *Visual and Other Pleasures;* 14–44; De Lauretis, *Alice Doesn't,* 134–49; and Doane, *Desire to Desire,* 1–13.

23. Kristen Brooke Schleifer, "Inside and Outside: An Interview with Kiki Smith," *Print Collector's Newsletter* 22, no. 3 (July–August 1991): 86. Inside and outside are synonymous, in, for example, *Black Madonna,* 1988 [destroyed], and *Nervous Giant,* 1987, or are contained, as in *Muscle Body,* 1987, and *Man,* 1988. I would like to thank David Little for help with bibliography on Kiki Smith.

24. From Robin Winters, "An Interview with Kiki Smith," in *Kiki Smith* (Amsterdam: Institute of Contemporary Art, 1990), 127–28.

25. I am reminded of Picasso's *Head of a Bull* (1943; Musée Picasso) made from a bicycle seat and handlebars.

26. Much like *Womb,* the floor piece *Untitled,* 1990, made of sperm-shaped glass, could be said to engage the current polemic about reproductive rights in addition to the hotly contested debate about exhibiting works that are sexually explicit.

27. Quotes from Schleifer, "Inside and Outside," 86. A longer version of the latter quote appears in Claudia Gould, "But It Makes You Think About What You Think About It Too: Conversations with Kiki Smith," in *Kiki Smith,* ed. Linda Shearer and Claudia Gould (Williamstown, Mass., and Columbus, Ohio: The President and Trustees of Williams College and Wexner Center for the Arts, Ohio State Univer-

sity, 1992), 24. The closing sentence is particularly interesting: "Jill Kroezon made this really great song about love oozing out the window and oozing out the door." Here Smith couples bloody noses, guts, and other fluids normally thought of as unpleasant with love, which is so often romanticized. Putting these together is another example of the blurring of binary oppositions I find so compelling in Smith's art.

28. Smith has made a life cast of her mother and often has cast her niece's hands and feet, which appear in *Skirt*. Many of her works are cast from life, including those exhibited at Joe Fawbush Gallery in the spring of 1992 and discussed below.

29. Roberta Smith, "Body, Body Everywhere, Whole and Fragmented," *New York Times,* May 15, 1992, C24.

30. I would like to thank Miriam Basileo, who suggested the analogy to the Pompeii figures.

31. Roberta Smith has described them as "battered women" in "Body, Body Everywhere," C24.

32. Schliefer, "Inside and Outside," 87.

33. Schliefer, "Inside and Outside," 86.

34. Gould, "But It Makes You Think," 24.

35. Schliefer, "Inside and Outside," 87.

36. Judith Williamson offers a good critique of the "elision of image and identity" (p. 91) in the chapter "A Piece of the Action," *Consuming Passions: The Dynamics of Popular Culture* (London and New York: Marion Boyars, 1986), 103ff.

37. Sherman has made this connection explicit. She tells us that her grotesque and sexually explicit imagery is powered by anger, anger "about 'the censorship that's going on right now with the NEA and artists in general and funding,' about Clarence Thomas' appointment to the Supreme Court, about the William Kennedy Smith and Mike Tyson rape trials, about AIDS" (cited in Amei Wallach, "Tough Images to Face," *Los Angeles Times,* June 7, 1992, 77). On the very day that I was writing this, Roberta Smith's article "Women Artists Engage the 'Enemy,'" in which she highlighted "a trend toward more confrontational art by women," appeared on the front page of the Arts and Leisure section of the *Times.* "Women in the art world, like women in politics, seem to have made a new connection between anger and power," Smith wrote (*New York Times,* August 16, 1992, 1). She also mentioned politically active groups like WAC (Women's Action Coalition), founded in January 1992, and the long-lived Guerrilla Girls.

Falcon, Marie-Cornélie, 73, 75

Feminism, 9, 127–28, 129, 131; critique of Ingres, 1–2, 4, 5, 145, 169*n5*

Fernow, Ludwig, 61–62, 91–92, 94, 108

Fighting Gladiator, 62

Film Stills (Sherman), 133

Flaxman, John: *Thetis Bringing the Armor to Achilles,* 22, *23*

Fontainebleau School, 117

Foscolo, Ugo, 50, 53, 54, 57–60, 61

Foucault, Michel, 7

France: subjugation of women in, 27, 28, 64; and classical Greece, 49; anti-Semitism in, 70, 71

French Directory, 103, 108

French National Assembly, 103

French Revolution: and artistic representation, 4, 102–3, 108; and subordination of women, 26–27, 151*n33*; *Busts of M. D'Orleans and Necker carried to Place Louis XV* (engraving), *104*; *Morning of July 12, 1789* (engraving), *104*

Freud, Sigmund, 105

Fuss, Diana, 8

Gautier, Théophile: on *Grande Odalisque,* 1, 89–90, 91, 121; and Jewish stereotypes, 73, 75, 77, 81–82; *Voyage en Italie,* 73, 77

Gebauer, Ernest, 89

Geffroy, L. de: on *Baronne de Rothschild,* 67, 68, 72, 78–82, 85, 87, 90, 119; and Jewish stereotypes, 67–70, 71, 82

Gérard, Baron François, 49, 50, 96; *Mme Récamier,* 39, *40,* 43, 44, 48; *Queen Caroline and Her Four Children,* 41, *42*; *Cupid and Psyche,* 105, *107,* 109

Gérôme, Jean-Léon: *Snake Charmer,* 73

Girodet, Anne-Louis, 49, 96, 105; *Sleep of Endymion,* 15, *16*

Grande Odalisque (Ingres), *34,* 73, 121, 128, 155*n45*; deformation of figure in, 2–3, 87, 96, 105, 108, 113, 115, 129; feminist critique of, 4, 127, 169*n5*; and sexuality, 7, 33–38, 142–43; commissioned by Caroline Murat, 33, 35–36, 39, 43, 45, 48; serpentine line in, 33, 87, 89–90, 92–93; model for, 36; and anacreontism, 49; criticisms of, 85, 87–88, 96, 98, 103, 105, 130; and modernism, 88, 113, 115, 117

Granet, François-Marius, 41

Granville, Lady Harriet Elizabeth (Cavendish) Leveson-Gower, 71

Greece, ancient, 19, 20–21, 49, 88

Gros, Baron Antoine-Jean: *Battle of Aboukir,* 33; *Battle of Eylau,* 33

Grosholtz, Marie. *See* Tussaud, Marie Grosholtz

Guillot, A., 75–77

Halperin, David M., 19

Hamilton, Gavin: *Andromache Bewailing the Death of Hector,* 23

Haraway, Donna, 129, 131, 145; "Manifesto for Cyborgs," 132–33

Hebe (Canova), 58

Hellenism, 49

Hercules and Lychas (Canova), 62, *63,* 65, 93

Hogarth, William, 11, 91; *Analysis of Beauty,* 2

Homer, 11, 26, 151*n29*

Homoeroticism, 11, 19, 26, 31

Homosexuality, 19, 20–21, 26, 31, 149*n16*

Hubert, Gérard: *Sculpture dans l'Italie Napoléonienne,* 38

Huet, Marie-Hélène, 103–4

Hugo, Victor: *Les Orientales,* 73, 78

Iliad (Homer): Ingres's *Achilles* and, 11, 12, 15, 17, 26, 27–28; homoeroticism in, 19, 20–22, 25

Ingres, Jean-Auguste-Dominique, 154*n27*; use of serpentine line, 1, 3, 6–7, 97, 109, 138; feminist critique of, 1–2, 4, 5, 145, 169*n5*; depictions of women, 1–2, 4, 11, 31, 68, 124; and neoclassicism, 3, 4, 7, 87–88; use of color, 3, 80–81, 88; deformation of figures, 3, 88, 93, 96–97, 111, 112, 114–15, 116, 117, 122, 129, 136; as modernist, 3, 88, 111, 112, 113, 115, 121–22; David's influence on, 4, 29–31; and classicism, 31, 53, 88–89, 92; letters on *Grande Odalisque,* 35, 36; Murats' patronage of, 35, 39, 41–43; marriage to Madeleine Chapelle, 41; and anacreontism, 49, 53; Canova's influence on, 53; as portraitist, 78–80, 82; critics' disgust at, 85–88, 97–100, 108, 109, 130; erotic paintings, 88, 89, 93, 109, 121; critical praise for, 88, 89, 111; history paintings, 93; odalisques compared to waxworks, 98, 100, 102, 103, 105, 108, 109, 140–42; women's responses to, 129–30

—works: *Achilles Receiving the Ambassadors of Agamemnon* (see *Achilles Receiving the Ambassadors of Agamemnon*); *Grande Odalisque* (see *Grande Odalisque*); *Baronne de Rothschild,* 3, 67–70, *69,* 78–83, 85, 90, 119; *Jupiter and Thetis,* 7, 8–9, 65, 114, 117–21, *120*; *Bather of Valpinçon,* 7, 43, 117, *118*; *Turkish Bath,* 7, 116, *119,* 121; *Martyrdom of Saint Symphorian,* 7–8, 9, 65, 93–94, *95,* 108; *Self-Portrait,* 29, *30*; *Sleeper of Naples,* 33–34, 43, 49, 53, 155*n45*; *Reclining Odalisque,* *34*; *Queen Caroline Murat,* 44–45, *46,* 154*n26*; *Bonaparte as First Consul,*

Introduction
Detail from Study for *Grande Odalisque,* by Ingres (fig. 15, plate 2), ca. 1814.
Medium pencil, 37 × 41 cm.

Chapter 1
Detail from *Achilles Receiving the Ambassadors of Agamemnon,* by Ingres (fig. 1, plate 1)

Chapter 2
Detail from *Queen Caroline Murat,* by Ingres (fig. 23, plate 3)

Chapter 3
Detail from *Baronne de Rothschild,* by Ingres (fig. 32, plate 4)

Chapter 4
Detail from *M. Bertin,* by Ingres (fig. 47)

Chapter 5
Detail from *Jupiter and Thetis,* by Ingres (fig. 57, plate 7)

Chapter 6
Detail from *Blood Pool,* by Kiki Smith (fig. 67)